Roman Cameo Glass in the British Museum

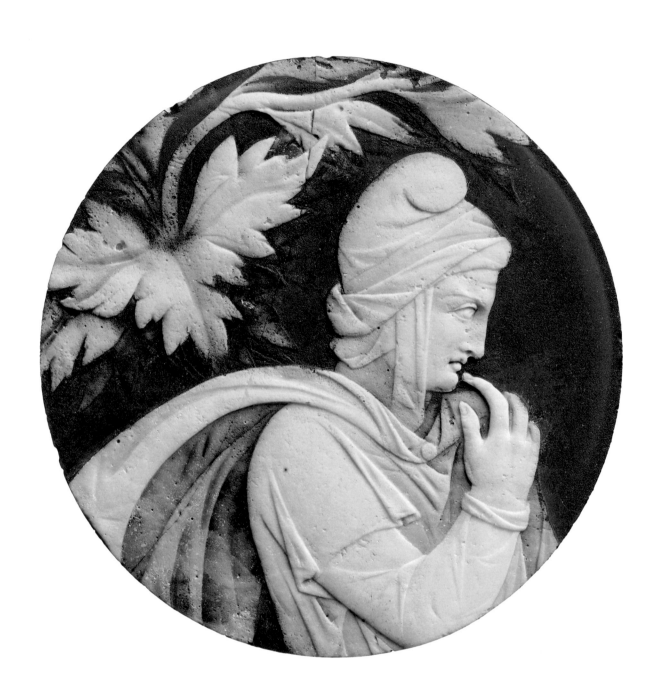

Roman Cameo Glass in the British Museum

Paul Roberts, William Gudenrath,
Veronica Tatton-Brown and David Whitehouse

THE BRITISH MUSEUM PRESS

Published in 2010 by The British Museum Press
A division of The British Museum Company Ltd
38 Russell Square, London WC1B 3QQ
www.britishmuseum.org

A catalogue record for this book is available from the British Library

ISBN 978 0 7141 2267 0

Designed and typeset by John Hawkins
Printed and bound in Hong Kong by Printing Express Ltd

The papers used in this book are natural, renewable and recyclable products and the manufacturing processes are expected to conform to the environmental regulations of the country of origin

Frontispiece
The Portland Vase disc (**34**).

Contents

Preface and Acknowledgements

The history of this volume begins with Bernard Ashmole, Keeper of the British Museum's Department of Greek and Roman Antiquities between 1939 and 1956, who first had the idea of producing a catalogue of the collections of glass in the Department. In 1946, at his suggestion, the Trustees of the British Museum entrusted the project to Donald Harden, then Keeper of the Department of Antiquities at the Ashmolean Museum, Oxford. The plan was to produce a catalogue in three volumes: I, Late Bronze Age, Hellenic and Hellenistic glass (cast Mycenaean objects and later core- and rod-formed vessels); II, cast and cut Hellenic, Hellenistic and early Roman vessels, and cameo glass; and III, the remainder of the collections. Harden was awarded a Leverhulme research grant between 1953 and 1955, allowing him to spend time with the British Museum collections and to travel the Mediterranean and the Near East, gaining vast experience of glass in museums and at excavations.

From 1956 Harden was Director of the London Museum, so it was only after his retirement in 1971 that he was able to turn again to the catalogue, effectively spending most of his time on it. In 1974 Veronica Tatton-Brown joined the staff of the British Museum's Department of Greek and Roman Antiquities as a Research Assistant and was assigned the task of helping Harden with the completion of the first volume of the catalogue. The year 1980 saw the publication of this volume and the following year, partly in recognition of her contribution to the volume, Tatton-Brown was promoted to the position of Assistant Keeper.

In the preface of Volume I Harden had remarked that 'the second and third volumes, already in draft, should follow the first with no long delay'. For much of the subsequent period, however, most of Harden's energies were devoted to the enormously successful exhibition *Glass of the Caesars* and the accompanying catalogue. Tatton-Brown continued to work closely with Harden on the preparation of the second volume, assuming increasing responsibility for its publication and then sole responsibility following Harden's death in 1994.

Another milestone in the history of the project came in 1995, when at the suggestion of Hugh Tait, then Deputy Keeper in the British Museum's Department of Medieval and Later Antiquities, William Gudenrath was brought into the catalogue project. Tait had edited *5000 Years of Glass* (British Museum Press, 1991) and had worked closely with Gudenrath, who contributed a chapter to the volume on 'Techniques of glassmaking and decoration'. Gudenrath, an American scholar specializing in historical glassworking processes and now Advisor at The Studio of The Corning Museum of Glass, was asked, in particular, to help determine the techniques used to make the objects, a very controversial issue in ancient glass studies. By 1997, at the invitation of Veronica Tatton-Brown and with the support of Dyfri Williams, then Keeper of the Department of Greek and Roman Antiquities, Gudenrath's role expanded to that of co-author.

Sadly, as work progressed and publication dates approached and passed, it became increasingly clear that Tatton-Brown's health was failing. Eventually, in 2002, she retired through ill health and work on the catalogue was suspended. At this point the structure and content of the second volume was, with the notable exception of Gudenrath's new material on glass technology, essentially an expanded version of the draft manuscript referred to by Harden in the 1980 preface to Volume 1. Yet in the intervening quarter-century there had been considerable advances, both in the field of glass studies and in the technology of publications. Elsewhere in the 1980 preface Harden reported that at the beginning of the project it had been proposed 'that all the glasses could be catalogued in two volumes of 500 pages'. He adds that 'such a catalogue might have passed muster then', but that 'thirty years later … a catalogue of British Museum glass … must aim at being a catalogue *raisonné*, providing full discussions of the historical and archaeological background … with comparative accounts of any important and relevant parallels. This is now the aim of the series.' It was this new concept that had made Volume I so important. By the same token, in 2004, almost twenty-five years after the first volume, with all the developments in our knowledge of glass and in the technology of imaging and publication, it was considered opportune to revisit the catalogue.

Thus, in 2004 Dyfri Williams relaunched the project and commissioned a review to examine the catalogue's scope and role in the context of other publications of similar material from the British Museum and elsewhere. The review committee comprised Williams himself; Kenneth Painter, formerly Deputy Keeper of Greek and Roman Antiquities; David Whitehouse, Executive Director of The Corning Museum of Glass; and Jennifer Price, then of Durham University. After much consideration, and in consultation with Teresa Francis of the British Museum Press, the concept of the catalogue was substantially revised.

Later in 2004 a meeting chaired by Williams took place in the Department of Greek and Roman Antiquities, attended by Whitehouse, Price and Paul Roberts of the Greek and Roman Department, who had taken responsibility for the Department's glass collections after the retirement of Veronica Tatton-Brown. At this meeting the decision was taken to divide the material covered by the planned Volume II into three

separate sections: the Canosa group of vessels and other Hellenistic objects; the cameo glass; and early Roman vessels made by fusing and slumping (ribbed bowls, etc.). David Grose was asked to take the Canosa Group and Hellenistic material forward to publication but was unable to do so because of ill health. Other plans are now in place for the publication of this volume. Whitehouse and Roberts agreed to work on the cameo volume with Gudenrath, and Jennifer Price offered to collaborate on the publication of the other early Roman vessels.

It was decided to begin with the collections of cameo glass, since these, together with the Canosa Group, were among the most important of the Museum's holdings. Knowledge of the BM pieces was greatly enhanced by a detailed re-examination of the cameo glass by Gudenrath, Whitehouse and Roberts. This permitted a focus on the iconography, typology and technology specifically of the cameo glass, in a way that, given the much larger number of vessels and range of techniques in the volume as originally envisaged, had not been an option beforehand. In order to provide as broad a context as possible for the British Museum pieces, Roberts conducted a thorough survey of Roman cameo glass in most of the major collections in Europe and the United States of America. This process, culminating in an international round table at the British Museum in late 2007, provided a wealth of comparanda for the BM pieces and also allowed, for the first time, a fairly accurate estimate of the number of Roman cameo glass fragments known worldwide. This formed the basis of the contextualization and much of the discussion throughout the catalogue.

This volume, therefore, is the result of more than sixty years of intermittent work by many hands. It is a pleasure – at last – to make the Museum's extraordinary collection of Roman cameo glass available to all.

Acknowledgements

We are most grateful to Dyfri Williams, Research Keeper, and Lesley Fitton, Keeper of the British Museum's Department of Greece and Rome, as well as their staff, including Celeste Farge, Alex Truscott, Alex Reid, David Hurn and in particular Judith Swaddling, who have helped in so many ways. Colleagues in other Departments who gave invaluable assistance include Ian Freestone (now University of Cardiff) who undertook scientific research on the glass; Denise Ling and the late Nigel Williams who ensured the glass was properly conserved; Ivor Kerslake and his photographic team, in particular John Williams and the late Sandra Marshall, who provided the images, and illustrators Marion Cox, Susan Bird, Candida Lonsdale and Kate Morton who executed the drawings, all of which were thoroughly revised and prepared for publication by Kate Morton.

Paul Roberts would like to thank friends and colleagues abroad who made their collections available for study, thereby enabling us to have a fuller picture of the global cameo glass assemblage and providing invaluable comparanda for our catalogue. These include Marinella Lista of the Museo Archeologico Nazionale of Naples, Chris Lightfoot of The Metropolitan Museum of Art, New York, Jutta-Annete Page and Sandra Knudsen of The Toledo Museum of Art, Karol Wight of The J. Paul Getty Museum, Malibu, Thorben Milender and Stig Miss of the Thorvaldsens Museum, Copenhagen, Friederike Naumann-Steckner of the Römisch-Germanisches Museum, Cologne, and Inge Hansen of the Butrint Foundation. A special thank you is due to Ruurd Halbertsma of the Rijksmuseum van Oudheden, Leiden, and in particular to Lucia Saguì of the Università la Sapienza, Rome, curator of the Gorga Collection.

Discussions on various aspects of the research contained in this book have benefited greatly from others who have been very generous with their time and experience, including Martine Newby, Don Bailey, Kenneth Painter, Jennifer Price of Durham University, Gertrud Platz of the Antikensammlung, Berlin, Susan Walker of the Ashmolean Museum, Oxford, and Peter Auldjo Jamieson. Special thanks on this front also are owed to Julia Schottlander, Kate Morton and in particular to Mark Taylor and David Hill of 'Roman Glassmakers'.

Paul Roberts wishes to thank the Department of Greece and Rome for its support in facilitating his study of collections abroad. David Whitehouse and William Gudenrath wish to acknowledge the generosity of The Corning Museum of Glass which funded their study visits to the British Museum. William Gudenrath offers sincere thanks to Amy Schwartz, Director of Development, Education, and The Studio at The Corning Museum of Glass.

Very importantly, all of the authors would like to offer their warmest thanks to Teresa Francis of the British Museum Press. With her infinite patience, professionalism and good humour, she has steadfastly guided the book and its authors on their long journey.

Finally, the encouragement and support that Veronica Tatton-Brown has received from her husband Tim and their children, both during her research and in recent years during her illness, are warmly acknowledged.

Paul Roberts, William Gudenrath and David Whitehouse

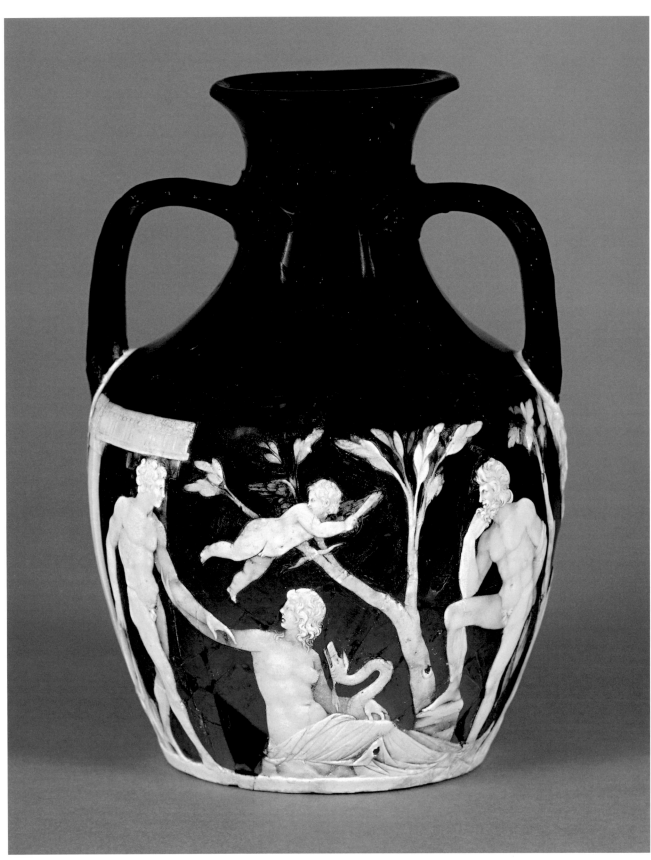

The Portland Vase (**1**), side A.

British Museum Cameo Glass in Context
Paul Roberts, David Whitehouse and William Gudenrath

The collection of Roman cameo glass in the British Museum comprises eighty-two pieces. Of these, seventy (**1–69**) are part of the classic, early imperial production of cameo glass, which, we believe, dates roughly to between 15 BC and AD 25 (see below, pp. 16–23), while five are examples of late Roman cameo glass of the fourth century AD (**70–74**). Seven pieces (**75–81**), classed by us as 'Egyptianizing layered glass', are an associated (if not directly related) type of decorative glass plaque. This type of glass dates, we suggest, to approximately the same time as the early cameo glass production.

The following discussion aims to present a comprehensive context, using archaeological, technological, iconographic and typological evidence to look at the origins of cameo glass and its place in contemporary Roman art and craftsmanship. It also tentatively proposes a relative and then an absolute chronology for cameo glass, and suggests possible models for the organization of the workshop(s) that produced it.

The major collections of cameo glass

The vast majority of all known cameo glass is held in a relatively small number of collections in Europe and North America (see table on p. 12). Below is an outline of these collections, including brief information on the people who helped to create them. Such analysis can, we hope, begin to give a good idea of where the collections were formed and where the pieces that constitute them were discovered (not always of course the same thing). This information might be a factor in establishing (or confirming), amongst other things, the place of manufacture of cameo glass. For the purposes of this introduction, and to enable meaningful comparisons to be made with other collections, we shall deal mainly with the seventy classic early cameo pieces. Throughout this volume British Museum pieces discussed in the catalogue are marked with the catalogue number in bold, e.g. **10**. Detailed discussion has been reserved for the individual catalogue entries of the pieces concerned.

British Museum, London

This collection is, on first inspection, not so useful in helping to determine the provenance of the collections of cameo glass. Of the seventy pieces of early cameo glass, only ten have a fairly certain provenance. Of these, five are from Rome, namely the Portland Vase (**1**) with its disc base (**34**), the multi-layered fragment (**10**) and two pieces previously in the Sangiorgi collection (**22, 24**) that are mentioned in his catalogue (Sangiorgi 1914) as coming from Rome. Three more are from Pompeii, namely the Auldjo Jug (**2**) obtained from Dr Hogg and Madeleine Auldjo, and fragments of two other closed vessels (**7, 8**), both bequeathed by Madeleine Auldjo (and presumed therefore to be

from Pompeii). Finally, there are two pieces from the Bay of Naples area, a fragment of a broad dish or tray from the island of Capri (**33**) to the south, and a large mounted medallion (**62**) from Cumae to the north.

But when we come to look at the collections and collectors who provided the pieces in the British Museum, the picture becomes more complete. Sir Augustus Wollaston Franks gave one piece of cameo glass in his own right (**10**), but in 1886 he gave seventeen more pieces of cameo glass to the Museum as part of the bequest from his brother-in-law, Alexander Nesbitt. Nesbitt was a member of a wealthy mercantile and banking family, and he was also an archaeologist, collector and a Fellow of the Society of Antiquaries. He had a large collection of glass and, in fact, wrote the introduction to the catalogue of the collection of ancient glass owned by Felix Slade (Slade 1871). Nesbitt stayed in Rome for part of the winter of 1858–9 (Stevenson 1999, 161) and probably bought all of his glass, including the cameo pieces, at that time. Some pieces of cameo may have come with the collection he bought from the Roman dealer Filippo Turchi (Whitehouse 1997, 33).

A further fifteen pieces of early cameo glass came to the British Museum from Felix Slade himself through the important bequest made on his death in 1868 (Wilson 2002, 167–8). Slade was a wealthy landowner and lawyer and an avid collector of books, prints, ivories and, in particular, glass. His interest in glass began early during a visit to Italy in 1817, and in 1871, three years after his death, a catalogue (Slade 1871) was published of his glass collection, co-authored by Slade, Augustus Wollaston Franks and Alexander Nesbitt. Some of Slade's cameo pieces came from the collection of Matthew Uzielli, a banker and railway magnate, who lived at Regent's Park, London. Sir John Charles Robinson (1860, 27), describing Uzielli's collection, mentions

> several thousand fragments of antique (glass) vessels … There are many examples of cameo glass fragments of vessels similar in work to the Portland Vase … This series of fragments, mostly from 'scavi' in the neighbourhood of Rome, was purchased in that city in the spring of 1859.

Interestingly, this is exactly the same period when Alexander Nesbitt was buying his glass in Rome.

Another donor of cameo was Henry Christy, who bequeathed his collection, including five pieces of cameo glass, to the British Museum in 1865. Christy was a banker and textile magnate, best known for his interest in palaeo-archaeology and ethnography (his bequest formed the basis of the British Museum's ethnographic department). It is unclear how he obtained the cameo fragments, but one piece, an edging strip (**65**), finds close parallels in the Gorga collection in Rome, while the layered Egyptianizing piece (**75**) forms part of a group of

seven fragments in the British Museum, of which three came from the Nesbitt collection (77, 79, 81), purchased almost exclusively in Rome (see above).

So when the circumstantial evidence of the collectors who contributed the pieces to the British Museum is examined, the number of pieces with a fairly secure provenance rises from ten to forty-seven, and those with a fairly secure provenance of Rome, from five to forty-two. To these can be added pieces which, by implication, must share this Rome provenance, for example the base of the dish in milky-opaque light green glass (27), which must surely be the base for the wall sherd (28) given by Felix Slade. Two of the Egyptianizing pieces (78, 80) very probably share the Rome provenance of the others in this group (75–7, 79), while the fragments of large plaques in purple glass (44, 45) almost certainly once formed part of the same plaques as fragments in the Gorga collection (personal observation), still in Rome at the Università la Sapienza (see below).

The Corning Museum of Glass, Corning, New York

The Roman cameo glass of The Corning Museum of Glass comes predominantly from two major collections. Of the thirty-eight or so pieces at Corning, many derive from the collection of Ray Winfield Smith, who was collecting in the middle decades of the twentieth century. Twelve of his pieces were definitely purchased in Rome, and another four have no provenance but may have origins in the city. A further twelve pieces were originally part of the Sangiorgi collection. Giorgio Sangiorgi was an antiquities dealer based in Rome at the Palazzo Borghese, south of the Mausoleum of Augustus. He collected primarily in the later nineteenth century and a catalogue of his glass was published in 1914. This catalogue clearly states under the individual entries that the Sangiorgi collection was formed almost exclusively from pieces bought in and around Rome.

The Metropolitan Museum of Art, New York

Most of the twenty-two pieces of cameo glass in the MMA derive from two major collections. Many came from John Pierpont Morgan, whose family grew rich through railroads, banking and industry. He was one of the wealthiest businessmen in America and, like many of his fellow tycoons, assembled an impressive art collection. Between 1890 and his death in 1913 he travelled extensively in America and Europe, collecting, amongst other things, ceramics, gems, books and glass. In 1911 he attempted (in vain) to purchase the entire Gorga collection (see below). Morgan died in Rome in 1913 after another of his travels. Other significant pieces in the collections of The Metropolitan Museum of Art came from Henry Gurdon Marquand. Marquand was a New York banker and one of the founders and chief benefactors of The Metropolitan Museum of Art. His collections of Greek and Roman glass and pottery were sold after his death in 1903.

Museum Bertel Thorvaldsen (Thorvaldsen Museum), Copenhagen

Bertel Thorvaldsen was born in Copenhagen, Denmark, in 1768 or 1770 and moved to Rome in 1797 where he became one of the foremost sculptors of his day. He also amassed a collection of Greek, Etruscan and Egyptian antiquities, along with gems and glass. In 1838 he returned to Copenhagen, and a museum was built to house his collection, which he had given to the city. The collection includes fourteen pieces of cameo glass.

Part of the great importance of the Thorvaldsen collection in general, and its cameo glass fragments in particular, is that most, if not all, of the collection was acquired in Rome and then removed to Copenhagen by 1838. Thorvaldsen's return to Denmark marks, in effect, a *terminus ante quem* for the assembling of the pieces. This is therefore the earliest surviving collection of cameo glass fragments (that of Menu von Minutoli, published in 1836, is lost) and proves the existence of sherd material in the hands of dealers by the early nineteenth century.

Rijksmuseum van Oudheden (National Museum of Antiquities), Leiden

The Roman cameo glass fragments in the collections at Leiden (approximately forty) were donated to the museum in 1950 by the widow of Walter Bachstitz, a German art-dealer who had his residence and shop in The Hague (Ruurd Halbertsma, pers. comm.). His vending catalogue was published in 1921 and consisted of three volumes, of which part 2 was dedicated to the antiquities. Interestingly, in this catalogue there is no mention of fragments of cameo glass.

Bachstitz had acquired his collection from Freiherr Friedrich Ludwig von Gans (1833–1920), a Jewish industrialist, philanthropist and collector from Frankfurt, Germany. Von Gans sourced his antiquities with the help of Peter Mavrogordato, the Berlin-based archaeologist and collector, who spent many years in Italy in the early twentieth century. In 1912 von Gans donated his first collection of antiquities to the state museums of Berlin, and during the First World War he placed his second collection under the care of Robert Zahn in that city. After von Gans's death in 1920 the collection was sold to Walter Bachstitz and left Berlin for The Hague. Assuming Bachstitz did not acquire antiquities from other sources, there is a good chance that all the Leiden fragments are from the von Gans collection.

Römisch-Germanisches Museum (Romano-German Museum), Cologne

None of the twenty cameo glass fragments in the Römisch-Germanisches Museum of Cologne has a definite findspot. The pieces came from individual collectors who seem to have had little idea of where their pieces were found. Many were from the collection of Carl Anton Niessen, a wealthy merchant, antiquarian and the British Consul in Cologne. He was also a keen collector, and although we do not have a very detailed provenance for his pieces, three of the cameo glass fragments are marked in his inventory with the findspot 'Italy'. Another belonged to a Herr Kramer, a wealthy Cologne jeweller, who was known to have Syrian and Italian items in his collection (F. Naumann-Steckner, pers. comm.). Karl Adalbert von Lanna, a Bohemian manufacturer in Prague, who was collecting in the eighteenth century, once owned 'Glas 1009' with its Bacchic inscription (Naumann-Steckner 1989, 73–4). This is a very important piece, since, apart from 45 in the British Museum, it is the only surviving inscribed piece of cameo glass known. Like the inscription on the British Museum piece, it is also in Greek. It was also collected remarkably early – one of the first sherds to be mentioned in a collection.

The Toledo Museum of Art, Toledo, Ohio

David Grose (1989, 17–23) has given a full account of the way in which the twenty-nine pieces of ancient cameo glass in Toledo

were obtained. Most were acquired in 1919 by the museum's founder, Edward Drummond Libbey. He bought them from the family of Thomas Hulse Curtis, an industrialist and collector based in New York, who had died in 1915. Hulse had acquired them at some point in the 1890s from Charles Caryl Coleman (1840–1928), an American artist who moved to Italy in the 1860s. Coleman lived first in Rome and then, from 1886 till his death in 1928, in his Villa Narcissus on the island of Capri in the south of the Bay of Naples. Most of the cameo pieces must therefore have come from in or around Rome and Naples in the mid- or later nineteenth and early twentieth centuries.

Università la Sapienza (Gorga collection), Rome

Gennaro Evangelista Gorga (1865–1957) was a famous opera singer who developed a passion for collecting. Based in Rome for most of his life, he collected everything from furniture, armour and bronze to glass and pottery, and in particular musical instruments. With regard to archaeological pieces such as cameo glass, he would have had first-hand access to much of the material emerging in Rome as the new capital expanded in the later nineteenth century. His collection, which included at least thirty-nine pieces of cameo glass, was spread over ten apartments in Via Cola di Rienzo in the new, fashionable area of Prati in north-west Rome. In 1911 John Pierpont Morgan, the American banker and collector, tried to buy Gorga's whole collection but Gorga refused. In 1929 the collection was, at Gorga's own request, taken into state ownership, in order to stop it being dismembered and sold off to pay off his debts.

Findspot and place of manufacture

We do not know the exact processes by which the fragments that found their ways into the collections listed above came into the hands of dealers. Agricultural activity and building works must surely account for the collections of Thorvaldsen, Nesbitt and Uzielli (via Slade). In the mid- to later nineteenth and early twentieth centuries the vast expansion of Rome within its walls to the south, east and north and finally beyond the walls into the new suburbs, caused a flood of archaeological material of all types, including, presumably, the cameo glass fragments eventually collected by Coleman (also on the Bay of Naples), Sangiorgi, Morgan, Smith, von Gans (via Bachstitz), Niessen and Gorga. One of these collectors (Smith) was still gathering pieces in Rome just after the Second World War. Although most cameo glass was spirited abroad, the Gorga collection fortunately remained in Rome and provided an anchor-like point of reference for the other pieces.

The evidence of the large collections across Europe and America indicates that, with regard to cameo glass, all roads do indeed lead to Rome. Thanks to its distinctive nature, isolated examples have been identified throughout the empire and beyond. Individual fragments or whole vessels have been found in Britain (Lightfoot 1988), Spain (Whitehouse 1991, 29–30), Albania (Hansen 2009), Turkey (Whitehouse 1991, 25), and far beyond the empire in Pakistan (Naumann-Steckner 1989, 86) and perhaps Iran (Whitehouse 1991, 25), though not a sherd is listed in the extensive publication of glass from the Athenian Agora by Weinberg and Stern (2009). The vast majority of the pieces of cameo glass vessels and plaques – perhaps as many as 90 to 95 per cent – were found in and around Rome.

Obviously, provenance and distribution pattern alone are not always good indicators of place of production. A case in point is the belief, widely held in the eighteenth century, that because Attic Greek vases were found in quantity in Tuscany in Italy, that they must have been the products of Etruscan workshops (Jenkins and Sloan 1996, 57–8). Nonetheless, although overwhelming and nearly exclusive patterns of distribution can be persuasive, conclusive proof for the location of the place of manufacture of cameo glass can come only with concrete evidence of working. Fortunately, this evidence exists in the form of blanks, that is, pieces that may have been partly or wholly covered in white glass but have a decorative scheme that is unfinished (or not started). The Gorga collection preserves parts of blanks of several plaques, a circular disc and two fragments of a small broad-rimmed dish (personal observation), all from Rome. Another fragment (unprovenanced) of a blank is probably from the central area of a large plaque; formerly in the John Woodman Higgins Armory in Worcester (MA), USA (Goldstein, Rakow and Rakow, 1982, 11–12, fig. 2), it was offered for sale at Sotheby's New York on 19 December 1991 (D. Whitehouse, pers. comm.). The Corning Museum of Glass possesses part of a disc, similar to the fragment in the Gorga collection (above) and also acquired in Rome, with an unfinished decorative scheme (59.1.117; Whitehouse 1997, 43, no. 49). On balance, therefore, the physical evidence for production of cameo glass points fairly convincingly towards Rome, a suggestion first argued strongly by Whitehouse (1991, 31–2).

Until quite recently Alexandria, with its rich cultural traditions in all forms of the fine arts, including, with particular relevance in this case, carved hardstone (La Rocca 1984, *passim*), was thought to have been the birthplace of cameo glass (Haynes 1975, 23–5). Cooney (1976, 36) wanted to see at least some cameo glass produced as early as the third century BC, while much more recently Vollenweider (1995, 126) proposed that the date of production of a major piece, the Seasons Vase in the Bibliothèque Nationale, Paris, was the mid-second century BC. Others maintained that there could have been a continued production of cameo glass in Alexandria alongside that of Rome (discussed by Whitehouse, 1991, 31–2). Certainly, centres of cultural and artistic excellence such as Pergamon, Alexandria and Ephesus continued to flourish as they had done for several centuries before Rome. But the focus of the vortex of artistic activity in the early empire was Rome, the home of the imperial court and of the empire's elite, as underlined by Whitehouse (1991, 31). This factor, together with the overwhelming evidence of production, findspots and collection formation, argues extremely convincingly for an origin for cameo glass in Rome.

Cameo glass, we confidently believe, originated in Rome, and given the rarity and beauty (and very importantly the novelty) of cameo glass, it is hardly surprising that Rome, hungry for fine, unusual and precious finished goods, was also by far the main consumer. It is very understandable, therefore, that the vast majority of fragments known today have an explicit or implicit origin in and around the city. It is difficult to be more specific because of the lack of detailed documentation of individual purchases, let alone the original archaeological findspot, but the pieces were found in or near Rome.

'Were', however, is the operative word. Only sixty years ago cameo glass, though never exactly common, was obtainable by

collectors such as Smith from the dealers and collectors of Rome. Yet now cameo glass has disappeared from Rome, and the supply of fragments from its rich archaeological deposits appears to have dried up. Lucia Saguì of the Università la Sapienza in Rome, and curator of the glass that once formed part of the Gorga collection, has an unrivalled knowledge of glass finds in and around Rome. With the exception, however, of the recent publication of a small fragment from excavations on the site of the ancient city of Veio, 15 km north-east of Rome (Lepri 2007, 2, fig. 3), neither she nor her colleagues know of any finds of cameo glass from Rome and the surrounding area since the Second World War. This adds considerable strength to the argument that there may not be very much more cameo glass to discover. If the rich, frequent and well-documented excavations of Rome, the very core of the empire, no longer produce cameo glass, then where might?

Quantification

Recent research by the authors is leading towards a better understanding of the number and range of examples of early cameo glass. We can now calculate with some certainty the number and type of pieces of cameo glass that are known to exist, and this information has several very important applications.

First, it gives a rough (perhaps to the nearest order of magnitude) idea of the scale of production, suggesting just how common (or not) cameo glass was. It also allows us to gain a fairly full picture of the range of forms and dimensions of all pieces, both vessels and plaques. The relative scarcity of cameo glass and the rare opportunity this gives us to begin to estimate its entire output, opens up other possibilities of investigation, beyond a simple assessment of numbers. Although it is always very important to exercise caution in the use of statistics, an estimate of the total number of fragments, however approximate, could be extremely useful. Combined with an understanding of how long it would have taken to make the various types of glasses, a total number of vessel fragments might provide the opportunity to assess with reasonable confidence how long the pieces took to make. This might give a broad idea of how long the art form may have lasted and even give some clues as to how its production might have been organized.

Problems in assessing numbers

However, even estimating the number of pieces of Roman cameo glass that have been discovered to date can never be a precise science. Examples doubtless lurk, forgotten if ever noted, in museum storerooms across southern (and perhaps northern) Europe. Private collectors may not have shared their collections with the wider academic community. Some other pieces may have featured in older publications but still remain undetected because of a lack of adequate description or a lack of illustration, such as some of the pieces in the important Sangiorgi collection publication of 1914.

Fragments of cameo glass, with the exception perhaps of (rare) undecorated elements such as plain bases or rims, are among the most recognizable categories of Roman glass. Yet in spite of its potentially high degree of recognition, cameo glass is still relatively scarce. This suggests that finds of cameo glass have either been very selective and patchy and that the Rome pieces were lucky finds, or that there really is not (and was not) very much to be found. This might have implications for

production, suggesting that cameo glass was neither very long-lived nor very diffuse.

The table below gives the number of pieces of early cameo glass, both whole vessels and fragments, known in the major collections. It estimates the number of pieces held by private collectors, which may together be quite numerous but which in our opinion are unlikely greatly to exceed the 40–70 pieces in the world's larger collections.

Early imperial cameo glass fragments in the major collections

COLLECTION	NO. OF PIECES
Bibliothèque Nationale, Paris	5
British Museum, London	70
The Corning Museum of Glass, Corning, New York State	38
The John Paul Getty Museum, Malibu, California	5
The Metropolitan Museum of Art, New York	22
Musée du Louvre, Paris	7
Museo Civico Archeologico, Aquileia	4
Museo Archeologico Nazionale, Naples	4
Museum Bertel Thorvaldsen, Copenhagen	14
Rijksmuseum van Oudheden, Leiden	40
Römisch-Germanisches Museum, Cologne	20
The Toledo Museum of Art, Toledo, Ohio	29
Università la Sapienza (Gorga collection), Rome	39
Other collections (estimated)	80
TOTAL	377

Size of output

Yet there is still one great unknown, namely the proportion of the total production of cameo glass that the current knowledge of the fragments represents. One necessary question is whether every fragment represents an individual vessel or plaque.

Obviously, figures alone (such as those in the table above) cannot tell the whole story. Of the surviving fragments within and across individual museum collections, a small number are so similar in scale, colour and decoration that they almost certainly came from the same vessel or plaque. Examples include groups of sherds of a plaque and spear-leaf cups in the National Museum, Leiden; two fragments of the same jug, one in the British Museum (5) and the other in the National Museum, Leiden; and fragments of the large purple glass plaque(s) in the British Museum (44, 44a, 45), which almost certainly belong with fragments in the Gorga collection, Rome, and the Thorvaldsen Museum, Copenhagen (see 44). There may be other cases where fragments are less obviously from the same plaque or vessel, but even so, after a fairly exhaustive examination of the fragments, we think it is reasonable to assume that most of the fragments represent an individual piece, whether plaque or vessel.

Assuming this, we arrive at a total number of just under 380 sherds known to the authors. It is of course wrong to imagine that we have representative fragments of all the cameo glass pieces ever made, so the survival rate must be factored in and the estimated number of vessels in the whole production will rise accordingly. We might guess that the extant fragments represent about one third of the total production; if this were so, the total production would have been around 1,100 pieces.

Organization of the industry

The question then arises: what kind of industry do the sherds represent? We cannot ask an ancient craftsman exactly how long it took to make any given piece of cameo glass. Nor can we quiz him over how many artisans were working alongside him or for him at any given time. Also unclear is the status of the glassmakers and carvers. Were they slaves, freedmen or even citizens? The only industry where we can perhaps begin to ask such questions with any remote hope of an answer is pottery manufacture. The most helpful information, we would argue, might be provided by the production of fine, relief-decorated red-slip tableware (Arretine ware) in and around Arezzo in central Italy during the Augustan period. It is obvious that Arretine ware and cameo glass were produced on a very different scale and it is almost certain that they were intended for quite different markets. But, nonetheless, the parallel of a layered and well-organized production in Roman times is attractive, particularly in the absence of other comparable 'industries'.

The Arretine ware 'industry', which began in the 40s BC and reached its peak in about 25 BC–AD 25, has provided us with abundant evidence for individuals involved in it. This evidence takes the form of name stamps, impressed and in relief, which are found on many sherds of Arretine ware. Interestingly, a piece of cameo glass in the Thorvaldsen collection (personal observation), Copenhagen, bears a raised rectangular area containing several (mostly illegible) letters that may be a maker's mark. If so, this would be unique.

The stamps on Arretine ware may well have had different meanings depending on which person or combination of persons was mentioned. They could, for example, be denoting ownership of a workshop, foreman status or individual potters (assuming these to be mutually exclusive, which they may not have been). Kenrick (2000, 10–12) discusses the complex and longstanding debate over the significance of the stamps on fine Arretine ware. He outlines two major purposes of the stamps – the first to sell the product and the second to assist in administration – whether at the workshop or in the marketplace.

Stamps can certainly give some idea of the numbers of people involved in manufacture, but there are still uncertainties. We cannot be sure, for example, whether each stamp represents one worker or whether it is actually representative of a body of people – a grouping of workers under one foreman. Furthermore, this does not mean that every manufacturer was thus represented, even less that those involved in the rather more mundane elements of production were represented, such as those who puddled and settled the clay, or the people who tipped the pots out of their moulds or roughly finished the bases and rims. Nonetheless, we can get some idea of numbers. Kenrick (2000, 20–24) lists some of the major producers of Arretine pottery and then gives the number of dependent workers, based on the number of names appearing on the stamp, directly linked to the workshop.

Surprisingly, perhaps, some of the larger workshops seem to have had quite varying numbers of dependents/co-workers. The workshop of P. Cornelius, active in Arezzo in the first half of the first century AD, has yielded just over 500 stamps with approximately fifty associated names – all apparently slaves. However, the workshop of L. Gellius Quadratus, a contemporary of P. Cornelius, with a much larger stamp representation (nearly

1,000), has produced evidence for only three dependents. So within any given production, manufacturing processes and methods may have varied enormously. As for the social status of these workers, Kenrick (2000, 15–19) gives evidence for the presence of slaves, freedmen and full citizens (i.e. with the full three names, or *tria nomina*, denoting citizenship).

The above considerations provide some approaches to the question of the scale of manpower in the production of cameo glass, but they cannot really inform us about how long this early, classic flowering of the technique may have lasted. At this point, we believe, the sherds of cameo themselves can help us to understand the production. Our premise is that we now have an idea of how many pieces exist and can have an educated guess at how many might have existed originally. We believe that it might be possible to look at the time necessary to create each type of cameo piece and then arrive at the total production time necessary. This calculation, based on technical comparanda and the archaeological remains, might, in effect, constitute an approximate period of duration of cameo glass production. Much more difficult is the task of trying to fit these calculations into the idea of an absolute chronology, and caution is necessary when pursuing new and uncharted avenues of investigation.

Time needed to produce cameo glass

Crucial to the above approach is an attempt to estimate just how long it took the ancient craftsmen to make such pieces. Given that, in general, the ancient sources are of little direct help, it is useful at this point to look at the manufacturing techniques (and speed) of modern glass craftsmen who have created pieces of cameo glass that are, to all intents and purposes, faithful to those of ancient Rome. Taking the statistics on the number of pieces known (vessels both closed and open, and plaques), Paul Roberts of the British Museum and David Whitehouse and William Gudenrath of The Corning Museum of Glass, together with David Hill and Mark Taylor – the Vitrearii Romani (Roman glassmakers) of Andover, UK – used their experience or 'educated guesses' to arrive at an agreement on manufacturing times for the different classes of cameo glass. There were, almost inevitably, some differences in opinion as to the exact methods of manufacture, but in terms of the time taken for various aspects of the manufacturing process, there is fairly close agreement.

As little as twenty years ago, some may have considered it unwise or unprofitable to try to use statistics on vessels in this way. As little as two years ago, we would not have had the knowledge of the global assemblage of cameo glass to enable us to begin to attempt it. But our understanding of all aspects of glass technology has increased, and given our current knowledge of the range and the extent of the cameo glass assemblage, such an approach is worth pursuing. If, as we believe, it is correct, it might produce telling results.

Before creating the final product, the craftsman/men had to arrive, by whatever means, at the formation of a blank that was ready for carving (see below, pp. 25–31). Here Gudenrath gives a comprehensive account of the techniques and methods that the authors of this volume, along with others, believe were used to work cameo glass. There is general agreement that the formation of blanks, even for more ornate pieces such as the Portland Vase (1) or the Getty skyphos (Painter and Whitehouse 1990d, 143–5), would not take a very long time, given the nature of hot glass-working processes (see below). But this leaves the

issue of the much more time-consuming aspect of production, namely the carving of the decoration.

The following discussion looks at the different categories of cameo glass in the global assemblage. Through the combination of data on the number of existing pieces, and the estimated time necessary to produce them, it attempts to arrive at a length of time necessary for the whole production. This argument presupposes that for much of the output there existed a workshop or workshops dedicated largely if not exclusively to the manufacture of cameo pieces. It also assumes that craftsmen involved in this work would have been experienced in making cameo glass. One essential factor is an attempt to estimate the length of the working day, as only then can we begin to try to measure the length of time that production of all the pieces would have taken. There would have been no Health and Safety directives, and long, potentially very long, stretches of work would have been feasible. Nevertheless, given the lack of strong artificial light, the essentially finite capacity of even the most skilled working eye and hand, and the possibility that some of the craftsmen, in particular the carvers, may have been working on other material (gems or hardstone vessels, perhaps), we are going to use as a model the modern 8-hour working day.

Closed-form vessels

In the known world assemblage there are approximately seventy closed vessels represented, either as whole pieces or as fragments. These range from masterpieces, such as the Portland Vase (**1**), the Blue Vase (Harden *et al.* 1987, 74–8), the Auldjo Jug (**2**) or the Getty bottle (Painter and Whitehouse 1990d, 150–53), to simpler, apparently much less ornately decorated pieces. Starting with these finer pieces, and the probable dozen or so fragments that, when complete, would have stood comparison with them, each of their blanks could have been fashioned comfortably in under half an hour. Blanks for others, including bottles such as the Getty (above) and Ortiz examples (Painter and Whitehouse 1990d, 161–2), which are ornate by merit of their carving but not their original form, may have taken far less time, maybe 5 to 10 minutes. Assuming 10 hours for the production of blanks for the most ornate twenty of the closed vessels, and fifty-five times 10 minutes for the less complex pieces, this gives a total of about 19 hours, perhaps 2.5 working days. Clearly the amount of time taken to create blanks, even for the most complex pieces, is almost negligible in the bigger picture of the man-hours required for decoration.

With regard to the carving of the closed vessels we can begin with the most ornate, the Portland Vase. Although John Northwood, the leader of the renaissance of cameo glass in Victorian England, took 3 years to make his true cameo copy of the Portland Vase (Painter and Whitehouse 1990a, 73) and Joseph Locke about half that time to produce his replica (Painter and Whitehouse 1990a, 74), it should be remembered that they were working part-time. Gudenrath, Taylor and Hill all agree that an experienced cameo worker, working exclusively on the piece, could have produced a good approximation of the Portland Vase in about 3 months. This means that the twenty or so more complex pieces mentioned above would have taken approximately 5 years of work hours. The fifty or so less complex pieces would require perhaps 1 month each, maybe less, giving about 55 months

or approximately 5 years again, a total of 10 years for the closed forms.

Open-form vessels

With the open vessels, for which we have the evidence of about 170 examples, there are again pieces that are ornate, whether in their form (the Getty skyphos: Painter and Whitehouse 1990d, 143–5), in their carving (the Morgan Cup: Painter and Whitehouse 1990d, 141–3) or in both (the Naples patera: Painter and Whitehouse 1990d, 153–5; and the fragment of a large dish in The Metropolitan Museum of Art, 17.194.358). Of the open vessels, approximately half are *skyphoi*, handled cups, often with complex handles, rims or rim/handle junctions. Making a blank for one of these or for one of the, say, twenty other more complex pieces, would take perhaps 30 minutes each. This gives a total of around 55 hours, or about 7 working days. For the approximately sixty-five remaining pieces of lesser complexity (of form), such as the Morgan Cup and other cups, dishes and bowls, the time for making a blank would probably be 10 minutes, giving a total of about 11 hours: 1.5 working days.

As for carving the open forms, complex decorative schemes such as the Morgan Cup or the Metropolitan dish (for both see above) would have taken, according to Gudenrath, Taylor and Hill, between 3 weeks and 1 month. Assuming half the open forms to have been of some degree of complexity (and this may be an overestimate), then we have approximately eighty-five vessels at 1 month, i.e. approximately 85 months (7 years) of work time. The other eighty-five vessels might have taken a maximum of 2 weeks each, giving a total of 170 weeks, or 42 months. This makes a total for the open vessels of about 127 working months (say 10.5 years).

Plaques

Among the (approximately) 100 plaques known, there is, just as with the vessels, a great variety of quality and complexity. Those such as the Carpegna plaque in the Louvre, Paris, or the two Pompeii pieces, now in Naples, seem to be quite ornate, although looking at fragments of plaques in other collections, especially the British Museum or the Leiden Museum, many plaques seem to have been of comparable and, in some cases, superior quality. Examples in the British Museum include a fragment showing a young man (**37**), the Egyptian-themed plaque (**41**) and of course the base disc of the Portland Vase (**34**). There may well have been a lesser degree of accomplishment in the plaques that were apparently of a vegetal decorative scheme, but it is worth bearing in mind that substantial sections of the plaques from Pompeii comprise vegetal decoration. If their vegetal fragments alone had come to light, then these obviously Bacchic plaques might have been interpreted as vegetal in theme.

It is probably useful to think in terms of a uniform time necessary for the production of blanks for plaques, and probably a fairly uniform time for the carving of each plaque, too. There is a degree of difference between the cited experts as to the process of manufacture of the plaques. Nonetheless, there is agreement on half an hour for the creation of each blank – resulting in 50 hours or about 6 working days for the creation of all blanks. A month seems to be accepted as the approximate time necessary to carve even a complex plaque such as those from Pompeii or the Carpegna plaque, giving a total of 100 months, or 8 work-years.

Total production time

Taking the production of closed vessels (estimated at about 10 years), open vessels (10.5 years) and plaques (8 years), we arrive at a total of approximately 28.5 years for the production of all cameo pieces known to date. Obviously these calculations are based on the assumptions laid out above. They necessarily imply experienced (designated?) cutters and a fairly realistic, we believe, working day of about 8 hours. It is conceivable, however, that such ideal conditions did not prevail all the time, so we are going to suggest a contingency of manufacturing time of one third. This way the period for production of cameo glass comes to roughly 40 years, still a feasible but, we believe, very outside figure for its production. (The linearity – or otherwise – of this work period is discussed below.) Nevertheless it is the idea of cameo glass production lasting for about 40 years that we will use for the purposes of this argument.

Such statistics can only be educated guesses, as we are very aware. So it is helpful to try and gain corroboration (or otherwise) from related industries. Turning again to the production of fine Arretine table pottery, Kenrick (2000, 323–4) suggests that the potter Marcus Perennius of Arezzo stamped his pots for approximately 30 years (20 BC–AD 10), while P. Cornelius may have been stamping his vessels for about 40 years (Kenrick 2000, 189–201). Whether these potters were still personally involved in manufacture we cannot say. If they were, were they preparing the moulds (i.e. executing the beautiful and complex scenes on the interior of the moulds; Roberts 1997, 190–92) or were they actually making the vessels? We cannot be sure, but nevertheless it is an interesting parallel in a field in which there are few reliable comparanda.

Having arrived at this figure there will (quite rightly) be protests that such statistics are necessarily based only on known pieces. In spite of the arguments laid out above, how can we really know the extent of what we do not know? There is certainly latitude for inclusion of more pieces – more will be discovered or will re-emerge from old publications and collections. But we should not forget, as mentioned above, the very high visibility of cameo glass and the considerable improbability (we would say) that there could be many more undetected pieces that are already above ground. The unexcavated areas of Pompeii and Herculaneum and the other Vesuvian sites may produce more pieces at some stage in the future. Such discoveries would certainly constitute a deepening of our knowledge of the typology and iconography of cameo glass. It would also enrich our understanding of the culture of the Vesuvian cities, but it would not essentially broaden our knowledge of the manufacture and distribution of cameo glass, nor need it essentially alter to any great extent the calculations laid out above.

Nonetheless, as already argued, in order to build in some compensatory factor for that part of the production that may reasonably have existed but for which we have, as yet, no evidence, we could perhaps say that we have fragments representing maybe one third of the total production of early Roman cameo glass. In this case, production would encompass some 1,100 items, and the time necessary for completion (assuming a uniform spread of types) would extend from 40 to 120 working years. This would be convenient for those who would argue for a production of cameo well into the mid- or later first century AD. Such an extension would see production

up to and even beyond the eruption of Mount Vesuvius in AD 79, which preserved five of the most celebrated pieces of cameo glass (the Blue Vase, the two plaques from the house of Fabius Rufus, the Naples patera and the Auldjo Jug [2]; see pp. 16–17).

However, the siren-like allure of a closely datable historical event such as the burial of the Vesuvian cities can sometimes distort rather than assist perceptions of the history and development of distinctive artefact types such as cameo glass. In reality, of course, the finding of such objects in contexts such as Pompeii provides not a pinpoint but a *terminus ante quem*. The possibility of artefacts of such rarity and quality surviving for a considerable time after their manufacture becomes not so much a possibility as a probability. The Blue Vase, for example, was without question a very prized possession, but we would argue that it had already been so for many decades before being buried in the tomb in which it was supposedly found (see p. 17).

Methods of production

Looking at a length of production of approximately 120 man-years is, in any case, very misleading. Each year constitutes the total output of a single man for 1 year. But it clearly does not make sense to think of production as a linear 120-year period. First, the partnership necessary to produce glass (maker and cutter) is unlikely to have survived for such a great length of time on such a small scale. There is the distinct possibility, of course, that worker and cutter were often one and the same, a plausible idea given the diverse skills of some modern craftsmen who have recreated elements of Roman cameo glass. But, if not, then there is an interesting question of the disparity in working time between the glassworker and the glass carver. As we have seen (pp. 13–14), the work of the cutter on just one piece, would have taken vastly longer than that of the glassmaker who had fashioned the blank. This being so, the glassmaker would have to have been working on other material, which has interesting implications regarding the working relationship within (and perhaps between) workshops.

From our knowledge of another related Roman craft for which we have some epigraphic evidence, namely the pottery manufacture of Arezzo, it becomes clear that the craftsman who carved cameo glass would not, almost certainly, have worked alone. There would have been other workers forming the blanks for him to work on and there must surely have been others to assist in decoration. Workshop production, albeit on a fairly limited scale and geographical distribution, seems the most likely mode of manufacture. Whatever the relationship may have been, the number of pieces, so small in absolute terms, and their limited diffusion speak loudly against any prolonged or extensive production.

Returning, then, to the idea of the duration of early cameo glass production, we have suggested a very tentative figure of approximately 120 working years. If, as seems extremely likely, there were small workshops, perhaps two or three, operating in Rome, then we might assume perhaps four to six carvers, and of course we must consider the possibility (or even probability?) of some workers executing only small elements of the work or at irregular times. This would bring the period of production back down to about 30–40 years, at maximum. If there were many more workers, it is likely that this estimate might decrease still further.

In summary, all the evidence at our disposal suggests strongly that the production of cameo glass vessels and plaques, made in the environment of small workshops, was relatively short-lived and that it would be extremely difficult to envisage production extending beyond our 40-year projection – if indeed it lasted even that long. Again, it should be stressed that we are very aware of the essentially tentative nature of our novel and, some would say, risky approach. It is based on the surviving ancient material evidence, combined with comparative studies of the working methods and output of modern craftsmen. But in order to provide completely relevant comparanda, it would be desirable to find a case study in modern times of a cameo glass production. Fortunately such a study exists.

A modern case study: George and Thomas Woodall

The suggestion that early Roman cameo glass was produced in a handful of workshops over a period of about 40 years is supported, we believe, by a very useful parallel in the short-lived vogue for cameo glass in Victorian England, and in particular the output of a single workshop. Two brothers, George and Thomas Woodall, managed the Gem Cameo workshop of Thomas Webb & Sons at Amblecote, which is now part of the Metropolitan Borough of Dudley in the West Midlands. This workshop made a prodigious quantity of cameo glass in just over 30 years.

In terms of technique, the Woodalls had one great advantage over their Roman predecessors. Unlike Roman craftsmen who had to remove all unwanted glass mechanically, the Woodalls, like other nineteenth-century makers of cameos, removed it using hydrofluoric acid. Indeed, the process of decorating an object might require as many as five stages. First, the decorator dulled the blank by immersing it in potassium fluoride. This enabled the artist to draw the design on the surface. The second stage was to paint parts of the design with a varnish, which resisted hydrofluoric acid. In stage three the blank was dipped in the acid to dissolve the unwanted glass. In the fourth stage assistants trimmed and smoothed the acid-etched surfaces, before details of the design were added by master craftsmen. Finally, the cameo was polished with emery and wooden and cork wheels (Whitehouse 1994, 11).

The Woodalls assembled a large team (although George's boast that seventy people had worked for him was an exaggeration: Perry 2000, 22) and without doubt the use of hydrofluoric acid increased the speed at which the decoration was executed. Nevertheless, the output of the workshop was extraordinary. Between 1884 and 1886 the Woodalls produced at least forty-two bottles and jars, some of which were large and all of which had elaborate decoration (Perry 2000, 24–6). A list of the documented cameo glasses that were made by the Woodalls or were marked 'Gem Cameo' contains more than one thousand items. All of these were produced between 1881 and the outbreak of the First World War (1914). The similarity in scale to the suggested output (and proposed duration) of the early Roman industry is striking.

Many Woodall objects are not only large but also elaborately decorated with figures, flowers or arabesques. For example, 'Moorish Bathers' (1898), which George Woodall considered to be his masterpiece, is a circular plaque, 46.3 cm across, decorated with six figures in an architectural setting (Whitehouse 1994, 49); the 'Great Tazza' (made about 1889) is a composite vessel, 38.9 cm high, with an overall pattern of leaf scrolls and flowers, etched and carved through four overlays (Whitehouse 1994, 33), and its companion piece, the 'Great Dish' (also about 1889), is 38 cm across and has similar vegetal ornament, again etched and carved through four overlays (Whitehouse 1994, frontispiece). While George and Thomas Woodall oversaw production in the Gem Cameo workshop, Thomas Webb & Sons also manufactured large numbers of less expensive, 'run of the mill' cameo glasses. This division of labour between skilled master carvers and apprentices must surely have been the case in the Roman workshops, too, and explains the disparity in the quality of carving between pieces.

The purpose of this discussion is not to reflect on the relative merits of the Portland Vase and Victorian pieces such as 'Moorish Bathers' but simply to point out that the suggestion that all early Roman cameo glass was made within a period of about 40 years is by no means unlikely. If our estimate of the scale of production of Roman cameo glass is even remotely accurate, the makers of early Roman cameo glass and the craftsmen in the Webb & Sons Gem Cameo workshop were equally productive. Without doubt, hydrofluoric acid speeded the Victorian process, but the secret of success in both periods, we would argue, was the combination of brilliant craftsmen and a highly organized team of assistants.

If we put forward the idea of a 40-year production period for early Roman cameo glass, and the Victorian comparanda broadly support us in this, we now face the even thornier issue of trying to anchor that period into an absolute chronological framework.

Absolute chronology

When attempting to establish an absolute chronology of cameo glass production, there are several main obstacles. First, and perhaps most importantly, there are few instances of a secure findspot and archaeological context, even for the very few (fourteen) complete or near complete pieces of cameo glass, and even less contextual information for the findspots of fragments, which of course constitute the overwhelming majority of known examples.

Circumstances of discovery: complete/near-complete vessels and plaques

The Portland Vase (1) is widely believed to have been found in the vicinity of Rome, though a previously much cited findspot of the Monte del Grano tomb to the south-east of the city (Painter and Whitehouse 1990e) is no longer universally accepted (Haynes 1995, 151–2). If it were true, the Portland Vase would have been associated with a sarcophagus of early- to mid-third-century date linked, anecdotally at least, to the Emperor Alexander Severus (died AD 235). The Portland Vase is certainly a piece that was a prime candidate to be an heirloom, but such a date, through association with the burial of Alexander Severus, would put the vase two centuries beyond the final date of manufacture (c. AD 25) that we suggest (below, p. 23).

The other near-intact piece in the British Museum, the Auldjo Jug (2), has a provenance of Pompeii, supposedly the House of the Faun, though even this is fraught with difficulties (see entry). The date of the burial of the Vesuvian cities, AD 79, provides a *terminus ante quem* for when the jug was made and suggests that it was still in use at that time, but does not give any information as to exactly when the piece was produced. The

same is true for the other cameo glass pieces found in Pompeii, now all in Naples at the Museo Archeologico Nazionale di Napoli (MANN). The Blue Vase (inv. 13521; Harden *et al.* 1987, 74–8) was 'discovered' during a visit by King Ferdinand II of Naples in late December 1837 (Harden *et al.* 1987, 75), together with a number of vases and terracottas. The findspot itself is suspicious and probably dependent more on the king's visit than archaeological fact. More importantly, the vases and terracottas associated (if they were) with the Blue Vase are now unidentifiable, so the dating evidence that they might have provided, and thereby any hope of true archaeological contextualizing, are lost.

The *patera*, or long-handled dish (MANN, inv. 13688; Painter and Whitehouse 1990d, 153–4, no. A9; Asskemp *et al.* 2007, 257–8, no. 6.39, and 162, fig. 1), is unmistakably mentioned in the excavation journals of Pompeii (*PAH* II, P.264 3–9) but with the tantalizing provenance of 'altrove' (elsewhere) in the city (see below, p. 44). The two plaques from the House of Fabius Rufus (inv. 153651–2; Harden *et al.* 1987, 70–73) are unique amongst all known cameo pieces because they come from their (presumably original) domestic context. The pieces of the plaques were found in soil supposedly from one of the rooms, and may have been part of larger elements that did not survive (Harden *et al.* 1987, 72). As *pinakes* (small pictures), they may have been set into painted walls or displayed in frames on stands, as shown in Roman wall paintings, for example the garden scene in the House of the Golden Bracelet, Pompeii (Mattusch 2008, 176, no. 65), and another from the House of the Orchard (Bragantini 2006, 166, fig.6). One of the Pompeii plaques (MANN, inv. 153651) was repaired in antiquity, implying some longevity, but otherwise the circumstances of discovery can give no clue as to how long the plaques had been in the room, less still when they were made.

So the pieces from Pompeii are extremely important in that they are some of the most complete and finest examples of the Roman cameo worker's art. With regard, however, to their value for dating cameo glass, they are far less useful, since all of them, in common with the Portland Vase, could be expected to have had an enduring value way beyond their date of manufacture. Even, therefore, when they have a fairly reliable provenance, they need not really do more than provide the *terminus ante quem* of AD 79 for their manufacture.

Elsewhere in Italy a near-complete bottle, now in the Museo Archeologico Nazionale, Florence (inv. 13688; Painter and Whitehouse 1990d, 153–4, no. A9; Casini 1992), was discovered at Torrita di Siena. Although a little is known of its context, nothing useful in the way of chronology has been put forward. Spain has produced a near-complete piece, a bottle from Estepa, near Seville, which is now in the collection of George Ortiz (Painter and Whitehouse 1990d, 161–2, no. A15). This piece, too, is virtually undocumented.

Other complete pieces include three now in France. The Carpegna plaque (Painter and Whitehouse 1990d, 160–62, no. A14), now in the Louvre, is supposedly from the Catacombs of Santa Priscilla to the north of Rome. If this is indeed the case, then all we can say is that the apparent commencing of burials in these catacombs in about AD 100 gives a *terminus post quem* for the deposition of the piece. The Seasons Vase, now in the Bibliothèque Nationale (Painter and Whitehouse 1990d, 158–60, no. A13), was already in France by the 1630s, when provenance and context counted for very little. In a letter dated 5 May 1633

the Provençal polymath Nicolas-Claude de Peiresc informed Claude Menestrier, librarian to Cardinal Francesco Barberini, that it was said to come from Rome (Whitehouse 1989, 19, n. 18). A jug from Besançon, now in the Musée des Beaux Arts, Besançon (Painter and Whitehouse 1990d, 146–9, no. A6), has no accompanying documentation regarding its discovery.

In American collections the Getty bottle (Painter and Whitehouse 1990d, 150–53, no. A8) and the Morgan Cup (Whitehouse 1997, 48–51, no. 47) are both supposedly from Turkey, and the Getty skyphos (Painter and Whitehouse 1990d, 143–5, no. A4) is said to be from a Parthian tomb in Iran but there is no further information. A complete skyphos of uncertain provenance, which used to be in the Constable Maxwell collection (Painter and Whitehouse 1990d, 157–8, no. A12), is now in a private collection in the Persian Gulf.

Circumstances of discovery: sherds

As for the sherd material, the picture is even more vague, though we can, with some certainty, point to Rome as the findspot of most cameo glass fragments. There is no recorded example of any dated context for any Rome sherd – perhaps unsurprising given that they were mostly discovered in the nineteenth and early twentieth centuries. One of the major exceptions comes, perhaps surprisingly, from Britain. A sherd of a closed cameo vessel, now in the Museum of London (199BHS[204]), was found during excavations in Southwark in south London (Lightfoot 1988). The sherd, found in a pit dating to the AD 120s to 140s, is highly interesting but does not, we believe, provide any evidence for the period of manufacture. Other recent finds include three sherds from Neris-les-Bains near Vichy in central France (J. Price, pers. comm.) and the sherd of an open vessel with a pastoral scene from Veio, north of Rome (Lepri 2007). A plaque fragment from Butrint (Albania) comes from a shrine building on the Forum, of which it may have formed part of the decoration (Richard Hodges, pers. comm.; Hansen 2009). All these sherds, however, come from contexts that considerably post-date the proposed end of early cameo glass in the AD 20s (see p. 23).

Forms and chronology

Given the lack of a secure chronology in terms of the findspots of the known pieces of cameo glass, is it possible to use the evidence of the pieces themselves – their forms and iconography – in order to secure their chronology a little further? The answer we believe is a qualified 'yes'. In terms of an absolute chronology there is strong evidence from silverware, pottery and glass tableware that helps establish most of the forms found in cameo glass, such as the skyphoi, hemispherical bowls, *canthari* (cups with high looped handles), *modioli* (cups with cylindrical bodies) and others, quite firmly in the later first century BC and the early first century AD (for more detailed discussion see below, pp. 19–23). In terms, however, of establishing some form of chronology within cameo glass, the task is very much more difficult.

Even were it possible to determine a particular order of development for the forms, we have very few complete pieces, and sherds can be very difficult to ascribe to particular forms. Where such identification is tentatively possible, there does not seem to be any particular correspondence between any given shape and any particular type of decoration. Themes of a Bacchic or Egyptianizing nature and of cupids or erotic scenes are distributed freely and seemingly without deliberate intent

over all the various forms of cameo glass (see the introductory pages to the catalogue below, pp. 32–3). Some themes are certainly more common than others and therefore provide a larger sample, such as the many examples of Bacchic imagery or vegetal motifs. But even within these larger groups, comprising both whole or nearly whole pieces and sherds, there seems no way of defining any type of chronological difference. There are of course differences in quality, but the modern example of the differing roles (and output quality) of masters and apprentices in the workshops of Thomas Webb & Sons (above, p. 16) suggests that it would be rather simplistic to place too much chronological importance on what may, after all, have been simply a question of different hands.

Decoration and chronology

Even distinctive groups of sherds, such as those made with a transparent base glass, the so-called 'clear group', or the vessels with a background glass that is milky opaque (below, p. 32), seem to share the same range of forms and decorative motifs seen on other cameo glass vessels. The one major decorative feature that has been given considerable chronological significance is the profuse and thickly carved vegetal decoration found on vessels such as the Auldjo Jug (2), the Blue Vase in Naples and pieces in other collections. Haynes (1975, 24) cites the 'cool elegance of the Portland Vase', contrasting this with the 'crowded "busy" decoration of the Blue Vase'. He is here underlining what he sees as major qualitative differences between the Portland Vase and the Blue Vase – the justification, in his eyes, for dating them to different periods. There is an implied superiority in the description of the 'coolly elegant' Portland Vase, while a later, decadent inferiority is implied in the description of the florid Blue Vase.

However, there are considerable similarities between the Portland Vase and the Blue Vase. Most importantly, in their form both are two-handled amphorae, almost certainly with a point-base or a terminal blunt finial, and they are of approximately the same scale (the Portland Vase would have been slightly larger when complete). They also share some decorative elements, in that both vessels show stylized, striated rocky outcrops also seen on plaques, including the piece from Pompeii of the reclining Ariadne (Museo Archeologico Nazionale di Napoli, inv. 153652), and both have a distinctive squared architectural element (a fallen capital) on the ground line.

There seems little reason to suggest, therefore, that the Auldjo Jug, the Blue Vase and other similarly decorated pieces need necessarily be later than the Portland Vase. They may arguably (though not necessarily) be by a different hand, but it is very difficult to argue that they are of a different date. There is even the possibility, given their profuse, high-relief vegetal decoration, which also appears on later Hellenistic silverware (see below, p. 47), that the vegetal pieces might pre-date the Portland Vase. We would argue that we no longer see the justification (or the need) to date the two vases or those like them to different periods on the basis of their decoration alone.

Cameo glass and its comparanda: other artistic media of early imperial Rome

This brings us to the question of the extent to which a meaningful context for cameo glass can be constructed in the world of early imperial art by looking at other media of the period.

Wall painting

Some have suggested that the large-scale, monumental art of the Augustan period is a suitable source of comparanda for the Portland Vase and, by implication, for other cameo glass. Painter and Whitehouse (1990f, 122–3) have pointed out that the decoration of the Portland Vase resembles the frieze-like compositions of some second Pompeian-style wall paintings, such as those of the Villa of the Mysteries, Pompeii. This chronology would imply a *terminus ante quem* for production of about 15 BC, the approximate date for the transition into the third style of wall painting. It was argued that the Blue Vase, on the other hand, can be dated by the setting of its groups of cupids to the AD 40s to 50s, the floruit of the fourth style of wall painting (Painter and Whitehouse 1990f, 122). In view, however, of the lack of a chronological break between the Portland Vase and the Blue Vase (discussed above), the potential of wall painting to inform a debate on the chronology of cameo glass is now, we would suggest, much less convincing. More plausible, perhaps, is the possible use of cameo glass plaques as *pinakes*, decorative panels in suites of wall painting.

Monumental sculpture

Others believe that good parallels for elements of the decoration of cameo glass can be found on larger-scale carved-stone reliefs, such as the Ara Pacis in Rome, with its procession of figures and panels of decorative vegetal tracery (Simon 1957, 47–8), or the altar of Amemptus, now in the Musée du Louvre, Paris (Simon 1957, 48 and fig. 20.2), with its strong vegetal motifs. These stone monuments undoubtedly shared the flow of ideas, inspiration and innovation that united all the arts in Augustan and early imperial Rome (and the Ara Pacis dating to the last decade BC is fully contemporary with our suggested production period of cameo glass). Furthermore, both media are carved. But their materials, scale and ultimately the contexts for which they were created and in which they were meant to be seen and used were completely different. Similarities between monumental stone sculpture, wall paintings, other 'large' art and cameo glass do of course exist and are obviously noteworthy. But to say that they were a significant, if not the main, inspiration for cameo glass is, we believe, to overlook much more likely candidates.

Hardstone carving

Some have seen the origins of cameo glass in the small, select art form of hardstone carving (Simon 1957, 52–76). Certainly cameo glass and hardstone share a fundamental characteristic, namely that their decorative scheme is achieved by peeling one layer off another. The stones chosen, mostly variants of onyx, are usually dark on the interior with the outer layer in white or off-white, resulting in a colour scheme that is echoed in cameo glass. Hardstone vessels with carved decoration are rare, with fewer than twenty pieces surviving. Their floruit seems to have been from about 50 BC to AD 30.

This dating is based largely on the decoration of some of the major pieces, which seems to show either very evocative historical allegories or explicit representations of real people and events. One of the most famous hardstone pieces is the so-called Tazza Farnese now in the Museo Archeologico Nazionale di Napoli (fig. 3 on p. 25 below; La Rocca 1984, *passim*). The tazza shows, according to La Rocca (1984, 64), Cleopatra VII as the earthly incarnation of the goddess Isis, thereby giving the

piece a *terminus ante quem* of 30 BC, the year of her death. The decoration perhaps relates to the events of 34 BC when Cleopatra joined her Roman lover Mark Antony in the celebrations for his triumph over Armenia and the East (La Rocca 1984, 94), a triumph that was held, significantly, in Alexandria. Other carved hardstone pieces such as the alabastron in Berlin (Simon 1957, 54–6, Taf. 28; Painter and Whitehouse 1990c, 136) and the Brunswick Vase (Simon 1957, 56–64, Taf. 29; Painter and Whitehouse 1990c, 136) seem to show allegories of the Roman imperial family. The Brunswick piece, originally from Mantua in northern Italy, perhaps shows Octavia, the sister of the Emperor Augustus, in deepest mourning following the death of her son (and potential successor to Augustus) Marcellus in 23 BC (Whitehouse 1990c, 136).

Not all hardstone vessels were carved with historical or political scenes. The so-called Rubens Vase in the Walters Art Gallery in Baltimore (Simon 1957, 54, 76, Taf. 26) carries a mask of Pan with the rest of the vessel covered in intricate tracery of vines. The sardonyx 'Cup of the Ptolemies' in the Bibliothèque Nationale, Paris, features Bacchic masks and other related symbols (Simon 1957, 56–7, Taf. 27). The few examples of hardstone vessels that survive, therefore, show some similarities with the decoration seen on cameo glass (Bacchic and vegetal imagery) and some marked differences, namely the emphasis on historical allegory of the ruling families of Egypt and Rome.

It is conceivable, though we will probably never know for certain, that hardstone cameos were the inspiration for cameo glass. But it should be remembered that very few people would ever have seen the original hardstone pieces, which, as Painter and Whitehouse (1990c, 135) point out, were reserved for the elite of society. To what extent, therefore, would cameo glass have been directly copying an art form that was so obscure?

Even if there were an influence from hardstone, the cameo glass 'imitators' would have had a considerable advantage. For the decorator, glass blanks have a huge advantage over layered hard stones, in that their layering is predictable; you could order (or make) a blank and feel confident that the overlay has a given, more or less uniform thickness. You could also of course determine the shape of the blank and therefore the final product, something seldom possible with a solid lump of stone.

Comparanda: tableware

Before looking further at other potential parallels with, or influences on, cameo glass, it would perhaps be useful to think about the purposes for which cameo glass was used. To do this, we should recall the fairly extensive range and function of its forms. In the British Museum collections alone there are closed forms such as jugs, amphorae and bottles, and open forms such as chalices, skyphoi, cups, modioli, paterae, dishes, plates and a *pyxis* (lidded bowl), as well as plaques, trays and, perhaps, an *oscillum* (double-sided, decorative rotating disc). Looking at the range of forms leads, obviously, to the consideration of how the forms were used.

Regarding the use of the cameo plaques, there is some discussion (see **44** below) as to whether they were ornaments in their own right to be framed and admired, wall decoration or (less likely we believe) decorative elements of larger items such as furniture. The forms of the vessels, on the other hand, indicate that the vast majority were used, almost certainly, for the storage and consumption of liquids. The decoration of the

pieces, which consists overwhelmingly of motifs connected with Bacchus or Dionysus, suggests that the liquid was wine. Motifs are often explicitly Bacchic, with figures of satyrs, maenads and elements of Bacchic ritual, or they feature vegetal motifs such as the vine or ivy, both of which were closely associated with Bacchus. We would argue therefore that, since cameo glass vessels are almost exclusively tableware, the closest parallels should be sought and can be found in other table vessels, whether of pottery, glass or silver.

Silverware

First, what may prove to be one of the most fruitful comparanda of all: silverware. Care, of course, must be exercised when looking at silverware as a potential comparandum, whether in iconography or in chronology, for a completely different medium such as cameo glass. The compendium of silverware is necessarily much less complete than that, say, of pottery, since quantitatively, then and now, there is simply so much less of it, so we cannot expect to have a full idea of its range of iconography. The Warren Cup, for example, now in the British Museum, with its scenes of male lovers is held by some to be unusual, even a fake, simply because it is unprecedented, while others believe that it is genuine but maintain that it is unique. The reality, as Williams (2004, 34) points out, is that there was almost certainly at least one companion piece for the cup. It is almost inconceivable that in the Greco-Roman world it was unique.

Most of our knowledge of silver tableware in the early imperial period comes from the great silver treasure of Hildesheim near Hanover in north-west Germany (Boetzkes *et al.* 1997), from the treasures of the House of the Menander, Pompeii (Stefani 2006a), from Boscoreale (Baratte 1986; Biroli Stefanelli 1991, 260–65; Stefani 2006b) and the recently discovered treasure of Moregine, near Pompeii (Mastroroberto 2006a and b). These all provide much valuable information on silver of the period and what was illustrated on it. But we must remember that the services found, for example, in or near Pompeii were not exclusive to that city and that silverware as fine as this was used by wealthy families throughout the empire. The Pompeian services are of course stunning by any standards, and importantly they all share the *terminus ante quem* of AD 79, but in other ways they were not unique. This poses the question of just what else has been lost. The Pompeian services and the Hildesheim treasure were preserved by either unexpected or deliberate burial. Most other silver remained above ground, where it passed from family member to family member, was dispersed, sold, damaged or worn out and eventually melted down in antiquity and after.

Of course, such factors had already partly affected the collections of silver at Pompeii and Hildesheim, and the services contain pieces whose manufacture is separated by many decades, perhaps as much as a century (Biroli Stefanelli 2006, 25). The dating of silver and its use as comparanda must therefore be approached quite carefully, though aspects of its manufacture and decorative technique are, we believe, very pertinent to our study of cameo glass.

Silver tableware vessels, for example, offer parallels for decorative motifs and schemes found on cameo glass. Bacchic scenes and motifs are common: for example, on the skyphoi from the House of the Menander, Pompeii, showing moments from the life of Bacchus (MANN, inv. 145508–9; Stefani 2006a,

200–201, cat. nos 282–3), and on a cantharus from the Hildesheim treasure showing in very high relief a sacred rural landscape (Berlin, Antikenmuseum 3779, 13; Biroli Stefanelli 1991, 178, figs 169–71, and 272, cat. no. 93). Both of these are dated to the later first century BC (Biroli Stefanelli 1991, 272) or the very early first century AD (Stefani 2006a, 201). Bacchic herms and masks are also very common: for example, on canthari from the House of Inacus and Io (MANN, inv. 25380, 25381; Lista 2006, 170–71, cat. 217–18), and on a cup decorated with masks in high relief in The Toledo Museum of Art (Biroli Stefanelli 1991, 10–11, no. 14 and figs 9–12), all again dating to the later first century BC and the early first century AD.

There are also Egyptian motifs: for example, on the pair of canthari from Moregine, near Pompeii, decorated with themes related to the cult of Isis (MANN, inv. 86775–6; Mastroroberto 2006a, 236–7, cat. nos 410–11). There is also a beaker from the *palaestra*, or exercise yard, in Pompeii showing Isis and her priest (MANN, inv. 6044; Biroli Stefanelli 1991, 172–3, figs 162–3, and 259, cat. no. 36). A dish from the Boscoreale treasure shows the personification of Africa, in particular Egypt (Musée du Louvre, Bj 1969; Biroli Stefanelli 1991, 134–5, figs 99–100, and 260, cat. no. 37). None of the silver pieces shows the pharaonic characters that feature on the cameo glass pieces, but all share an Egyptianizing theme and, again, all are dated to the Augustan and early Tiberian period. Themes of explicit lovemaking, as seen on the multi-layered piece in the British Museum (**10**) and the Ortiz bottle (Painter and Whitehouse 1990d, 161–2), find silver parallels most obviously in the Warren Cup (Williams 2004), while skyphoi from the House of the Menander show love scenes between Venus and Mars (MANN, inv. 145515–16; Stefani 2006a, 206–7, cat. nos 289–290).

Cameo glass has other parallels in silver. Cupids, as on **6, 15, 27, 36,** can be found on many pieces of silverware. Adolescent cupids with long, elegant wings attend Venus and Mars on the skyphoi from the House of the Menander (above); younger, chubbier cupids similar to the BM cameo pieces (**15, 27, 36**) are found riding chariots on a pair of modioli from the House of the Menander (MANN, inv. 145510–11; Stefani 2006a, 202–3, cat. nos 284–5), and riding wild animals in a Bacchic procession (*thyasos*) on skyphoi from the House of Inachus and Io (MANN, inv. 25310–11; Lista 2006, 170–71, cat. nos 217–18) and on skyphoi from Boscoreale (Biroli Stefanelli 1991, 142–3, fig. 109–12, and 261, cat. no 41). Rarer motifs also appear, such as the 'historical' depictions of real persons on skyphoi from Boscoreale showing Augustus, Tiberius and Drusus (Kuttner 1995, *passim*).

Vegetal motifs are extremely common. There are highly ornate traceries of tendrils of plants, in particular acanthus, sometimes inhabited by tiny animals, that cover nearly all of some pieces, for example the cups from the British Museum (1960,0201.2 and 3), the skyphos from Boscoreale (Musée du Louvre, Bj 1907; Biroli Stefanelli 1991, 59, fig. 39, and 262, cat. no. 45) and the large krater from Hildesheim (now missing: Berlin Antikenmuseum, inv. 3779,62; Boetzkes 1997, 75–6). The *modiolus*, dated to the Augustan/Tiberian period, from the *palaestra* at Pompeii (MANN, inv. 25301; Guzzo 2006, 84–5, no. 18) shows the apotheosis of Homer against a background of acanthus tendrils and flowers. These vessels clearly have a shared tradition with developments in Augustan sculpture – for example the ornate vegetal tracery on the Ara Pacis in Rome – but this is not to say that they were directly copying it.

In addition to this finer decoration there are also much heavier, robust motifs. Some silver vessels have extremely high relief decoration, for example a cup from Rome in the British Museum (1867.5-8.1410; Silver 82) with a decoration of vine leaves standing high above the surface. From Pompeii come numerous examples of high relief decoration, for example the ivy on two skyphoi from the Casa dell'Argenteria (MANN, inv. 25378–9; Giove 2006, 120–21, cat. nos 108–9), the vines on a *calathus* (modiolus) from the House of Inachus and Io (MANN, inv. 25300; Lista 2006, 172–3, cat. 219) and the olives on a pair of canthari from the House of the Menander (MANN, inv. 145513–14; Stefani 2006a, 204–5, cat. nos 287–8). A cantharus from Hildesheim has high relief ivy and vine around suitably Bacchic masks, and even uses intertwined ivy to form the handles (Berlin Antikenmuseum 3379,11; Boetzkes *et al.* 1997, 45). The Hildesheim example is held to be from the second half of the first century BC and very influenced by late Hellenistic silver work. The other pieces, like the vast majority of surviving early imperial silver, date to the later first century BC and the early first century AD.

We would argue that silver vessels in many ways provide the most extensive and satisfactory parallels for cameo glass. Yet it could be said that the most obvious source for parallels for characteristics of and developments in cameo glass ought to be the other areas of contemporary glass production. As can be seen below, however, results of these comparisons between cameo glass and other glasses are sometimes surprising.

Glass

The decades around the turn of the first millennium AD were a formative period for the glass industry in Italy in general and in Rome in particular. While very little glass has been found in Rome on sites of the early and middle republican periods, Strabo, who compiled a *Geography* of the Mediterranean region between 26 and 7 BC (or AD 17–23 at the latest), wrote that glassmaking was a thriving industry in the city (Strabo XVI.2): many ways of producing coloured glass had been invented and a glass cup or bowl could be purchased for a single copper coin (Grose 1977, 13–14). The production of early Roman cameo glass may therefore be seen in the context of the city's new and, according to Strabo, innovative glass industry.

Glassmaking had undergone a revolutionary change in the first century BC, when it was discovered that glass could be blown. This discovery took place in the Syro-Palestinian region, where the earliest datable blown-glass objects consist of small 'tube-blown' bottles from a deposit of about 'the mid-1st century BCE or even slightly earlier' in the Jewish Quarter of the Old City, Jerusalem (Israeli and Katsnelson 2006, 412), and a bottle from Ein Gedi, which is believed to have been buried before 40–37 BC (Grose 1977, 11). The knowledge of glassblowing seems to have reached Italy and other parts of the western Mediterranean before the end of the first century BC. Scatozza Höricht (1986, 42) noted the discovery of blown glass in deposits of about 40–10 BC at Pompeii, while Béraud and Gébara (1990, 156–7) reported fragments of blown glass at Fréjus in Provence, perhaps as early as 35 BC. Finds from numerous sites, including Priene in Turkey (Platz-Horster 1979), Cosa in Italy (Grose 1977, 26) and Magdalensberg in Austria (Czurda-Ruth 1979, 108), show that blown glass was widely available by the reign of Augustus (d. AD 14).

Nevertheless, as Grose (1983) emphasized, glass tableware and small containers made by the traditional techniques of casting remained popular for a generation or more, although in Italy the repertoire of forms expanded and many of the new shapes have lathe-turned profiles reminiscent of Arretine ware and metal vessels. At Rome, for example, deposits at the Regia in the Roman Forum and the House of Livia on the Palatine show that both cast- and blown-glass vessels were in use in the last decades of the first century BC or at the beginning of the first century AD. At the Regia a small group of fragments that accumulated after 37/36 BC included window glass and part of a blown-glass bottle with trailed decoration; at the House of Livia the blown glass included part of a deep blue bottle or jar, also with trailed decoration (Grose 1977, 17–25).

The glass industry expanded rapidly in Italy in the first few decades of the new millennium. The quantity of glassware and the range of its uses increased to unprecedented proportions and ran the gamut from low-cost blown vessels for daily use in the kitchen, through relatively expensive mosaic glass, to *objets de luxe* such as cameo glasses.

Having considered the background against which cameo glass developed, it is perhaps useful to look at the nature of cameo glass itself, to see whether any of its own characteristics within the framework of glass and cameo glass production can advance our discussion of its absolute chronology.

Perhaps one of the most important characteristics of early Roman cameo glass, made in and not much beyond the Augustan period, is the fact that at the time there was very little other glass with pictorial decoration. What, if anything, constituted the (glass) competition for cameo glass in the luxury market? It is generally believed that monochrome (almost always colourless) glass with relief decoration – an obvious type to be associated with cameo glass – did not come into use until the AD 60s. There are some exceptions, for example the early first-century-BC bowl with relief-cut sprays of olive(?) leaves from the shipwreck off Antikythera, Greece (Weinberg 1992, 105, no. 62), and, most relevant perhaps, a ring-handled skyphos now in The Corning Museum of Glass (66.1.207; Goldstein 1979, 141–2, pl. 39, no. 292). This deep blue vessel, though fragmentary, shows part of two male figures, one of whom may be Hercules, carved in high relief. But these two pieces are extremely unusual. What of the other types of decorated glass that emerged in the first century AD and their links (or lack of them) with cameo glass?

Mould-blown glass, with its vegetal ornamentation, figural motifs and so on, did not come into use until about AD 25 (Price 1991, 64; Stern 1995, 45–8). Production seems to have lasted for about 50 years or so, with moulded vessels made in their hundreds, if not thousands, travelling to every corner of the empire (Price 1991, 72–4).

Makers such as Ennion, Jason, Aristeas, Artas and Megas included their names in the decorative scheme of the vessels, for example in winged panels (*tabulae ansatae*) on the body or as simple name stamps on the surface of the handles. The discovery of numerous fragments of their moulded beakers and other vessels in well-dated archaeological contexts makes it possible to estimate the duration of their production. Vessels bearing the name of Ennion, for example, first appear in about AD 30, while the last production pieces, including elegant and beautifully decorated jugs, are found in deposits of about AD

65–70 (Price 1991, 64–9). Such a production period (about 35–40 years) is very comparable to that which we propose (above, p. 15) for cameo glass. As to the location of early mould-made production, it seems probable that, although mould-blown glass was thought to be largely an eastern Mediterranean product, there may in fact have been an early establishment of glass production in Italy (Price 1991, 64–9).

With regard to decorative schemes, mould-blown pieces often show scenes of racing chariots and gladiators, as well as gods, vegetal patterns including vine, ivy and acanthus (Price 1991, pp. 67–8), and geometric designs including lattice work and gadroons. It is interesting that explicitly Bacchic imagery, one of the most popular themes of silver, pottery and cameo glass, is almost completely absent from mould-blown glass. One of the very few exceptions is the tall mould-blown beaker said to be from Aleppo in Syria and now in the Yale University Art Gallery, Connecticut, USA (Moore collection 1955.6.50; Matheson 1980, 54–6, no. 136). The beaker shows large-scale figures of Pan, a maenad and a hermaphrodite taking part in a frenzied Bacchic celebration. This extraordinary vessel, if not unique, is certainly a very rare example of mould-blown glass with figural Bacchic decoration. Furthermore, as far as we are aware, another major decorative element of cameo glass, namely Egyptian-style ornament, is absent from mould-blown pieces.

Another important development of the first century AD was the appearance of glass with enamelled (painted) decoration (Rütti 1991). Probably originating in the Near East, the technique had spread to workshops in Italy by the AD 20s. This type of glass is highly distinctive and recognizable, so it is possible to be fairly sure about the number of pieces surviving – somewhere in the region of forty at the time of writing by Rütti (1991, 124). There are, so far, only two main forms recognized, namely hemispherical cups (Isings form 12: Isings 1957, 27–30) and a miniature, two-handled amphora, or *amphoriskos*. Vessels travelled throughout the empire and beyond as far as Kertch on the northern shores of the Black Sea. Decorative motifs include complex vegetal schemes, birds, fish, deer, a racing chariot and even Egyptian-style scenes of pygmies battling with cranes (Rutti 1991, 124–31). So in the range and nature of its motifs, enamelled glass has much in common with cameo glass. Yet, just like mould-made glassware, enamelled glass seems to have stopped being produced in the AD 70s. The implications of a surviving global assemblage of fewer than fifty pieces after a production period of about 50 years are considerable and show that the output of the enamelling workshops was very restricted indeed.

Perhaps to be included at this point are the small but important series of drinking vessels in obsidian, naturally occurring glass of volcanic origin, set with inlays of coloured glass and stone. The most famous group, including two large skyphoi (De Caro 2006, 212–14, cat. no. III.136; MANN, inv. Stabiae 396–7), a smaller version and a dish, was discovered at the Villa of Stabiae at the southern end of the Bay of Naples and is now on display at the Museo Archeologico Nazionale, Naples. The large skyphoi are decorated with intricate Egyptianizing scenes of offering. The poses and clothing of the figures shown find close parallels in cameo glass, in particular the incuse fragment in the British Museum (**22**). Other vessels, all inlaid, have vegetal decoration, among them the four pieces in

the British Museum from Anzio (1879,0408.1, 2, 3 and 4). These inlaid pieces are also dated to the earlier part of the first century AD.

Quite why the production of the major series of mould-blown vessels and enamelled glass should have ceased almost completely by the AD 80s remains a mystery. Price (1991, 74) suggests the end of mould-blown production was possibly linked to the soaring popularity of colourless glass, with its resemblance to luxurious rock crystal. The same might well be true of the demise of enamelled vessels. It is conceivable that a similar change in taste and style, perhaps the surge in popularity and availability of decorated and coloured glass (such as mould-blown and enamelled vessels), could have spelt the end of the early Roman cameo production in the AD 20s.

Pottery: Arretine ware

Although silver might offer most iconographic parallels for cameo glass, and glass would (on the surface) seem potentially to be closest to cameo production, the most abundant of the tableware comparanda for cameo glass is fine table pottery. The most interesting case is Arretine ware produced in and around Arezzo in central Italy and other cities in the peninsula. Production at Arezzo began in about 40–35 BC, about 20 years before the date that we are suggesting for the beginning of the major production of cameo glass. By about 25–20 BC the finest Arretine products began to be made. These were decorated in high relief and were made in moulds, which had their designs applied through stamping the interior of the moulds with *poinçons* (finely carved stamps with figures or scenes) and through hand carving.

There are of course dissimilarities between cameo glass and Arretine ware. Arretine was produced in very much larger numbers than fine glass in general and cameo glass in particular. The presence of so many more Arretine pieces naturally poses questions as to the relative contemporary values of the two products. Looking at pieces with similar decoration, such as the large cameo cup with an erotic scene between two males (**10**) and the similar vessel in Arretine pottery at the Ashmolean Museum, Oxford (1966.253; Brown 1968, 8, no. 6 and pl. VI), it is obvious that far less of an artisan's time would be taken up making the Arretine piece. Unlike the cameo glass vessel, which would have required the services of a vessel maker and a carver, the Arretine pieces were made very much more quickly and, consequently, very much more cheaply.

So in its technique and the time needed for its manufacture, Arretine ware was very different from cameo glass. It could also be argued that the markets for the two were equally different. The availability of Arretine (of all types, including the highly decorated relief wares) was much greater than that of cameo glass, as demonstrated graphically by Kenrick (2000, 39), who presents a tabulated distribution of Arretine sherds that bear name stamps. Though the significance of these stamps is the subject of considerable discussion, they are undeniably a good control for observing the movement of Arretine ware. Interestingly, although about 30 per cent is found in Italy (two thirds of that total coming from Rome and Ostia), some 70 per cent of the total was exported. Clearly the scale of production ensured that (a) the product was not so rare and choice as cameo glass and (b) that it was deliberately marketed and exported abroad, joining the wave of 'Made in Italy' goods that were sent over the Mediterranean in the later first century BC and early first century AD.

In this context, by contrast, the concentration of cameo glass pieces in and around Rome is telling. The fact that cameo glass did not travel in any great quantity beyond Rome and central Italy indicates, we suggest, that not a great deal was made and that the little that was produced was quickly snapped up by the local market. Cameo glass certainly did not travel piggyback with other cargoes as Arretine and other pottery fine wares did. The distribution patterns of cameo glass simply do not support the idea of any kind of organized export mechanism, as might have been expected if it had been made on any scale for a prolonged period.

In terms of the length of production, the manufacture of finely decorated Arretine ware, having begun in about 20 BC, seems to have come to a sudden halt in about AD 20–25 (Paturzo 1996, 175). Major workshops, such as those of Perennius, Rasinius and others, seem to have stopped production quite abruptly at this period. Their workshops were abandoned and their name stamps disappeared from circulation. Subsequent production at Arezzo featured simpler and heavier forms, with decoration not in the form of fine mould-made high relief, but instead as separately produced relief appliqués. Theories as to the reasons for its disappearance include the collapse of the market for fine Arretine products in the face of competition from other types of fine pottery from southern France or northern Italy, or even from glass (Paturzo 1996, 174–5). But this is problematic because subsequent productions simply did not replicate or attempt to imitate the decorative schemes of Arretine. Some other reason must be sought and perhaps a simple but fundamental change of style and taste lay behind the market change and the disappearance of fine moulded Arretine. Such a reason, if we could ascertain it clearly, might have considerable resonance for the disappearance of cameo glass.

Much of the decoration of Arretine ware is broadly comparable with that on cameo glass. It is certainly true that some of the motifs that were stamped or carved in the Arretine moulds, to appear in relief on the vessels, were often repetitive and formulaic. But some Arretine pieces, on the other hand, present scenes as complex as any of those seen on silver or cameo glass. A mould in the British Museum (Walters 1908, 27–8, no. L93) shows the birth of Bacchus/Dionysus. The scene comprises a number of carefully placed and well-executed figures, including Silenus carrying the infant Bacchus, a woman behind a draped screen, an attendant holding a tray of offerings, a woman and a satyr making sacrifice to Bacchus, and satyrs holding torches. Some of these elements are closely paralleled on cameo glass, for example on the Morgan Cup in The Corning Museum of Glass (Whitehouse 1997, 48–51, no. 47). Another complex scene represented on a mould of Arretine ware in the British Museum shows a *thyasos*, or Bacchic procession (Walters 1908, 28–9, no. L94). Generally, Bacchic imagery is as popular on Arretine ware as it is on cameo glass, with an abundance of satyrs, maenads and Bacchic echoes and attributes: see among many others, for example, Arretine pieces in the Museo Nazionale, Rome (de Luca 1988, 257–68, nos 289–306 and tav. xxviii–xxx).

Other shared motifs between Arretine and cameo glass include images of cupids in racing chariots. This appears, for example, in two mould fragments now in the Boston Museum of

Fine Arts (Chase *et al.* 1916, 83–4, nos 82–3 and pl. xxvii), which show cupids in *bigae* (two-horse racing chariots). There are of course decorative schemes on cameo glass, both on vessels and plaques, that consist primarily of vegetal motifs, for example on the Auldjo Jug (**2**) and the Blue Vase (MANN, inv. 13521; Harden *et al.* 1987, 74–8), and these, too, are paralleled in Arretine pieces: cf. examples of vessels from Cosa in central Italy (Marabini Moevs 2006, 95–6, no. 4 and pl. 60; 91–2, no. 3 and pl. 59), where vines, acanthus and flowers completely encircle the vessels. A series of shallow cameo glass cups decorated with long, spear-shaped (olive?) leaves finds good parallels in pottery (see **26** below). These strongly vegetal decorative schemes seem to be exactly contemporary with the figural scenes.

One major theme that is common in cameo glass, but almost totally absent from Arretine pottery, is Egypt. There is considerable use of Egyptian vegetal motifs such as lotus buds and flowers on Arretine ware, for example in the Museo Nazionale at Rome (de Luca 1988, tav. v–vi, nos 44–8, 53, 57, 63 and 72), but there is a curious absence of recognizably Egyptian figures. Only one Arretine ware fragment that bears an image of a definitely recognizable Egyptian figure is known to exist. Chase *et al.* (1916, 70, and pl. xxix, no. 62) present a fragment of a *calathus* (a tall, flaring beaker) decorated with a male in Egyptian dress holding a sceptre topped with a *uraeus* (the image of a sacred snake). Assuming the piece to be genuine, it is, we believe, unique.

So there are numerous similarities between cameo glass and Arretine ware – inevitable, perhaps, given their largely shared functions as part of the massive cross-fertilization of artistic influences in the Augustan period. Because of the relative abundance of Arretine ware and its high survival rate, we have a good idea of the output of the Arretine potters, in terms both of range of decorative motifs and forms. Thanks to the work of Kenrick (2000), based on the earlier works by Oxé and Comfort on the dating of stamps on the ware, we also have a good idea of the duration of these productions. As we have argued above

(p. 22), the terminal date of the fine moulded Arretine ware in about AD 25 may have some bearing on our proposed terminal date of cameo glass and the reasons for its collapse.

Conclusion

It is important to underline the inherent difficulties in trying to suggest how great an influence one art form has had on another. The complex relationship between glass, pottery, silver and hardstone is encapsulated by von Saldern (1991, 118–19), who points out that influences could and did flow in many different directions between the media. Nonetheless, fine table pottery and cameo glass, though different in their scale of manufacture and their intended market, certainly shared a great deal of artistic common ground.

This discussion is based on the idea that we can, with necessary caution, look at other, similar media in order to obtain some idea of the chronological context in which to place early Roman cameo glass. We believe that the evidence of the most relevant media, namely tableware of silver, glass and pottery, points towards a production period for cameo glass of the last decades of the first century BC and the first decades of the first century AD. It seems very likely that cameo glass production ceased around AD 25, the same time as other major developments in glass (the beginning of mould-blown, enamelled and other decorative glasses) and approximately the same time as the collapse of the great Arretine pottery workshops. These were of course very different media, but it is not inconceivable that there was a general change of taste and fashion that led to these simultaneous developments.

For reasons given above (p. 15), the production of cameo glass is very unlikely to have lasted for more than 40 years, at the outside. This would imply that the cameo glass industry began in about 15 BC with a cessation of the major workshop(s) in about AD 25. With all necessary caution, therefore, we should like to propose 15 BC–AD 25 as the approximate parameters for early Roman cameo glass production.

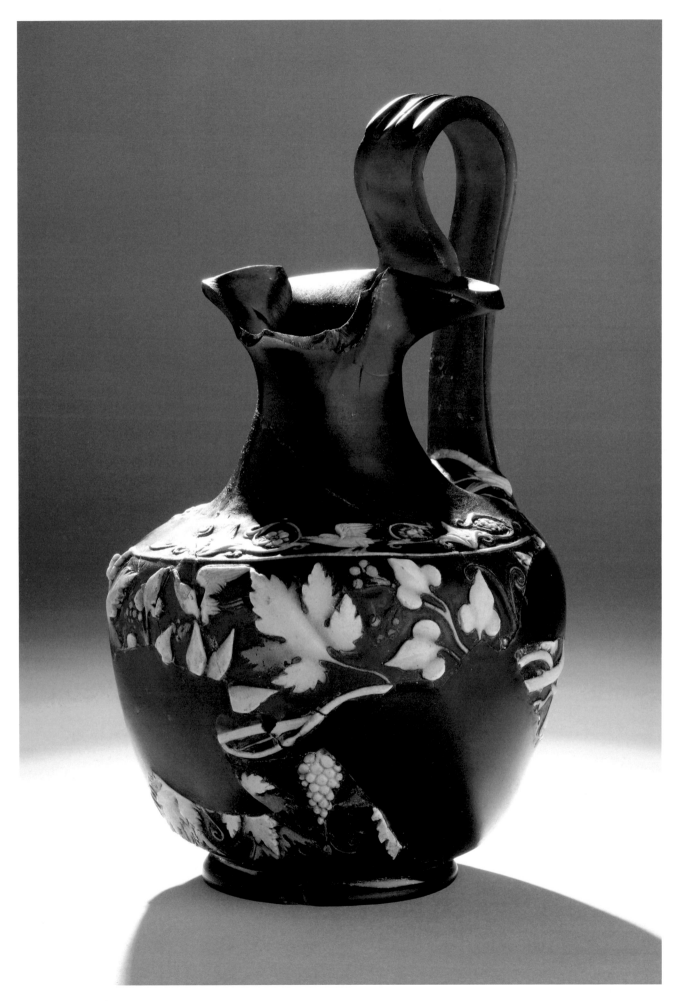

Fig 1 The Auldjo Jug (**2**).

How Vessel Blanks Were Made
William Gudenrath

The technology by which the blanks for the Portland Vase (**1**) and the Auldjo Jug (**2**; fig. 1) were made is a significant aspect of their historical importance. For, if our views are correct – that they were made by the process of glassblowing (see the defence of this thesis below) and that they date from as early as the later first century BC (see pp. 16–23) – we have the opportunity of carefully investigating two of the earliest, reasonably closely datable objects made by one of the first generations of glassblowers. It is because of their great potential to help illuminate the early years of glassblowing on the Italian peninsula that we revisit these already much studied objects.

The materials and technology context
The Portland Vase and Auldjo Jug were made at a time when the hot glassworking processes of casting, fusing and slumping were the routine activities of glass workshops. Core-forming, that most ancient method of producing glass vessels, apparently also continued to be practised until the beginning of the first century AD, as has been suggested by David Grose (1989, 109–25).

The knowledge and skill needed to make the two-coloured glasses required for cameo work had long been mastered: an impressively varied palette of physically compatible glasses was being produced during this period by Roman glassworkers for use in ribbon bowls, for example. Also, later core-formed vessels often feature a blue/black vessel body with opaque white glass decoration, the same two colours that predominate in early imperial Roman cameo objects. Therefore, at this time, making compatible glasses of different colours would have required no innovation.

In addition to the glasses, creating glass cameo vessels combined two very different technologies: the first, fine lapidary work, was long established and well understood; the second, glassblowing, was in its infancy and would soon prove to be revolutionary.

In the later first century BC and early first century AD luxury objects of multi-layer hardstones were being produced using lapidary techniques for making small ornaments (fig. 2) and, more rarely, vessels (fig. 3). Thus the processes for partially grinding away and polishing the overlay to sculpt the decoration were at hand and readily available for new applications. At some point enterprising glassworkers began to use two contrasting coloured glasses to make blanks for the lapidary workers. As in the case of stone cameo work, the simplest glass versions seem to have consisted of small flat objects (**40, 62**) and larger plaques (**34, 43**). When vessels were made, their shapes often imitated forms common in ceramics and silver (see pp. 19–23 for a discussion of these influences and similarities).

The small two-layer blanks were probably made by a simple two-step casting process whereby one glass was poured and flattened, immediately after which the contrasting glass was

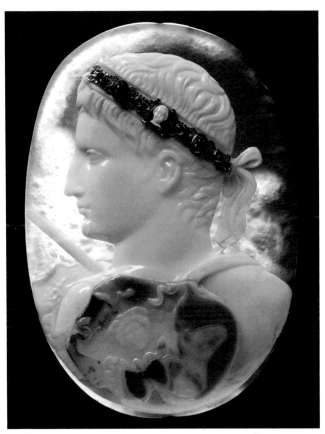

Fig 2 The Blacas Cameo, a three-layered sardonyx cameo engraved with a portrait of Augustus wearing the aegis of Minerva and a sword belt, Roman, AD 14–20 (H. 12.8 cm; British Museum).

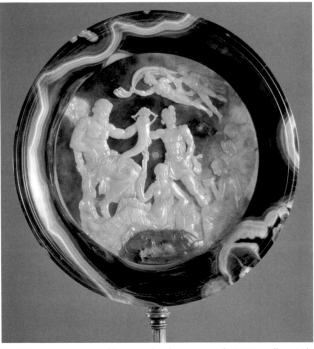

Fig 3 The Tazza Farnese, a cold-engraved sardonyx cameo depicting an allegorical scene set in Egypt, c. 199–150 BC (D. 20cm; Naples, Museo Archeologico Nazionale/The Bridgeman Art Library).

Figs 4–8: Making a blank for a plaque

Fig 4 A gather of blue glass is allowed to drip onto a ceramic plate and is cut free of its gathering iron.

Fig 5 The glass is immediately pressed flat with a tool.

Fig 6 Opaque white glass is allowed to drop onto the still hot but now hardened blue glass.

Fig 7 The opaque white glass is immediately flattened on top of the blue glass.

Fig 8 The blank is broken to reveal the threshold or interface where the two glasses meet.

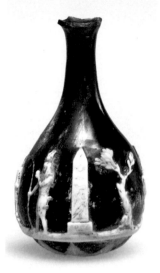

Fig 9 Flask, Roman, 15 BC–AD 25 (H. 7.6 cm, W. 4.2 cm; J. Paul Getty Museum, Malibu, California, JPGM 85.AF.84, formerly in the collection of Ernest Kofler and Marthe Truniger). Figs 10–16 show a replica of this flask being made.

Figs 10–16: Making a blank for a vessel

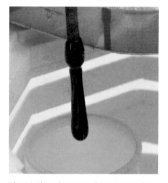

Fig 10 Blue glass is gathered onto the end of a blowpipe, inflated and then elongated to form a tube.

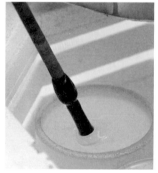

Fig 11 After cooling to the point of hardness, the blue tube is submerged part way into a crucible of molten opaque white glass.

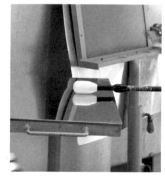

Fig 12 The opaque white glass is marvered – that is, rolled back and forth on a hard, flat, heat-resistant surface to make it evenly distributed around the blue tube.

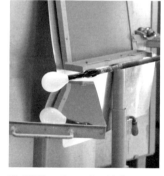

Fig 13 When the newly added opaque white glass has resoftened the lower portion of the blue tube, the two are inflated together.

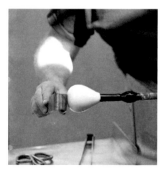

Fig 14 The vessel body is shaped and its tip is flattened to form a base.

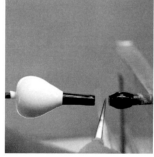

Fig 15 A pontil is attached to the base of the vessel, then a drop of cold water is placed on the blue tube near the blowpipe cracking it and allowing the vessel to be broken free of the blowpipe.

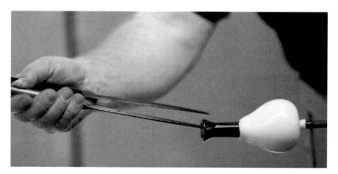

Fig 16 After reheating the open end of the blue tube in the mouth of the glassworking furnace, the edge is given its final shape. The vessel can then be broken free of the pontil and placed into the annealing oven.

poured on top of the first, then flattened (figs 4–8). As with all hot glass-forming processes, the work had to be immediately followed by annealing, the slow cooling of objects in a kiln to avoid the development of thermal stress in the finished object that could cause it later to crack. The blanks for cameo vessels appear to have been made by a specialized glassblowing process. The basic steps can most clearly be described by illustrating those used to make the blank for a small cameo flask like one now in the J. Paul Getty Museum (fig. 9). The process involves creating a blue glass tube that is, after hardening, partially submerged in opaque white glass. After the two are inflated together and shaped, the vessel is broken free of the blowpipe and attached at its base to a punty, or long metal rod used as a handle. Finally, after reheating the open end to soften it, the rim is given its final shape (figs 10–16).

Because of the very early date that glass cameo vessels are now believed to have been made (see p. 23) and that period's coincidence with the beginnings of glassblowing on the Italian peninsula, understandable doubts have been raised as to the likelihood that a technology so new could have been employed for making objects so extraordinary. A full explanation here follows as to why we believe the blanks for the Portland Vase and Auldjo Jug (and, by association, other cameo vessels such as the Blue Vase in Naples) to have been made by glassblowing rather than some other process.

The Portland Vase blank

For a number of reasons we can be nearly certain that the blank for the Portland Vase was made by glassblowing.

1. Variations in the shape of bubbles

The patterns of bubbles in the blue and white glasses and the many bubbles trapped at the interface of the two (see drawing, p. 83) closely resemble those seen in a model made by a similar glassblowing process (fig. 17).

The shapes of bubbles trapped within the wall of glass objects constitute an accurate record of the material's movement – or lack of it – during its last moments of plasticity in the hot-working processes. Their size, shape, orientation and distribution can be invaluable evidence when trying to determine the manufacturing process. Indeed, in some cases bubbles are an essential part of often very limited physical evidence remaining to give us a clue as to what hot-working process was used when subsequent cold working has removed so much surface material that the completed object bears little or no resemblance to its original hot-worked form.

Conveniently for analytical purposes, during different stages of the glassblowing process the shapes of bubbles in the glass change in predictable ways. In the freshly gathered mass of molten glass at the end of a blowpipe, all bubbles are spherical. Any change of their shape from subsequent marvering (or blocking) immediately disappears because the glass remains very soft after this brief operation. As the glass is gradually inflated, bubbles in the wall flatten and become increasingly lens-shaped, while in the area of the 'equator' (if the blowpipe is 'north') the bubbles also begin to elongate noticeably in an orientation perpendicular to the blowpipe. Any subsequent alteration of the overall shape of the inflated glass will further alter the shape of bubbles, with the areas of greatest change having the greatest effect on the bubbles. The pattern of bubbles in the Portland Vase is consistent with this phenomenon (see drawing, p. 83).

By sharp contrast, casting processes such as ladle casting and kiln casting result in spherical bubbles. This is because within the confines of a mould no movement of the glass can take place that would alter the naturally occurring spherical shape of bubbles. The elongated bubbles visible in nearly all parts of the Portland Vase unambiguously indicate a dynamic hot-working process rather than the static hot-forming process of casting.

On similar grounds, core-forming can also be ruled out as the manufacturing process for the Portland Vase, partly based on the observation that in the glass wall of core-formed vessels bubbles appear to be uniformly spherical in shape. As we have seen, this is not consistent with the widely varying shapes of bubbles evident in the Portland Vase.

2. Variations in wall thickness

The variations in the wall thickness of the Portland Vase (see drawing, p. 83) correspond closely with those in a model made by glassblowing (fig. 18). When a spherical parison is altered by elongating it to become ovoid, three changes happen simultaneously. As the inflated glass increases in length, its diameter correspondingly decreases. At the same time, the wall thickness diminishes most in the area where the greatest lengthening (stretching) occurs. Wall-thickness variations appearing in the Portland Vase are consistent with this phenomenon.

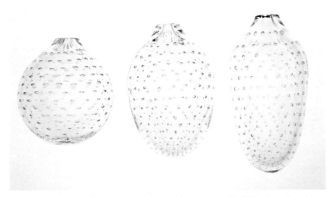

Fig 17 Three blown-glass vessels with a regular pattern of bubbles introduced to demonstrate their progressive distortion.

Fig 18 Two blown-glass vessels cut in half to demonstrate wall-thickness variations in different areas accompanying alterations of the vessel's form.

By contrast, these variations are inconsistent with what we see resulting from the core-forming process (fig. 19: for illustrations of the core-forming process used to make this example, see Tait 1991, 214–15, figs 1–150). Based on an informal survey of fragments of late core-formed vessels in the British Museum and The Corning Museum of Glass, it can be said that such fragments show a noticeably uniform wall thickness from top to bottom. There is no aspect of core-forming that inherently leads to any significant variation in wall thickness, much less one that closely mimics those that invariably accompany the glassblowing process.

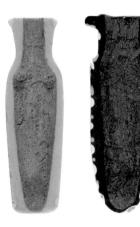

Fig 19 Two core-formed vessels (made by the author) cut in half to reveal the relatively uniform wall thickness that is characteristic of this manufacturing process.

Lastly, in casting processes the manufactured object perfectly reproduces all features of the 'positive' used to make the mould. There would be no reason for the maker of a positive for use in casting a glass object in the late first century BC to closely imitate the wall-thickness variations that we now know accompany the glassblowing process. Accordingly, the variations in wall thickness in the Portland Vase make any casting process of manufacture, such as *pâte de verre* (where a mould is filled with ground glass and a binder, such as water and gum arabic, and heated until it becomes a solid mass), highly implausible.

3. The tubular neck

The rather narrow neck of the Portland Vase consists solely of blue glass (p. 34). At their lower attachment points the handles sit on top of opaque white glass while at their upper attachment points they sit directly on blue glass. This confirms that during the process of making the vase, the neck was never covered by the overlay: the overlay's upper edge, subsequently removed by cold working, must have lain somewhere between the upper and lower attachment points of the handles.

The narrow, bare blue glass neck on the Portland Vase, Auldjo Jug, Blue Vase and numerous other examples of ancient cameo glass suggests that the specific process by which they were made was in principle similar to that used for making domestic free-blown and mould-blown vessels: most first-century blown-glass objects with furnace-finished rims have a tubular neck above their wider vessel body. This narrow section was purposefully created by glassblowers to facilitate the removal of the vessel from the blowpipe and was a nearly unavoidable vestige of the early glassblowing process. The fact that the Portland Vase and its close parallels have this feature supports, by association, the argument that their method of manufacture was a glassblowing process that required having a section of tubing between the vessel body and the blowpipe.

4. Flaws created during annealing

From the presence of a number of flattened areas on the exterior of the Portland Vase and a bulge inside the lower neck it can be seen that, on completion of the hot-working processes, the hollow, finished blank was significantly too hot when it was placed in the annealing oven for gradual cooling. (A full and detailed account of the damage that occurred in the annealing oven can be found in Gudenrath and Whitehouse 1990b.) For these distortions to have occurred, the blank had to have been hollow, that is, empty. In the cases of both core-forming and casting processes, annealing takes place with the object still filled with core material or surrounded by rigid refractory material, respectively. For these reasons both can be discounted as possible manufacturing methods for the Portland Vase blank. To our knowledge, the only later first-century-BC process that could have been used to produce an empty, large, closed vessel ready for placement into the annealing oven is glassblowing. (The Blue Vase was similarly distorted: the entire length of its otherwise cylindrical body has an inadvertently flattened area.)

The internal grinding of the Portland Vase

Large areas of the interior surface of the Portland Vase are covered with more or less concentric grinding marks (fig. 20). We can be sure that these are the result of a cold-working process because, with magnification, their edges appear sharp, indicating that the glass was abraded with a hard tool. Fundamental investigations of ancient cold-working practices have been carried out by John Gwinnett, Leonard Gorelick, Margaret Sax and N.D. Meeks (Gwinnett and Gorelick 1983). By contrast, when similarly observed, hot-working tool marks have rounded margins made smooth by heat, rather than sheer, well-defined edges associated with cold working. Because this was probably the first action taken by the lapidary worker on receiving the blank, the internal grinding can be considered an integral part of the manufacturing process. For this reason it is included here.

After annealing, the blank was apparently mounted in a lathe perhaps as described by Alfred Mutz (1972) or vertically, as in work done on a potter's wheel. As it turned, a sharp, hard tool – probably a stone attached to a long, bent handle – was pushed firmly against the interior surface while the tool was slowly moved up and down inside. The most likely purpose of the internal grinding was to search for large bubbles in the blue glass lurking just beneath the interior surface. I no longer view the primary purpose of the internal grinding as having been to check for and/or relieve mechanical stress between the two glasses

Fig 20 The interior of the Portland Vase showing the extensive internal grinding-tool marks (photo by Mark Taylor and David Hill).

(Gudenrath and Whitehouse 1990b, 137). Although it remains a plausible theory, later research has revealed much stronger evidence that my current interpretation is correct. Sizeable bubbles lying beneath the exterior and interior surfaces of the blank would have been of immense concern to the lapidary workers: accidentally breaking through into a large void could instantly ruin hundreds of hours of work already accomplished. To help avoid such a catastrophe, it was essential to detect and note as thoroughly as possible the locations of potentially threatening bubbles before laying out the decoration.

Lapidary workers experienced in working with glass must have been well aware of this peril. Both the blue and opaque white glasses from which the Portland Vase and Auldjo Jug were made contain myriad bubbles. Also the 'dip-overlay' method used for creating the overlay in antiquity is a process that is inherently prone to trap air bubbles between the two layers of glass. The alternative is the 'cup-overlay' method used in the nineteenth century (Whitehouse 2007, 60–73). The bubble 'maps' of the vase and jug published in this catalogue (see drawings, pp. 83 and 84) record only a small percentage of bubbles within the glass that are easily visible with intense light and moderate magnification.

When the decorators received the blank, the blue glass would have been thickly covered by a layer of the intensely opaque white glass except for the uppermost neck and rim area. Thus, while substantial bubbles in the white glass might reveal themselves as bumps on the outer surface, there was no way to look for bubbles in the blue glass by examining the blank from the exterior.

Large, blister-like bubbles in the blue glass near the interior surface could have been detected by careful inspection with a long, bent probe: the worker would have felt for bumps. However, substantial bubbles lying less near that surface could easily go undetected using this method alone. By grinding away glass inside the blank, perhaps to a depth of a millimetre or two, a worker could have used a pointed, sharp probe to find and assess the size of bubbles, then carefully mark their locations on the outside of the blank. Thus, accidentally cutting into a bubble during the decorating process could be avoided by simply adjusting the layout of the ornament based on this information. For this reason it is entirely likely that the internal grinding procedure was the very first action taken by the lapidary workers on receiving the blank from the glassblowers.

Two features of the Morgan Cup in The Corning Museum of Glass strongly support this theory (fig. 21). The cup is probably roughly contemporary with the Portland Vase, and the shapes of bubbles in the glass suggest that it, too, was made by glass-blowing.

The interior surface was ground by a process that left cutting marks like those visible in the Portland Vase. A large oval depression (approximately 20 × 8 mm and 1.5 mm deep) on the inside surface oriented ten or so degrees off the vertical axis is most probably the vestige of a large blister-type bubble once trapped within the blue glass (fig. 22). It is likely that this bubble was detected by grinding away the original interior surface to a sufficient depth to reveal it. The edges around the cavity were then carefully smoothed by cold working.

The key corresponding feature of the decoration that strongly supports this theory is the presence of a large *krater* exactly on top of the large oval depression inside. This correspondence of

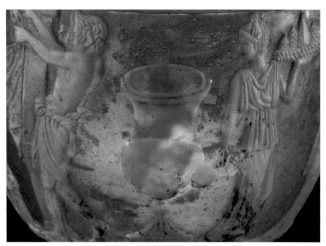

Fig 21 Detail of the Morgan Cup, late 1st century BC–1st century AD (H. 6.2 cm, D. 7.6 cm; Corning Museum of Glass, gift of Arthur A. Houghton Jr, 52.1.93).

Fig 22 The interior of the Morgan Cup showing the site of an excavation that took place to fully remove and disguise a large bubble in the blue glass (Corning Museum of Glass, gift of Arthur A. Houghton Jr, 52.1.93).

locations is too close to have occurred by chance, and the implausibly large size of the krater seems purposeful, distinct from any purely aesthetic or iconographic reason. It seems very likely that the size and location of the krater were determined by the size and location of the large bubble once present in the blue glass. Other examples of such a correspondence of an internal flaw in the blank and careful placement of decoration have been observed, although none so vividly suggests cause and effect as in the case of the Morgan Cup.

The internal grinding process used to detect potentially perilous bubbles in the blue glass was nothing short of ingenious. By contrast, in the nineteenth century undetected bubbles remained a troublesome and costly problem (Whitehouse 2007, fig. 20). Perhaps some of the exterior surface was similarly ground away, too, in search of bubbles in the opaque white glass: this can never be known, though, as any evidence will have been removed by the subsequent lapidary work.

In spite of their best detection efforts, when it came to bubbles deep in the walls – especially threshold bubbles – workers had no choice but to cut blindly further and further into the glass. This cannot have been pleasant on occasion: two features appearing on the Portland Vase vividly reveal what must have been a truly frustrating reality for the ancient workers decorating cameo glass objects.

A large patch of unsightly bubbles (mostly in the blue glass) was unknowingly revealed in a sizeable area extending above and below the right foot of the seated female figure holding a

Fig 23 A close-up photograph of the Portland Vase showing a large, vertically oriented patch of bubbles now exposed by the cameo cutting (photo by Mark Taylor and David Hill).

Fig 24 A close-up photograph of the Portland Vase showing a deep cold-worked trench, probably the site of a large bubble once trapped in the vessel wall (photo by Mark Taylor and David Hill).

staff (fig. 23). Also – impossible to miss face to face with the vase, but difficult to see in photographs – is a deep, vertically oriented scar in the form of a 'trench' (approximately 3 mm deep and about 2 cm long) at the base of the shoulder (fig. 24). This is probably an excavation left behind from the process of disguising an exceptionally large, elongated bubble once trapped at the upper threshold of the opaque white overlay.

None of the well-known surviving cameo glass objects – including the Auldjo Jug – is without such flaws: they can easily be seen in widely published photographs of the Blue Vase and the Naples plaques, too, for example. Apparently, though, given the exceptional nature and unprecedented size of the blanks being newly made by the hot-glass workers, the lapidary workers and their customers must have considered these bubbles tolerable.

The Auldjo Jug blank

For the reasons concerning the shapes of bubbles in the glass and varying wall thickness cited above in the case of the Portland Vase, the blank for the Auldjo Jug, too, was most likely made by glassblowing.

1. Variations in the shapes of bubbles

As well as helping to show that the manufacturing process was glassblowing, the shapes and orientation of bubbles in the glass indicate how the base of the jug was probably made. When the

flat bottom was created with its corresponding groove just above, the combination of friction from tools used for constricting and flattening the glass, together with the necessary rotation required to keep the soft glass centred, resulted in a twisting of the lower third or so of the vessel (fig. 25). In a model made by what we believe to be a similar process, the orientation of the slanting bubbles closely resembles the pattern in the jug.

2. Variations in wall thickness

Like the Portland Vase, the thinnest part of the vessel body of the Auldjo Jug is about midway between its point of greatest diameter and its lowest point (see drawing, p. 84). This is the area where the greatest stretching of the inflated glass took place, so consequently the greatest reduction in wall thickness took place there, too.

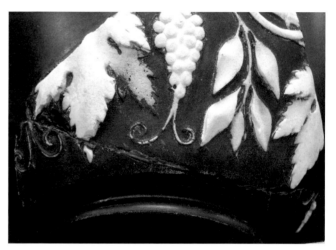

Fig 25 A close-up photograph of the Auldjo Jug near the base showing both the elongation of bubbles in the glass near the foot and their skewing away from vertical as a result of making the base constriction (photo by Mark Taylor and David Hill).

3. Two revealing features created inadvertently

While there are no flattened areas or internal distortion indicative of excess heat during the initial moments of the annealing process like those in the Portland Vase, the shoulder of the jug has an upward bulge at the lower attachment point of the handle (p. 84). With a long probe a corresponding depression can be felt on the inner wall. This was probably created while shaping the high, graceful 'hoop' portion of the handle soon after its application. Immediately after the glass for the handle was added (as a thick, somewhat flattened mass forming a 'bridge' between the shoulder and the edge of the rim), the object would have been returned to the furnace for reheating. This would have helped ensure the seamless join between the rim and handle. Apparently, during this reheating the vessel wall softened somewhat, and the forceful upward pull on the handle required to create the 'hoop' also pulled the shoulder upward. If the jug had somehow been made by a core-forming process, the interior wall of the vessel would have firmly adhered to the core when the handle was added and shaped, thus preventing any upward movement and the resulting distortion of the shoulder profile and interior shape. Evidence of the tenacious adhesion of glass to the surface of cores during the core-forming process can be seen in fig. 19.

Also the presence of vertically oriented folds on the inside surface of the jug's neck helps rule out core-forming or any kind of casting process as the manufacturing technique for the jug.

These folds were an inadvertent result of a constricting action to which the neck was subjected as it was given its final shape. The inner surface was insufficiently hot to compress uniformly and, instead, bunched up or buckled as the neck was squeezed from the outside with a tool. The jug must have been hollow during manufacture for this defect to have occurred: in the core-forming process the object is at all times filled with rigid core material to which the glass tightly adheres. An informal and limited survey of fragments of historical core-formed objects has failed to find a similar feature. Apparently, manipulating the glass to shape the neck, shoulder and rim affects only the outside of the vessel, not the inside as well.

These folds also rule out casting as a method of manufacture: they are clearly the result of manipulation and movement of the glass, whereas casting is an entirely static process.

4. Plane-like evenness of the threshold

The threshold where the two glasses meet is exceedingly smooth in ancient cameo objects. This can best be seen where only the thinnest layer of opaque white glass remains in the decoration. On the Portland Vase the thinly cut wings of Cupid are an excellent example. In the constriction just above the base of the Auldjo Jug, a slip of the hand during the process of squeezing the soft glass with a tool accidentally pushed a band of opaque white glass a little too deep into the threshold's otherwise even, curving surface. As the cold working proceeded to remove the overlay and refine the shape of the lower part of the jug, the workers apparently chose not to cut deeply enough to excise all of the opaque white glass, thus leaving behind the vestige we see today.

Lastly, had the Auldjo Jug or Portland Vase been made by a *pâte de verre*-type casting process, the threshold of the two glasses would have been too uneven to make possible these exceedingly thin and uniform features. The initial granular interface would, on fusing, have remained markedly uneven. As this is not visible in Roman-period cameo objects, both in vessels made by glassblowing and plaques made by casting, we can rule out the granular casting process, *pâte de verre*, as the method of manufacture in antiquity.

The original appearance of the Portland Vase and the purpose of the base disc

If we are correct about the manufacturing process, we can reasonably safely speculate about the original appearance of the Portland Vase and the origin of its accompanying base disc (34).

In its present form the vase is completely open at the bottom. Just below the heavy white base line is a chipped, rough edge. As can be seen from the surviving casts of the vase made by James Tassie in the late eighteenth century, it was to this edge that the Portland Vase's base disc was once attached with an adhesive or cement-like material, perhaps pitch. The joining of the base disc to the vase was probably part of a restoration that may well have taken place during the first century AD. The lower portion of the vase must have sustained damage severe enough to have warranted its removal. This was done by the process of grozing, whereby pointed pliers were used to gradually – and coarsely – clip away the unwanted glass. The base disc shows evidence of originally having been made specifically for a different use and it was probably adapted to help salvage and return to usefulness the damaged, now open-ended vase. While the Tassie casts show that they were once attached, in recent times the vase and base disc have been displayed together, but unattached. (For an illustration of a Tassie cast, see Painter and Whitehouse 1990e.)

What might the vase have looked like before its damage? On a number of grounds it seems most likely that the original form of the Portland Vase was that of an amphora rather than a flat-bottomed vessel (see reconstruction drawing, p. 41). When comparing features of the vase (as it has come down to us) with the Blue Vase and the Auldjo Jug, based on variations in wall thickness and the shapes of bubbles in the glass at different locations on the objects, the Portland Vase is little different from the Blue Vase. Indeed, they must have once been strikingly similar in both overall impression and size. Also, and perhaps most convincing, on close inspection of the grozed edge, vestiges of what must have been a non-symmetrical decorative frieze can be clearly seen (fig. 26): this feature alone leaves us with little doubt that, when the Portland Vase left the hands of its maker, it was a very grand and beautiful amphora.

Glassblowing in the first century BC? A postscript for sceptics

These celebrated objects, the Portland Vase, the Auldjo Jug and the Blue Vase, unquestionably force on us an uncomfortable technological conundrum: were their blanks made with an emergent technology, glassblowing, that requires great skill and even greater experience to master – incredible though this seems – or, as some would believe, not at all unreasonably, were these masterpieces created by a merging of the long-established processes of casting, fusing, slumping and core-forming that were for some brief period combined in a way that we, as yet, do not fully understand? The conclusions here, although they may well be correct, do not pretend to be the final word. Only when a process other than glassblowing is demonstrated for making models of these objects, and one that unavoidably and repeatedly mimics all the 'symptoms' of the manufacturing process cited in the previous pages, will it be time to seriously entertain other possibilities. In the current rather small world of historical glassworking investigation, speculation unsupported by rigorous practical experimentation is merely conjecture (Lierke 1999). In the absence of compelling evidence to the contrary, we must, at least provisionally, accept the likelihood that the great cameo glass objects, the Portland Vase, Auldjo Jug and Blue Vase, do not represent a culmination of traditions but are, on the contrary, bellwethers of brilliant innovations.

Fig 26 A close-up photograph of the lower edge of the Portland Vase showing vestiges of most probably a scenic frieze.

Catalogue

Introduction

The following catalogue discusses all the pieces of cameo and related glass in the British Museum. The collections contain seventy pieces (1–69) of cameo glass of the classic, early period of Roman cameo glass production, which we suggest dates to about 15 BC–AD 25 (see above, pp. 16–23). In addition, there are five examples of late-antique cameo glass vessels dating to the fourth century AD (70–74), as well as a group of seven pieces of early imperial 'Egyptianizing' layered glass (75–81), probably to be dated with the early cameo glass to around 15 BC–AD 25.

Vessels

There are thirty-three fragments of vessels in classic, early cameo glass. Of these, all are in the Department of Greece and Rome except for one fragment (23), which is in the Department of Ancient Egypt and Sudan. Nine pieces (1–9) are certainly (or almost certainly) closed forms. In this category are two near-complete vessels, the amphora-shaped Portland Vase (1) and the Auldjo Jug (2). Another amphora of comparable size to the Portland Vase is represented by 3. Two fragments (4, 5) are probably from jugs and are both noteworthy for their decoration, which, like that of the Auldjo Jug, extends above the shoulder and, in the case of 5, reaches all the way up the neck. In addition, there are sherds from two bottles (6, 7) and two unidentifiable forms that were probably closed (8, 9).

The remaining twenty-four pieces are almost certainly from open forms. *Skyphoi*, or ring-handled drinking cups, are represented by three examples (11, 22, 25). The majority of the other open vessels are fairly tall, straight-sided cups (12–19, 21, 23, 24 and 26), similar to the Morgan Cup in The Corning Museum of Glass. In fact, the rim sherd (12), with its prominent external ridge, closely resembles the rim of the Morgan Cup. Also included are one example of a straight-sided mug (*modiolus*) (20), two dishes/bowls (30, 31) – possibly *paterae* (long-handled dishes) – a *pyxis* (lidded bowl) (29), two fairly shallow bowls (14, 27/8) and two large dishes or trays (32, 33). Only one other example of a pyxis in cameo glass is known, in Leiden (personal observation), while the modiolus is not a common form.

There are numerous decorative schemes, but the most popular decoration by far is vegetal, appearing on a third of all vessel fragments (2, 5, 7–9, 12, 13, 26, 29, 32, 33). The most abundant vegetal decoration appears on the Auldjo Jug (2), the surviving parts of which are completely covered with vines, acanthus, ivy and laurel. Other pieces are decorated with vines (7, 8, 13, 25, 33), acanthus (5) and olive (26). Also popular are Bacchic scenes and motifs (3, 11, 16–18, 30, 31), including Bacchus' faithful followers, the satyrs (11, 30) and maenads (3, 16–18, 31). Egyptianizing motifs are well represented (20, 21–3, 24), showing scenes of offering with royalty or deities (21–3), or Nilotic scenes (20, 24). The Egyptianizing piece (22) is one of only two known incuse pieces, in which the scene is cut into the vessel, rather than being sculpted in relief from its surface. The other incuse piece is in The Metropolitan Museum of Art, New York (see entry for 22). Cupid (6, 15, 27) is also a popular subject and is shown driving a chariot (6), carrying armour (15) and walking in a sacred precinct (27). The erotic scene (10) finds a close parallel in the figures shown on one side of a bottle now in the Ortiz collection (see entry for 10). As with the incuse piece (above), only two pieces with such erotic scenes are known. Several fragments depict fauna, including quadrupeds such as big cats (4), deer or other ungulates (4, 19), as well as birds (2, 29), a bee (29) and a butterfly (27).

Most vessels are on blue background glass, but a small group (5, 15, 21) are on purple glass and two (27, 28), almost certainly the same vessel, are on turquoise green. The five layers of glass used for the design of the erotic scene (10) make it one of the most complex pieces known, along with another multi-layered piece in The Corning Museum of Glass (see entry for 10). Four vessel fragments (12, 13, 27, 28) are in milky-opaque glass, making this the largest group out of the ten such pieces known in the global assemblage (personal observation). The four pieces comprise two mid-blue drinking cups (12, 13) and the small turquoise green bowl (27/8). Five vessels are on a very light, thin, transparent background (16, 17, 26, 31, 32). This group can perhaps be referred to as the 'clear group' and forms a small but noticeable grouping across the major collections, including nearly all the spear-leaf cups (as 26).

Plaques

The British Museum possesses thirty-five fragments of classic, early cameo glass plaques. Of these, all are in the Department of Greece and Rome except 41, which is in the Department of Ancient Egypt and Sudan. The possible function of these plaques is discussed in detail elsewhere (see 44). In summary it seems obvious that they were decorative panels (*pinakes*), but it is not clear whether they were set in painted walls, mounted in frames, perhaps on separate stands, or whether they were smaller elements of, say, screens or (less likely perhaps) larger pieces of furniture.

With regard to the decoration of the plaques there is a wide range of themes. The disc-shaped element of a plaque (34) that served as the base of the Portland Vase, almost certainly shows Paris, Prince of Troy. He is seen preparing to choose the most fair of the three goddesses, Minerva (Athena), Juno (Hera) and Venus (Aphrodite), a choice that would ultimately spark the Trojan War. This is, oddly perhaps, one of the few definite representations of mythological figures seen on cameo glass (other than Bacchus and Cupid). Another possible mythological scene might be shown on 40, which perhaps depicts the faces of Venus and Mars (see entry).

Like the vessel fragments, the majority of the plaque fragments are decorated with vegetal motifs (49–59), in particular elements of acanthus and lotus. One fragment (49) shows laurel or myrtle, while another features an acorn (50).

Also very popular are scenes relating to Bacchus/Dionysus (**35**, **37–9**, **42**, **44**, **44a**, **45**). The depiction of his consort, Ariadne (**35**), is extremely similar to that seen on one of the plaques in Naples (see entry), while other Bacchic themes include satyrs (**38**, **42**, **44**), Silenus (**39**) and Cupid (**36**), who is shown involved (almost certainly) in Bacchic mischief. The large edge fragment in purple glass (**45**) bears an inscription, one of only two in existence (see entry), that has sacred and, we would argue, Bacchic significance. Related to **45** are two other fragments (**44**, **44a**), almost certainly part of the same plaque. Although there are no explicit erotic scenes in the plaques as there is on the vessel fragment (**10**), the male and female faces on **40**, perhaps the deities Venus and Mars, certainly seem to be in intimate proximity. The fauna includes a bull (**41**), a deer (**47**), a cockerel (**46**), a goat (**38**) and a sea creature (**48**).

The Egyptianizing theme of **41**, showing a bull being led to sacrifice, appears to be unique in cameo glass plaques. Vessels with Egyptianizing themes are not uncommon (see **20–24**), and the Egyptianizing layered plaques (**75–81**) associated, we would argue, with early cameo glass nearly all feature Egyptian themes, but no other early cameo plaque appears to do so. The form of the piece is also unique, with its narrowed lower edge and flat side, indicating a narrow, portrait format. Another extremely unusual piece is **48** with its odd, marine(?) decoration and its deep brown background colour. This colour is unique in ancient plaques (as opposed to medallions), as far as we know. Nos **50** and **51** may be isolated vegetal elements in an otherwise figural scene, but this does not seem to be the case with **53–8**. These six sherds, all made of three layers of glass and probably part of the same plaque, show no trace of any figural elements, suggesting that the plaque was, unusually, completely vegetal – the only such plaque known to us. The border fragment (**49**) with its unusual construction (the white possibly only laid in the broad channel around the edge of the piece) is extremely rare, with only one approximate parallel in the Museo Civico, Bologna (see entry).

With regard to colour, most of the plaque fragments are on a blue glass background, but a sizeable minority, a third of the total number of plaques, are on purple glass (**35**, **37**, **38**, **40**, **41**, **44–7**, **50** and **62**). These include the fragments of the largest and most substantial plaques in the collections (**44–6**), together with the imperial portrait (**62**). The same colour is represented in fragments of plaques of this size in collections in The Corning Museum of Glass, The Metropolitan Museum of Art, New York, the Gorga collection in Rome and the Thorvaldsen Museum in Copenhagen (see **44**). It is reasonable, we believe, to suggest a prestige production in purple glass of larger or more monumental and ornate pieces, often with much higher and finer relief than others. The fact that one of these (now in The Corning Museum of Glass) was found in the Horti Sallustiani, one of the aristocratic and even imperial urban estates of Rome's ruling classes, might give support to the idea of an intended high-status market.

The fragment (**43**) showing part of a female torso is, as far as we know, the only example of a cameo plaque with a base layer of colourless glass. This piece may perhaps be related to the clear group of vessels (**16**, **17**, **26**, **31**, **32**), which all share a transparent underlayer. There is, however, no example in the British Museum collections of a plaque on milky-opaque glass

as in The Toledo Museum of Art, the Römisch-Germanisches Museum, Cologne, and the Thorvaldsen Museum, Copenhagen (personal observation). The multi-coloured, if not originally a truly multi-layered, piece (**46**) showing a cockerel and garlands was made by applying elements of colour in selected places and not by wholesale carving away of the coloured areas.

The group of pieces with three layers of colour (**53–8**) is rare, and even more so is the fragment with five layers (**59**). All of these pieces have a vegetal decorative scheme. It is significant that all the three-layered pieces are very similar in thickness, motif and condition. Their provenance, except for **58** (provenance unknown) is also the same (Nesbitt collection), implying that they may have had the same findspot and, if so, are very likely to have been part of the same plaque. The purpose of and need for multi-layers – in particular the five-layered piece (**59**) – are puzzling, since light could not penetrate beyond the first two layers. One unique, plaque-like piece (**61**) is decorated on both sides, indicating either that it was reversible or that both sides were potentially visible at the same time. If the latter, then this could be an example of an *oscillum*, a round, decorative plaque, usually of marble or terracotta, that was hung between the columns in a peristyle (interior colonnaded garden).

Late Roman cameo glass and Egyptianizing layered glass

The British Museum also has five pieces of late Roman cameo glass (**70–74**) dating to the fourth century AD. Although none is a complete vessel, the number of vessels represented by these fragments makes this the largest assemblage of late cameo known to us. In contrast to the early cameo vessels (above), in late Roman pieces the base glass is of uniformly colourless or almost colourless glass and has a transparent or translucent coloured overlay. Two colours of overlay are used on these pieces: blue (**70**, **73**) and green (**74**), with both blue and green in **72**. Forms comprise a deep, narrow cage cup (**70**), a broad, shallow bowl (**72**) and three small beakers or cups (**71**, **73**, **74**). The cage-cup fragment (**70**) preserves, in very high relief, part of a tragic mask, while two pieces feature vegetal decoration, a garland (**72**) and a leaf (**73**). Two examples (**71**, **72**) carry the remains of an inscription in Greek letters.

The British Museum has the largest known collection of fragments of Egyptianizing layered plaques (**75–81**), which, we would argue, are contemporary with classic early cameo and associated with it, even if made in a quite different way (see p. 77). Human figures, both seemingly male, are shown in **75** and **76**. One (**75**) depicts the feet of a standing figure and apparently preserves four original edges, suggesting the figure was composed of several pieces. The other (**76**) appears to show an Egyptian making an offering to a deity – a scene repeated in early cameo glass vessels (**21–3**). A fish is evident on **77**, while **78–81** feature vegetal motifs including vine (**79**), acanthus (**80**, **81**) and lotus (**78**). Two of these pieces (**80**, **81**) appear to be border or edging fragments. With regard to colour, all seven pieces use milky-opaque glass in their background and main elements. Nos **76**, **78** and **79** have a denser, more shiny form of milky-opaque glass, in particular a bright orange background (**76**) or a deep brick red background (**78**, **79**), also seen in the piece in the Thorvaldsen Museum (see entry for **79**).

Closed-form vessels

1

The Portland Vase

1945,0927.1 (previously 1810,0609.1); the disc base (**34**; registered as 1945,0927.2) is discussed separately in the entry; a number of tiny fragments of the vase were returned to the BM in 1948 (see below, p. 36) and were also registered separately (1948,1018.1).
H. 24.5 cm, D. (body max.) 17.7 cm, D. (rim) 9.3 cm, D. (base aperture) 11.8 cm; weight 1.306 kg. The vase is likely to have been found in or around Rome; it was purchased in 1945 with funds bequeathed by James Rose Vallentin.
15 BC–AD 25

Glass The vase is made of translucent, dark cobalt-blue glass overlaid with opaque white. For a full discussion of the composition of the two glasses see pp. 27–30. There is slight iridescence in patches all over the inside of the vessel, slight pitting on the exterior, and red streaks and bubbles in the blue glass. Grinding marks extend over much of the inside of the vessel.

Form The vase can best be described as having formerly been an amphora, now truncated due to damage and loss, with a cylindrical neck widening out to a sloping shoulder and an ovoid, rather squat body, accentuated by the lack of the original lower body and the foot (see below). The mouth is everted, with a rounded rim that is somewhat oval and not horizontal. The inside of the rim is decorated with asymmetrical grooves. Below the rim the neck curves out smoothly to the carination of the shoulder. A pair of handles extend from raised, horizontal, almond-shaped plateaux on the centre of the neck to the shoulder, forming almost a right angle. The handles are sharply ridged on the outside and v-shaped incisions decorate their upper surfaces.

The vase has been broken and mended on more than one occasion. The bottom of the vase – perhaps as much as one third of its original height – is missing, and the lowest surviving part has been roughly trimmed and the edge left grozed, almost certainly in antiquity. The disc that formed the base of the Portland Vase at the time of its first mention in the early seventeenth century and almost certainly at the time of its burial in the Roman period (see p. 60), too, is discussed separately (**34**).

Decoration (single capital letters in bold denoting the figures refer to those in the drawing opposite) The main decorative scheme, in white glass, comprises a complex figured scene of large-scale figures. The scene is divided into two portions by a bearded (and perhaps horned?) head below the lower attachment of each handle. On side A there are four figures. On the far left, a young man (**A**) emerges from the doorway (of a shrine?) formed of squared pilasters and a Doric architrave with triglyphs (relief decoration of groups of three vertical lines) and dentils (ornamental knobs below the triglyphs). Behind this structure grows a small tree. The right arm of **A**, held behind him, drops (or

clasps) his tunic, which is draped around the pillar of the shrine; his left arm is stretched before him, and is clasped by the right arm of a half-draped woman (**C**) seated on the ground with her legs out in front of her. Her drapery covers her lower body and is gathered around her waist. She is turned back towards **A** and with her left arm she embraces a serpent-like creature that rises up towards her face. Cupid (**B**) flies to the right above the woman, holding a bow in his left hand and a torch in his right. He looks back, directly at the face of the young man. To the right stands an older, bearded man (**D**) resting his chin on his right hand, and his right arm on his bended right knee. His drapery is entwined around his left arm behind his back. His right foot is supported by a rock. In front of him a tree spreads out its branches, and there is another tree behind him.

On the other side of the vase, at the extreme left, is a rectangular column or pilaster, beside which is a young man (**E**) seated to the left on a rocky outcrop, shown in a striated, heavily idealized form. The young man is naked, and his drapery, partly behind him, is held in his left hand and draped over his lower thighs. His head is turned back towards a woman (**F**) reclining on the same rock. Her legs stretch out in front of her, left, with her lower legs crossed. Her right arm is raised up so that her right hand rests on the top of her head, which is turned

back to look towards the ground between her and **G**. In her left hand she loosely holds a torch, downturned, but with the flames still burning. Drapery covers her lower body and bunches around the waist. To her left, seated to the right on another rock and looking back towards the scene, sits another woman (**G**), supporting her weight on her right arm and holding in her left hand a long staff that disappears behind her knees. This woman is also naked from the waist up, with some drapery over her left arm. The scene is closed by the small tree growing from the back of the doorway described above.

Comment The Portland Vase is the best known and most discussed of all ancient cameo glass vessels. Recent publications, since the devotion of a whole volume of *Journal of Glass Studies* to it in 1990, include those by Painter and Whitehouse (1991), Dawson (1995, 112–14), Jenkins and Sloan (1996, 187–9, no. 63), and Walker (2004). The 1990 journal remains indispensable to anyone with a serious interest in the Portland Vase in particular, and Roman cameo glass in general.

Original form With regard to its form and technique, it is very clear that the disc that was once the base of the Portland Vase was not part of its original form. It now seems likely that the vase has suffered at least four incidents of

1 Side B (side A is illustrated on p. 8).

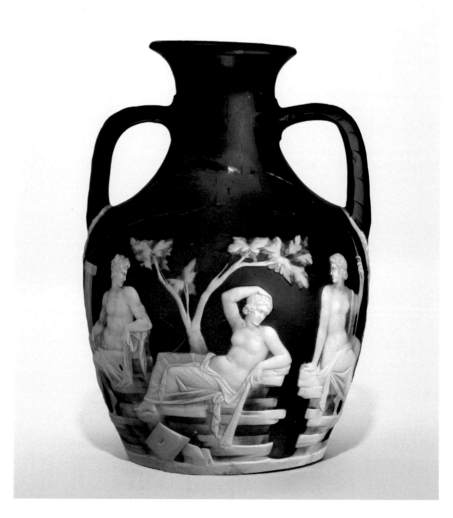

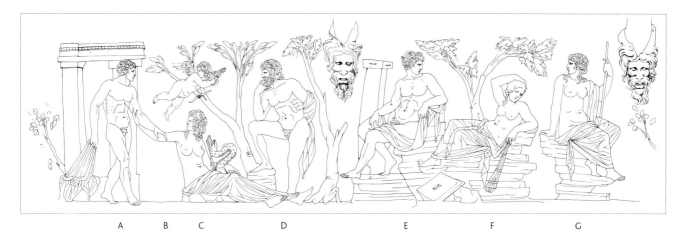

A B C D E F G

damage (see Gudenrath, Painter and Whitehouse 1990, 21, and below, p. 36). The first of these, almost certainly in antiquity, saw the breaking of the lower part of the vase and its replacement with the disc. The second seems to have occurred before Tassie made his casts of the piece in 1781, while the third was probably at the hands of the Duchess of Gordon in the late eighteenth/early nineteenth centuries, and the fourth was the disastrous shattering of the vase on 7 February 1845 by William Lloyd (William Mulcahy).

Furthermore, as Gudenrath and Whitehouse point out (1990, 108–11), the remains of the extra band of decoration below the figures, observed as a very small area of white continuing below the thick ground line, together with the change in the thickness of the white and blue glasses and the elongated shape of the bubbles within them, make it very likely that the lower body of the Portland Vase continued to taper downwards for some distance. This suggests that the vase was originally an amphora, probably point-based or point-based terminating with a blunt finial. Its closest surviving parallel, in terms of form, would be the Blue Vase in the Museo Archeologico Nazionale di Napoli (Whitehouse 1991, 19, no. 2 with references).

This idea, first tentatively proposed by Harden and taken up by Simon (1957, 49 and Taf. 5.1), was later abandoned by Harden in favour of the idea that the vase had a flat, ring-base similar to that of the Auldjo Jug (Harden 1987, 57). The original pointed form of the vase was finally proven by Gudenrath's technical analysis (Gudenrath and Whitehouse, 1990, *passim*). The evidence given there is unequivocal.

History The discovery and remarkable history of the Portland Vase have been chronicled in some detail in recent years (Painter and Whitehouse 1990a; Jenkins and Sloan 1996, 187–91), extending even into the popular press (Brooks 2004), and the following account reiterates the important events in its story.

The vase was first recorded by Nicolas-Claude Fabri de Peiresc in 1600–1601 in the Palazzo Madama, the palace of Cardinal del Monte (now the Italian Senate), Rome. In continuous correspondence with other antiquaries of the time, Peiresc was fascinated by the Portland Vase, and letters, drawings and casts were passed between him, the Flemish painter Peter Paul Rubens and the Italian antiquary and draughtsman Cassiano dal

Pozzo. Cassiano dal Pozzo was secretary to Francesco Barberini, whose brother Antonio bought the vase from del Monte's heir after his death in 1626. The Barberini brothers were nephews of Pope Urban VIII, meaning that the vase, already held in high regard by scholarly circles, had passed into the hands of the most powerful family in Italy, where it was to remain for the next 150 years.

From the end of the seventeenth century the Portland Vase appeared in a number of printed books, which made it still more famous. Bernard de Montfaucon, for example, arrived in Italy in 1698 and spent three years collecting information and images for his monumental *L'Antiquité expliqué,* which appeared in five folio volumes in 1719 (followed by a five-volume *Supplément* in 1724) and contained an account of the vase.

As for the circumstances of its discovery, the story widely believed in the eighteenth century was that it was found in a sarcophagus in the Monte del Grano funerary monument, a few miles south-east of the old walled city of Rome (Painter and Whitehouse 1990e). The story was first told by P.S. Bartoli (1697) in his work on the ancient tombs and mausolea of Rome. The tomb was said to be that of the last emperor of the Severan imperial family, Alexander Severus, and the vase was supposed to have come from the sarcophagus, now in the Musei Capitolini in Rome (inv. no. 218). The fact that the sarcophagus was indeed found in the funerary monument in 1581 or early 1582 seems fairly certain, but the story that the Portland Vase was found in the sarcophagus is not now always so readily accepted. Haynes (1995, 151–2) sets out some very strong arguments for not seeing the tomb or the sarcophagus as the findspot of the Portland Vase.

By the mid-eighteenth century, if not before, there were few cultured Europeans who had not heard of the Portland Vase, or the Barberini Vase as it was then known. But the fortunes of the Barberini family were in decline. The last of the Barberini line, Donna Cordelia Barberini-Colonna, Princess of Palestrina, fell on hard times, supposedly after losing heavily at cards, and decided to sell the vase. James Byres, a Scotsman who had come to Rome in 1758 and acted as a guide to travellers, as well as being an architect, antiquarian and dealer, was a ready buyer and the vase was in his possession before 1782. Byres commissioned Giovanni Pichler, a gem engraver, or one of his brothers to make a plaster of Paris mould of the vase, and then asked his lifelong friend James Tassie to make

sixty casts from Pichler's moulds. These casts were initially, perhaps, made to attract purchasers for Byres' intended sale of the vase but were in fact available for the next fifty years. Seven of these still survive and the one that was owned by Tassie himself is in the British Museum (Painter and Whitehouse 1990a, 39 and n. 11, figs 24–7). Byres was, apparently, not only interested in the financial value of the piece. He also speculated on how the vase was made (the first person recorded to have done so).

Nevertheless, in the summer of 1782, as revealed in a letter (Jenkins and Sloan 1996, 187), he sold the vase for £1,000 to Sir William Hamilton, British ambassador to the court of Naples and an ardent collector of antiquities. Sir William, himself in financial straits, could only provide Byres with a bond, but in August 1783 he took the vase (evidently smuggling it out of the papal state) with him to London, intending to sell it. He was in touch with his niece, Mary Hamilton, who in November 1783 went to stay with Margaret, Dowager Duchess of Portland, who had a private museum of curiosities in London. Margaret became keen to buy the vase for her collection, and Mary Hamilton acted as go-between in the protracted and convoluted negotiations with her uncle (Painter and Whitehouse 1990a, 41–2).

By the middle of January 1784 Hamilton had finally agreed to sell Margaret the vase, together with four other antiquities, for 1,800 guineas (Haynes 1975, 10). However, not until June 1784 could she install it in her museum, as Hamilton had already agreed to lend the vase to the artist Giovanni Battista Cipriani to be drawn; copper plates for an engraving were then to be made by Cipriani's friend Francesco Bartolozzi. Hamilton read a paper on the vase to the Society of Antiquaries of London on 11 March 1784, where among his audience were notable public figures, and the vase remained in the public eye. Sadly, Margaret only enjoyed the vase for a year, as she died in July 1785, and the contents of her private museum were put up for sale. The vase, lot 4155, was sold on 7 June 1786 to a Mr Tomlinson, acting on behalf of Margaret's son, the third Duke of Portland, for 980 guineas.

Three days after the sale it was in the hands of Josiah Wedgwood, who probably advised the duke to buy it. It was, however, not until three years later, in the autumn of 1789, that the first successful copy was made, in Wedgwood's famous black jasper ware. When satisfied with his reproductions, Wedgwood started to

market his copies; but we do not know how many vases were made in this first edition or the names of all the people to whom they were sold. Subsequent editions were made in various sizes and finishes, and the popularity of Wedgwood versions has continued into the twenty-first century. There can be little doubt that, in terms of public awareness of the Portland Vase, the Wedgwood copies (see Dawson 1995, 112–225), perhaps more than anything else, are responsible for its fame. Nineteenth-century glass copies have already been mentioned (p. 14), and in the 1820s and 1830s several silver gilt versions of the vase, used as wine coolers, were made by the firm of Rundle, Bridge and Rundle, jewellers and silversmiths of Ludgate Hill, London (Clayton 1985, p. 453, no. 708).

The Portland Vase, as it was now known, suffered its first damage in modern times at the hands of the Duchess of Gordon (evidently Jenny of Monteith, the wife of Alexander, Duke of Gordon) when in the ownership of the third Duke of Portland (1786–1806). Perhaps to avoid similar domestic incidents, the fourth Duke of Portland deposited it on loan in the British Museum in 1810. It entered the Department of Antiquities that had been established three years earlier.

It was here that thirty-five years later, on 7 February 1845, it was shattered, together with its case, by a young man wielding a small stone antiquity that had been exhibited nearby. Painter and Whitehouse (1990a, 62–71) give a full and fascinating account of the breakage of the vase, the subsequent legal proceedings, the swift, skilful restoration of the vase by John Doubleday and the vase's eventual redisplay. The young man gave his name as Lloyd when charged, but a quirk in the law meant that he could only be fined for damaging the case. Lloyd was in fact an Irishman by the name of William Mulcahy, but the Trustees of the British Museum seem to have agreed with the Duke of Portland not to reveal his real name to protect his poor but respectable family. The smashing of the vase caused a sensation, and its vulnerability even led to a question being asked in the House of Commons (Hansard 1845, vol. 78, c. 783). In reply, the Prime Minister, Sir Robert Peel, reluctantly gave the answer that 'the law as it stood was confessedly defective, and that it afforded no protection for valuable works of art'. In September 1845, however, the vase was on exhibition again, restored to some semblance of its former glory by John Doubleday, the Museum's restorer, who was paid 25 guineas for his work. Now, for the first time the disc, which had served as the base of the vase, was displayed separately (Painter and Whitehouse 1990a, 69–71).

The loan of the vase to the British Museum was renewed by the fifth Duke of Portland; he died in 1879, by which time the Portland Vase was in the care of the British Museum's Department of Greek and Roman Antiquities, established in 1860. The Dukes of Portland continued to renew the loan, although the general public's interest in the vase seems to have waned. An interesting reflection of this can be seen perhaps in the markedly sharp decline in sales, in the early twentieth century, of postcards showing the vase (Painter and Whitehouse 1990a, 75). The vase then remained on loan to the British Museum until

1945, apart from the period from 1929 to 1933, when it was retrieved by the sixth Duke of Portland, who wished to sell it. The vase was put up for sale at Christie's on 2 May 1929 but failed to reach its reserve of £30,450, in spite of the interest aroused by press reports. The lowered opinion of the vase and its artistic merit was even shared by the then Keeper of Greek and Roman Antiquities, H.B. Walters. On the return of the piece from the auction house Walters went so far as to contemplate its removal from its old position of honour, citing its 'comparative unimportance from an artistic point of view' (Painter and Whitehouse 1990a, 76). The sixth Duke of Portland died in 1943, and in 1945 the vase was sold to the British Museum by the seventh Duke for £5,000. It was bought with funds bequeathed by James Rose Vallentin after his death in 1931.

Three years later thirty-seven small chips from the vase re-emerged and were registered separately from the vase and the base disc under the single number 1948,1018.1. These pieces, evidently not included by Doubleday in his 1845 restoration, were given to the British Museum by a Miss Reeve, executor for Mr G.H. Gabb, who had bought them from Doubleday's family, and this prompted the Museum to restore the vase again. The reconstruction of 1948, which took in some of these chips, was undertaken by J.H.W. Axtell and greatly improved the appearance of the vase. Forty years later the adhesive used in the 1948 restoration had become unstable, and it was decided to take the vase to pieces again. Restoration was carried out by Nigel Williams, assisted by Sandra Smith, and this gave us the Portland Vase that is now on display (Williams 1989).

Interpretations of the iconography Certain objects from classical antiquity attract endless attempts at interpretation, and this is certainly true of the Portland Vase, one of the most analysed and debated Roman antiquities in existence. In 1990 some forty-four interpretations of its decorative scheme, going back to the earliest recorded (1633) were listed by Painter and Whitehouse (1990b) in an extremely useful, tabulated format – with all the different interpretations in columns below the relevant figure.

Since 1990 there have been a number of noteworthy interpretations. Hind's revision (1995) of his earlier suggestions was the forty-fifth. In it he saw side A as the wedding of Peleus (**A**) and Thetis (**C**), with side B representing the wedding of Achilles (**E**) and Helen (**F**). Hind's interpretation relies very heavily on the use of several examples of a *rebus*. This device is the representation in a scene of an object, the name of which is a pun on the names of people or events associated with the scene. An example is the torch held by the reclining woman (**F**). Hind believes that one of the Greek words for torch, *elene*, reveals the identity (Helen) of the character holding it.

Daumas (1998) gives a mythological slant, proposing that the scenes on the two sides of the vase are in fact one and that they involve the legend and rites of the Cabiri. These were the mysterious deities, also known as the 'Great Gods', whose centre of worship was on the island of Samothrace in the northern Aegean.

More recently, Susan Walker (2004) suggests that the scenes may show the ill-fated love affair between Mark Antony (**A**) and Cleopatra VII (**C**) of Egypt on one side, with Augustus (**E**) and Venus (**G**) flanking Augustus' wronged sister Octavia (**F**), cruelly deserted by Mark Antony for his Egyptian lover, on the other.

The first ever recorded interpretation was made by Bernardino Capitelli in 1633. Born in Siena in 1589, he was one of the young artists working for Cassiano dal Pozzo, the secretary to the brother of Antonio Barberini, who had bought the vase in 1626 (see above). Capitelli suggested that the scenes illustrate the dream of Olympias, the mother of Alexander the Great (Painter and Whitehouse, 1990b, 172, no.1). Thus the young man emerging from the shrine is Alexander; the reclining lady (on both sides) is Olympias, his mother; and the snake is Jupiter, his father. Two years later Peiresc suggested a scene from the Iliad (Painter and Whitehouse, 1990b, 172, no.2).

Both Capitelli and Peiresc distinguish two linked scenes on either side of the vase, and this is common to nearly all interpretations, except for that of Haynes (1975, 1995), who was the first to argue that that the two sides represent a single scene. In the same way all interpretations follow the lead of Capitelli and Peiresc and fall into one of these two categories, history or mythology (though some interpretations blend historical and mythological characters).

HISTORICAL: The most plausible historical interpretation remains, we believe, that put forward by Painter and Whitehouse (1990c, 1991, 38–40). In this interpretation side A celebrates Octavian/Augustus, the first Emperor of Rome and the founder of Rome's golden age. The advancing male (**A**) is Octavian/Augustus himself, while the reclining female (**C**) who reaches out to him is his mother Atia, cradling Augustus' legendary father Apollo, in the form of a snake. Above them hovers Cupid (**B**) looking back towards Octavian. The scene is watched over by Neptune, god of the sea (**D**), one of the deities to whom Augustus attributed his naval victory at Actium in 31 BC. This sea battle, in which Octavian destroyed the fleet of Cleopatra and Mark Antony, confirmed Octavian as the ruler of the Roman world. If side A represents the ushering in of a new dawn for Rome, side B, it is suggested, marks the opposite, the beginning of the end for another great city, Troy. In this interpretation the central reclining female (**F**) is Hecuba, Queen of Troy. The seated figure (**E**) is her son Paris. Paris' understandable, though unwise, choice of Venus/Aphrodite as the most fair of the three goddesses Juno/Hera, Venus/Aphrodite and Minerva/Athena caused the Trojan War and the destruction of Paris' city. But the destruction of Troy led ultimately to the founding of Rome, through the descendants of Aeneas, refugees from Troy who finally made their home in Italy. The seated figure of Venus (**G**) looks on, the essential partner in Paris' unintentional sealing of his city's fate. On both sides of the vase, therefore, deities look on as events unfold of great importance for Rome and Troy. On side A Atia, the *materfamilias*, proudly brings forth her son, while on side B the despairing Hecuba turns away from hers.

MYTHOLOGICAL: The most persuasive interpretation based on mythology alone is, we believe, that laid out by Walters (1926, 376–7) and most recently and coherently expounded by Haynes (1975, 1995). In contrast to most other interpretations, both historical and mythological, which see two different scenes (though occasionally loosely linked in some way), Haynes argued that the two sides made up one continuous scene. The advancing figure (**A**) in this interpretation is Peleus, the mortal who married the sea deity Thetis, identified by Haynes as the seated female (**F**) in the centre of side B. These are to be the parents of Achilles, the Greek hero who led the Greeks to victory over Troy.

Peleus is encouraged to go to Thetis by Cupid (**B**) and by the reclining female (**C**), who is identified as either Thetis' mother Doris or her grandmother Tethys. Central to this interpretation is Haynes's identification of the creature cradled by **C** as a *ketos*, or sea serpent, providing as it does a suitably marine link to the sea deities shown. Watching that part of the story shown on side A is the standing male (**D**), to be identified, according to Haynes, either as Nereus, Thetis' father, or Oceanus, her grandfather. The continuation of the decoration on side B shows Thetis (**F**) flanked by the seated figures of Mercury (**E**), who attended the wedding of Peleus and Thetis, and Venus (**G**), who plays an obvious role in overseeing the love between the two.

Problems of the historical and mythological interpretations Both the interpretations described have very strong points, but neither is above criticism. Regarding the historical interpretation, there are some who think that the young man does not perhaps immediately convince as the young Augustus (Octavian). In the highly stylized, classicizing art of the Augustan period, there is a danger in identifying Augustus too readily (Haynes 1995, 148). As for the identification of the reclining woman (**C**) as Atia, the mother of Octavian/Augustus, this is problematic, not least because no portrait of her in any form is known so far. By the same token, of course, identification as Atia cannot be categorically ruled out. The identification of the reclining woman as Atia depends on identifying the creature she cradles as a snake rather than a sea serpent (see below).

Turning to the mythological interpretation, it is perhaps surprising to note that, with the exception of Bacchus/Dionysus and related mythological figures such as Ariadne and Silenus, there are remarkably few definitely identifiable deities on cameo glass. It is reasonable to assume that, if we are correct in identifying the figure on the base disc of the vase as Paris at the contest of the goddesses (**34**), then those goddesses (Juno, Minerva and Venus) should also have appeared originally on the plaque before it was cut down. But these representations are exceptional.

Iconographically, one of the strongest objections to Haynes's interpretation (the marriage of Peleus and Thetis) is its very great dependence on the identification of the serpent cradled by the woman (**C**) as a *ketos*, or sea serpent. As Painter and Whitehouse argued (1990c, 133), serpent iconography was not set in stone in Roman art (or literature), and if the

serpent were not a *ketos*, then it would cease to have the immediate link with the watery heritage of Thetis and her family. This is clearly a crucial point, as Haynes's argument stands or falls largely on the identification of this creature. Much, therefore, of Haynes's reply (1995) to Painter and Whitehouse deals with bolstering the identification of the serpent as a *ketos*.

Haynes's idea that the narrative on both sides of the vase is united, not just linked, is also questioned by Painter and Whitehouse (1990c, 133), who point out that both sides cannot possibly be seen at the same time. Haynes (1995, 150, n. 26) again defends his argument, citing the unified narrative of various Greek vases and the cameo glass Getty skyphos (1990d, 143–5, A4 and figs 100–101). Painter and Whitehouse (1990c, 133) suggest that the decorative field is 'firmly divided by the masks and handles'. Perhaps, but the vessel, after all, had to have handle supports, and their function was not to interrupt narrative, but to allow the handles to be joined to the body. They had to be somewhere. Such handles are not always decorated, for example the plain attachments of the Blue Vase (Lierke 1999, 72, figs 180–81).

As for the subject of the masks, widely identified as Pan, they need have no particular relevance to the story of Peleus and Thetis, but likewise they might not have any particular relevance to Augustus or Paris. Masks of Pan would, however, provide a link with the Bacchic theme that is so prevalent in the decoration of cameo glass. From examination of the majority of extant cameo glass it is clear that masks of Pan are common, for example on the Getty skyphos (Lierke 1999, 72, figs 178–9) and fragments in the Römisch-Germanisches Museum, Cologne (N. 6243a), and The Metropolitan Museum of Art, New York (11.91.5b). But, as suggested by Haynes (1995, 151, n. 30), this need not necessarily influence in any way the interpretation of the decorative scheme. In the case of the Portland Vase they are ornate and finely carved, befitting such a fine vase and enabling attempts to identify the characters depicted – something that is not possible with some other pieces. We would argue, however, that these handle terminals are no more significant than on any other item of cameo glass.

Both interpretations, the birth of Augustus and the marriage of Peleus and Thetis, would seem to fit very well with the spirit of the Portland Vase and the period in which it was made. Such a scene suits the general celebration of Greek culture and mythology in Roman art, especially during the reign of Augustus, and both interpretations link with the aetiological mythology of the birth of Rome and the death of Troy. Troy, after all, was the place from which Prince Aeneas and his followers fled before crossing the Mediterranean to Italy, where one of his descendants, Romulus, founded Rome.

In the context of either interpretation (and of course they are just as open to criticism as some of the other serious interpretations), the identification of the young man shown on the base disc as Paris (for fuller discussion of the disc, see **34** below) is particularly interesting. It was Paris who had to choose the 'most fair' of the three goddesses Venus, Minerva and Juno,

following events at the wedding of Peleus and Thetis, and, by so doing, unwittingly triggered the Trojan War. Assuming that the choice of the Paris motif was not casual, then this would greatly reinforce the idea that the Trojan War and what ultimately arose from it, namely the pre-eminence of Rome, is celebrated on the vase.

Materials and technique When Nicolas-Claude Fabri de Peiresc, a French antiquary, first recorded the vase in the collection of Cardinal del Monte in Rome during the winter of 1600–1601 (Painter and Whitehouse 1990a, 24), he recognized that it was made of glass (it was generally thought to be of agate until the mid-eighteenth century). However, even Peiresc seems not to have fully understood how the vase was made, describing it as an 'enamelled-glass vase' in other letters. A similar description was applied to the second Roman cameo glass vessel that came to light, also in or around Rome: the Seasons Vase (Whitehouse 1989). This is a deep blue bottle with an opaque white overlay carved with representations of the *Horae* (Seasons). In 1633 the figures were said to be 'en camahieu d'esmail blanc' (in white enamel cameo). These descriptions suggest that the supposed technique involved painting the surface with enamel (see Gudenrath 2006). The failure of the Renaissance artists and academics to understand that the ornament was achieved by cold working may account for the absence in Renaissance and early modern Italy of any attempts to produce cold-worked cameo glass. It is, nonetheless, conceivable, even likely, that the surfaces of cameo glass vessels were thoroughly cleaned and 'tidied up' after their rediscovery. But some have taken this idea much further.

Renaissance masterpiece? In 2003 Dr Jerome Eisenberg published his theory that the Portland Vase was not a Roman artefact but, rather, a product of the Renaissance. He based this on the iconography, emphasizing that the figures were all curiously devoid of any of the attributes that, in most other contexts in Roman art, would allow us to identify those figures with certainty. He later reiterated this point (Eisenberg 2004), suggesting that such undifferentiated figures would have been more acceptable to the great religious families of Renaissance Rome (the likely owners of the vase): 'Narrative depictions were not associated with paganism and would have been more acceptable to the papal families and thus to Cardinal del Monte, the owner of the vase at that time' (i.e. the later sixteenth and early seventeenth centuries).

A reply from David Whitehouse (2004) definitively answers, we believe, Eisenberg's points and refutes once and for all the idea of a Renaissance origin. An initial important point involves possible copies of chance finds of Roman cameo glass. As we would all agree, it is extremely unlikely that a Renaissance glassworker, having discovered the beauty of cameo glass carving, would have stopped at one piece. Yet Whitehouse underlines the complete and utter absence of any complete vase or fragment of cameo glass that can be dated to the Renaissance, either from among pieces in museums and private collections or amongst archaeological material. Extensive

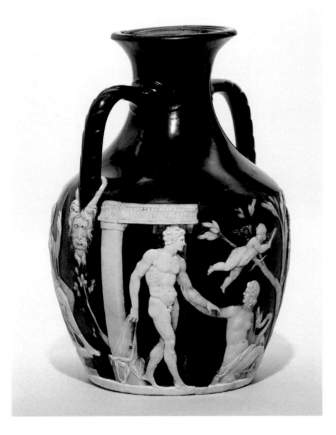
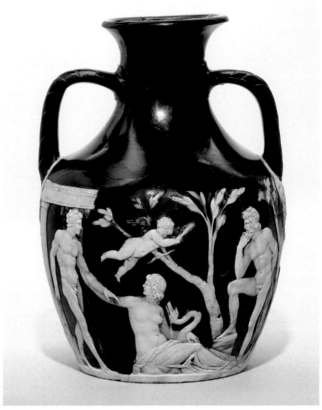

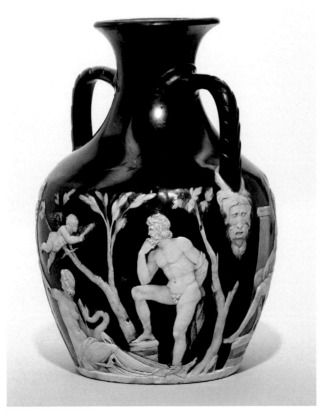
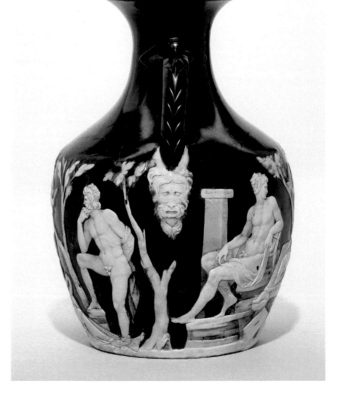

Above and opposite: Eight views of the Portland Vase.

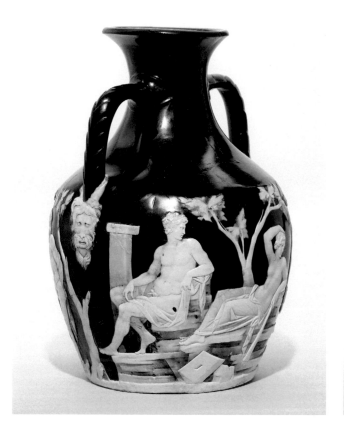
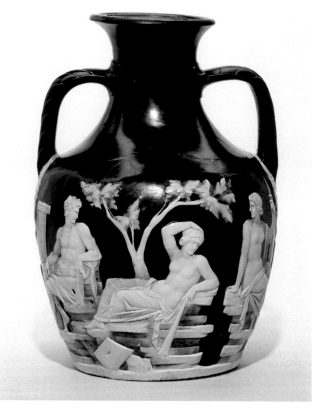
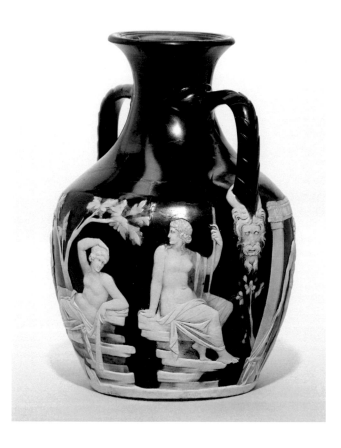
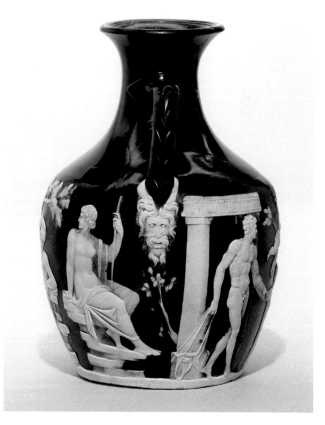

Catalogue: Closed-form vessels

Details showing the heads of figures **A–G** on the Portland Vase and (*bottom right*) that of the figure on the Portland Vase disc (**34**).

Mask between figures **D** and **E** on the Portland Vase.

Mask between figures **G** and **A**.

Reconstruction of the Portland Vase with a pointed base (drawing by Pamela Becker).

Fragments of the Portland Vase (watercolour by T. Hosmer Shepherd, 1845).

study and compilation of data from these sources should surely by now, he argues, have revealed some trace of Renaissance cameo glass vessels or plaques if they existed.

Turning to science, Whitehouse cites a crucial reason for the Roman date of the Portland Vase, namely the composition of its white and blue glasses. Soda, lime and silica are the primary ingredients of glass that are common to both the Roman world and the Renaissance. But Roman glass uses natron (a naturally occurring salt from several sources, but principally Egypt) as the source for its flux, whereas the Renaissance generally used plant ash, which contains much higher quantities of potassium and magnesium. Whitehouse cites articles by Bimson and Freestone (1983) and Freestone (1990), which give statistical data proving beyond all doubt the Roman nature of the constituent parts of the glass.

Ian Freestone's scientific analysis of fragments of the white and blue glass in the 1980s had, by 1990, already led him to state with some certainty that 'suggestions that the vase may have been the product of a Renaissance workshop' were 'most improbable' (Freestone 1990, 104). This research has proven that the potassium and magnesium levels for the white and blue glass of the Portland Vase were relatively low, i.e. that they were the product of natron, as used in Roman period glass. These levels matched perfectly results from other pieces of Roman cameo glass including samples from the Auldjo Jug, discovered at Pompeii in the early 1830s and therefore unknown to the Renaissance world. A synopsis by William Gudenrath of Freestone's conclusions from his detailed analysis of the glass composition of the Portland Vase, Auldjo Jug and other pieces can be found elsewhere in this volume (Appendix I).

One of Eisenberg's major hypotheses (2003, 40) was that a Renaissance master 'could have found an unfinished or damaged ancient cameo glass vase … stripped off most or all of the outer white layer … and reapplied another'. To which Whitehouse replies that, in theory, a cameo vessel could have been discovered largely intact and the white glass removed (though if the vessel were broken such removal could have had very damaging consequences), but the glassmaker would then have had to reapply a layer of white glass – with all the enormous technical difficulties this would have posed.

Perhaps the most serious problem would have been the tendency of the blue glass of the vase body to become almost unworkably soft at 500 degrees centigrade, while still needing (in Eisenberg's scheme) to come into direct contact with the white glass that was at nearly 1,100 degrees. There is the added complication that the 'Renaissance' maker of the piece would have had to think to use white glass with natron as its flux, in Roman style, even though he could not possibly have known about the presence of natron. Unless a ready supply of ancient white glass were available (plausible, but even if it were, the glassmaker would have had the same insurmountable problems of applying the white to the blue), he would certainly have used contemporary white glass made with plant ash.

A decisive point against Renaissance manufacture is Gudenrath's thorough

examination of the disposition and shape of bubbles in the glass (Gudenrath and Whitehouse 1990, 108–11), and his observation that the white overlay and the blue glass beneath it must have been given their final form simultaneously. Furthermore, Gudenrath's discovery in 1989 (Gudenrath, Painter and Whitehouse 1990, 19, n. 2 and fig. 9) of the remains of the lower frieze of decoration poses more problems for a Renaissance origin. Eisenberg must, by his argument, necessarily argue that this lower band was made in the Renaissance, but if so, the vase must have been broken during the Renaissance and then repaired using the disc. This must presuppose the existence during the Renaissance of a plaque that could provide the disc. There is no mention of such a plaque, nor indeed is there any mention of the discovery of a 'blank' or recarvable vessel to form the body. Yet surely both such pieces would have been well known and celebrated at the time, just as the Portland Vase and the Seasons Vase, now in the Bibliothèque Nationale de Paris, were? The idea that the disc base could have been cut down in the Renaissance from a large plaque that had somehow survived is extremely unlikely for two main reasons. First, any plaque that had survived or been discovered in the Renaissance would have been well known and thought a masterpiece in its own right, like the Carpegna plaque, now in the Musée du Louvre, Paris. Eisenberg himself states (2003, 40) that the disc is 'unquestionably a Roman work of the first half of the 1st century AD and was set into the vase at a later date, either in the first century or perhaps even in the 16th century'. We can be fairly sure that the disc was performing its role as the base of the vase in the Roman period, not least because there are weathering deposits on both the surfaces *and the edges* of the disc, which show that it was in its present shape and size before deposition.

It is very likely that in the Renaissance there were other fragments of Roman cameo vessels available in addition (we would argue) to the then recently unearthed Portland Vase. Ogden (2004, 21) mentions how Vannoccio Biringuccio, a Siennese metallurgist in the first half of the sixteenth century, saw what sounds remarkably like fragments of cameo glass vessels, including one bearing the head of Medusa with undercut hair and serpents, and adds: 'When Renaissance craftsmen or their patrons were intrigued by ancient works of art, an attempt to copy usually followed.' If we exclude the Portland Vase, then where are these copies? The answer must surely be they were never made, because even the great craftsmen of the Renaissance could not crack the secret of manufacturing cameo glass. The conclusion seems inescapable that the blank for the Portland Vase and the finished vessel itself were made, in their entirety, in the Roman period and not in the Renaissance.

Artistic context of historical allegory and influences from other media One of our preferred interpretations of the iconography is that the decoration of the vase is a historical allegory of the rise of Rome. Such an interpretation (i.e. that the vase shows, at least in part, historically attested characters) should ideally be supported by other instances of historical narrative on comparable pieces.

On silverware such imagery is surprisingly rare, a point that Kuttner (1995) underlines in her thorough analysis of two silver cups from Boscoreale near Pompeii (now in the Louvre, Paris). These certainly show historical personages, namely the Emperor Augustus, his stepson the future Emperor Tiberius, and Tiberius' brother Drusus. Kuttner (1995, 5, pls 13–16) presents the scenes on the two cups. Side A of the first cup (BR1) depicts the bestowing and confirmation of Augustus' control of the known world. Augustus, seated, is surrounded by deities including, on the right, Roma, the personification of the eternal city; Cupid, god of love; and Venus, mother and protectress of the city. On the left Mars, god of war and patron of Rome, strides forward bringing personifications of Rome's provinces, including Africa, Asia and Gallia. On side B is the elder Drusus, Augustus' stepson and Tiberius' brother, who is shown encouraging bearded, Gallic chieftains to make their children wards of Augustus. On side A of the second cup (BR 2) Tiberius makes sacrifice before his Germanic campaigns, while side B shows him in his chariot, taking part in the great triumph that he celebrated after his victorious return.

Here, then, is the same mix of real and mythological characters as can perhaps be seen on the Portland Vase. These are explicit depictions of real people, almost certainly made when the people concerned were still alive. But to what extent are these exceptional in silver tableware and would we expect to see the same themes also in cameo glass?

There are other, more allegorical or less explicit historical representations in silverware. A silver dish from Aquileia, northern Italy, now in the Kunsthistorisches Museum, Vienna, AS VII.A.47 (Kuttner 1995, 28 and fig. 17), may be one of the prototypes for the Roman imperial pieces that followed. The dish shows Mark Antony, the Roman general and lover of Cleopatra of Egypt, in heroic stance as the mythological character Triptolemus. The silver cups from Hoby, Denmark, portray allegories possibly recalling the power and status of the Emperor Augustus and of Rome (Birolli Stefanelli 1991, 256–7, nos 26 and 27, and figs 89–90).

Another possible example is the identification, according to Mastroroberto (2006a, 38–42, 237, figs 410–11), of Mark Antony and Octavian in the two busts shown on the Egyptianizing silver cups from Moregine, near Pompeii. Even if correct, the identification hardly renders the scene an account of a historical event. On the other hand, the decoration on the scabbard of the 'Sword of Tiberius' in the British Museum (1866,0806.1, Bronze 867) shows a moment of history, with Tiberius rendering to his stepfather Augustus a victory in battle, perhaps the same German victory celebrated on the Boscoreale cup. But this is armour, not tableware, and is arguably not a very relevant comparandum for cameo glass.

Looking at another of the main sources of comparable iconography for cameo glass, namely the fine moulded pottery of Arezzo, we find the picture is even more limited. Kuttner (1995, 3 and figs 65–7) points out that the appearance of historical or potentially historical figures on Arretine pottery is very

rare indeed. She cites only two examples of Arretine bowls with similar decoration, namely a heroically nude *imperator*, a supreme military commander who in the imperial period was nearly always the emperor himself. The *imperator* stands by a trophy of victory, made up of arms and armour, taken from the defeated army, and is approached by the personifications of two provinces (Germania and Armenia). The maker's stamps on these pieces name L. Avillius Sura, dated by Kenrick (2000, 158, no. 406) to 10 BC–AD 10. The *imperator* in this instance, if he were the same person as the emperor, would be Augustus himself.

Another fine art form, comparable to cameo glass in that both employed conscious carving of the surface, is cameo-cut hardstone (see above, pp. 18–19). Painter and Whitehouse (1990c, 135–6) discuss examples that may carry historical allegory or even outright historical depiction. The Tazza Farnese, now in the Museo Archeologico Nazionale di Napoli (La Rocca 1984), came originally from the Farnese collections formed in Rome. Painter and Whitehouse suggest that it may be the keepsake (the only one) taken by Augustus from the treasury of Cleopatra after the queen's suicide in 30 BC (Suetonius, *De Vita Caesarum – Divus Augustus*, 71; Painter and Whitehouse 1990c, 136, n. 37). It is widely held to represent Cleopatra as Isis. The only problem with this interpretation is that Suetonius explicitly tells us that the vase that Augustus took was made not of hardstone but of *murra*. *Murra* has now been identified, beyond reasonable doubt, as fluorspar (Williams 2004), a banded semi-precious stone that, though beautiful, is quite soft and not good at holding fine carving. Painter and Whitehouse name other hardstone pieces that have tentative historical identifications, but there are few of them and, as Painter and Whitehouse (1990c, 136) concede, 'none of these objects can have been created to be seen by the populace at large, and it is likely that they were owned and admired exclusively by the imperial family and their immediate circle'.

In cameo glass, however, the other vessels and fragments show no convincing evidence of any representation of a historical nature. There are recognizable portraits of actual personages in cameo glass medallions, for example the Octavian in The Corning Museum (Whitehouse 1997, 42, no. 37; 70.1.16) or the probable image of an imperial prince (perhaps Germanicus, the son of Drusus and the grandson of Augustus) in the British Museum (see below, **62**; 1868,0501.926). But these stand out precisely because of the intentionally recognizable nature of their subject and the particular form (small oval plaques, functional as ornaments or jewellery) on which they appear. To the knowledge of the authors no other piece of cameo glass shows a demonstrably historical event. The Portland Vase is of course an exceptional piece in many respects – of this there is no doubt – and, if we are to assume that it alludes to a particular moment of imperial history, it would also be unique amongst all known cameo glass in its iconography.

We do not rule out that the Portland Vase could show some form of historical allegory, in this case the rise of Augustus, and indeed it is one of our preferred interpretations. As noted above, there were of course certain types of art, medallions, cameos and so on, that were specifically designed to help the individual express very visibly their pride, loyalty or celebration of those historical people or events. But this doesn't seem to appear at all frequently in fine tableware. It is perhaps worth bearing in mind Kuttner's cautionary words (1995, 2) that 'literal historical narrative … was not the usual province of any luxury art'. Suggestive allegory, however, may be a possibility for Roman cameo glass.

Findspot and original owner As mentioned above, pp. 35–6, the account of the discovery of the vase in a sarcophagus in the tomb known as Monte del Grano is now considered by some to be very unlikely (Haynes 1995, 151–2). First, there are detailed (for the time) accounts of the discovery of the tomb and its contents in which the vase simply does not feature. Second, the vase supposedly contained ashes – a strange discovery in an inhumation sarcophagus. Nevertheless, although its iconography is still controversial, the Portland Vase has enormous power, even in its damaged condition. With a leap of the imagination we can begin to see how stunning the piece was when intact, and this raises the question of the owners of cameo glass in general and the Portland Vase in particular.

There is considerable variation in the quality of the forms and carving of cameo glass. However, the small (in absolute terms) quantities of cameo glass that remain suggest that it was a fairly rare and prestigious commodity. A piece such as the Portland Vase or the Blue Vase would have been even more so. Painter and Whitehouse (1990c, 136), in an attempt to guess at the first owner, start from the undeniable accomplishment of the piece, and then bring in the historical interpretation of the decoration. Unsurprisingly, they consider the piece to have belonged to one of the elite of Roman society and trace the ownership to the very highest element of imperial society, the Emperor Augustus himself.

In terms of the pure form of the vase and not its decoration, there are no close parallels for the original form of the Portland Vase (i.e. with pointed base) in fine pottery and none in glass, other than the Blue Vase in Naples. In metal, however, there are some possibilities. A pair of silver amphorae from Pompeii (Guzzo 2006, 80, nos 1 and 2, inv. 111768, 111769) are comparable in size and have the same body form but taper to a restricted flat base, rather than a point or button. Two bronze vessels, though intentionally flat-based, have a remarkable similarity to the Portland Vase in their general proportions, details and dimensions, including the position and formation of the handles and the incisions along them (Tassinari 1993: I, 175, no. 3618 and tav. XLIX 5 and 6; II, 4; I, 272, no. 3128 and tav. XLIX 1 and 2; II, 5). On a much smaller scale a silver pepper pot from the House of the Menander, Pompeii, has a form similar to that of the Portland Vase (Stefani 2006a, 222–3, no. 389). A fragment of a small bottle in The Corning Museum of Glass (66.1.63; Whitehouse 1997, 57, no. 58) has an upper body and handles that are reminiscent of both the Blue Vase and the Portland Vase, though much smaller. It is possible that it, too, may have terminated in a similar fashion.

Gudenrath (Gudenrath and Whitehouse 1990, 108, 110–18) shows that the Portland Vase was made using the dip-overlay method: this involved inflating a gather of blue glass adhered to the end of a hollow metal blowpipe, and then dipping the lower portion of it into a crucible of opaque white glass. The decoration was achieved by carving away the opaque white glass when cold, using traditional lapidary techniques. For a full discussion of the process of making glass cameo blanks, see pp. 25–31.

Bibliography Walters 1926, 376-8, no. 4036; Simon (1957); *Journal of Glass Studies*, vol. 32 (1990); Dawson 1995; Jenkins and Sloan 1996; Walker 2004; Brooks 2004; Haynes 1995; Hind 1995; Daumas 1998; Eisenberg 2003 and 2004; Whitestone 2007, 116–17, 121–33

2
The Auldjo Jug

1859,0216.1; 1840,1205.41 (base)
H. (body) 18cm, H. (inc. handle) 22.8 cm, D. (body max.) 14.3 cm, D. (base) 7.8 cm; weight 0.676 kg.
Found between 1830 and 1832 at Pompeii, perhaps in or near the House of the Faun; bequeathed by Miss M.H.H. Auldjo, reunited with the base bought from Dr Hogg in 1840. The other fragments that would fill the gaps are currently not located. Some were reported as remaining at Naples in the Museo Archeologico Nazionale (Parliamentary Reports 1859, 13), but attempts to find any such fragments have so far proved unsuccessful.
About 15 BC–AD 25

Glass The vessel is made of translucent, dark blue glass overlaid with opaque white. For full discussion of the two glasses see pp. 30–31. There is milky-white weathering film, becoming brown in patches, covering the exterior of the vase and the interior of the mouth and neck. The white glass is worn away in places. There are small bubbles in the blue glass, in the white glass and at their interface.

Fragment/form The vessel is a jug with a double-lobed mouth and a high-arched handle from the rim to the shoulder. The back of the neck is flattened and the shoulder slopes outwards to a fairly sharp carination marked by a white ground line; the body is ovoid but quite squat and angular, with a fairly straight wall and another sharp carination taking the lower wall to a ring-foot with moulded rim. The handle has an angular, squared section, with two wide vertical grooves running along its length and a ridge at its base.

The jug has been broken and mended from several fragments, so the body is now considerably restored. Much of the centre of the body is missing, including most of the area at the back below the handle. The remaining parts of the upper and lower body join by means of a 'bridge' only 3 cm across. The frontal lobe of the mouth is largely broken away at the front, but the neck, handle and base are mostly complete, though with some chips to the base.

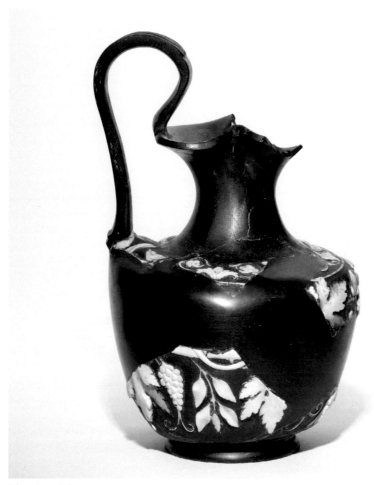

2 (see also p. 24)

Decoration Shown in white on the shoulder is a band, approximately 2 cm wide, comprising acanthus leaves and tendrils enclosing rosettes. Between these vertical motifs birds peck at the tendrils. Two birds are perched either side of the handle pecking at leaves(?) now mostly missing. On the body is a finely executed vine laden with bunches of grapes and intertwined with laurel and ivy with umbrels (ball flowers of the ivy plant). In the centre a bird, with wings raised, perches to peck at an ivy leaf. A narrow white horizontal rib divides the shoulder from the body and also acts as a ground line for the decoration on the shoulder.

Comment/history The Auldjo Jug is always thought to have been found in the House of the Faun, Pompeii, excavated between 1830 and 1832, along with other houses in the area (Regio VI). However, in the publication by Fiorelli of the excavation diaries of that period in the *Pompeianarum Antiquitatum Historia* (*PAH*) there is no evidence linking the jug to the House of the Faun. The piece is outstanding by any criteria, unusual enough to warrant royal attention (see below), yet there is no record of its discovery in the official published records.

The first conscious description of the vase was in 1836, when Heinrich Menu von Minutoli, the Prussian traveller and antiquarian, wrote of the vase he had seen in 1834 (after Harden 1983):

The present owner obtained about half the vase, a lady has another important part, given to her by a high-up person, and some unimportant pieces lay unnoticed in the

ruins or were mislaid, since the present owner did not obtain them. He has, however, joined most of the pieces together and had the gaps restored by a skilled draughtsman.

So which pieces did the 'present owner' and the 'lady' possess? Of the two major pieces that make up the now reconstituted vase in the British Museum, the upper part comprises one large sherd with neck and handle and one, possibly two outliers. The lower part is an amalgamation of several pieces. The 'previous owner' must, therefore have been the owner of the base, the 'lady' being the owner of the neck and handle.

Who exactly were the 'present owner' and the 'lady' and how did the pieces come into their possession? It is perhaps useful here to recall the ultimate owners of the pieces before they were reunited in the British Museum. In 1840 seven fragments (registered together as 1840,1215.41) comprising the base and lower body of the jug were sold to the British Museum by a Dr Hogg. In 1859 the neck and the handle were bequeathed to the British Museum by Miss Madeleine Auldjo. Yet how do the fragments of the vase connect with Dr Hogg and Miss Auldjo?

An entry in *PAH* (II, 275) begins to shed some light. On 11 June 1833 'L'Altezza Sua Reale ha voluto entrare nel maggazzino riservato ove si conserva gli oggetti antichi e ne ha fatto una scelta di essi, come si nota qui sotto nel notamento' (His Royal Highness [Charles, brother of King Ferdinand II of Naples] wanted to enter the closed storeroom where the

ancient artefacts are stored and made a selection from them, as is noted here in this note below). As well as bronze vessels and figurines and some pottery vases, he chose some pieces of glass, one of which was 'una bocca di nasiterno con manico, il tutto di colore blu con ornati bianchi' (the mouth and handle of a *nasiterno*, blue in colour with white decoration). The term *nasiterno* was used by archaeologists to describe lobed-mouth jugs.

Interestingly, there is no mention of the findspot of this piece, but there is a findspot given to pieces of marble (mosaic?) that the prince also took. The provenance was the House of the Faun. Close scrutiny of the entries in the *PAH* relevant to the discovery of the House of the Faun reveals no mention of anything remotely like the Auldjo Jug – whether base or neck. This seems strange, given that door fittings, simple glass 'lagrymatoj' (i.e. *lachrymatoria*, or perfume bottles) and even nails are usually mentioned in the list of objects found.

The absence of any mention of the Auldjo Jug (or its fragments) is even more frustrating, given that the cameo glass patera now in Naples (MANN, inv. 13688; Painter and Whitehouse 1990d, 153–4, no. A9; Asskemp *et al.* 2007, 257–8, no. 6.39 and 162, fig. 1) is unmistakably mentioned in *PAH* (II, P.264 3–9) in November 1832: 'Altrove si e rinvenuto un pezzo rotto di una bella patera sul quale in bassorilievo osservasi un ramo ravolto a serto con foglie e frutti, nonche una piccola testa faunesca, colorita in bianco ed il fondo di colore celeste' (Elsewhere was found a broken piece of a beautiful patera on which can be seen in relief branches formed into a wreath with flowers and fruit, as well as the little head of a faun. The patera was made of white glass on a mid-blue background). Yet there is no sign of anything of this type in the records of the House of the Faun.

So in June 1833 the neck of the Auldjo Jug was taken out of its storeroom by Prince Charles, brother to King Ferdinand. In the same year John Auldjo published a volume entitled *Sketches of Vesuvius* (Longman, London). The volume was dedicated to His Royal Highness Charles, Prince of Capua, the same Charles who had taken the pieces (including the neck of the jug) from the storeroom in Pompeii. It is worth noting that the dedication shows that John finished the work in May 1832. It is tempting to see some form of aristocratic gift exchange linking the book and the neck of the jug.

This opinion is shared by John Auldjo's biographer Peter Jamieson (2009, 136): 'It was some time after Auldjo's return to Naples in August 1833 that a remarkable antiquity came into the hands of the Auldjo family at Villa Farina.' From discussions with Jamieson it seems very likely that, had John received the neck of the vase, he would almost certainly have passed it on to his brother Thomas and Thomas's wife Anna Maria (Annie), who were both, unlike John, collectors of antiquities and curios. Whatever the sequence of events, and even if the neck and the book were not part of such a formal exchange, it is clear that, assuming one of the Auldjo ladies to be the lady who had 'an important part of the vase', Annie seems to be the most likely. There can be little doubt that the 'high-up person' who gave her the piece was (directly or indirectly) Charles, Prince of Capua.

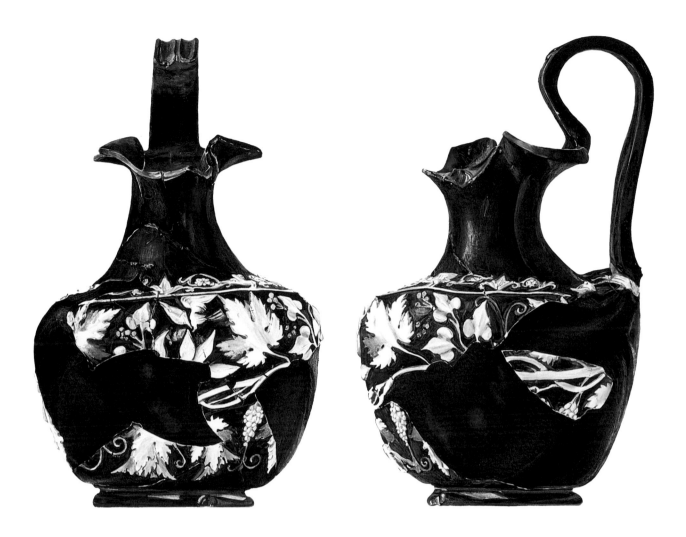

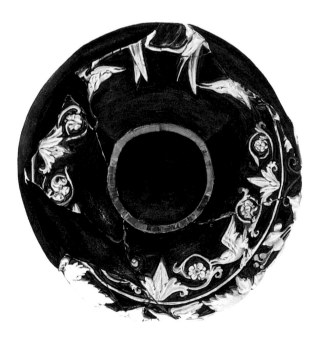

The front, side and top (without handle) of the Auldjo Jug (watercolours by Kate Morton).

The Auldjo link with the neck through Prince Charles seems now quite clear. But what of the fragments sold to the British Museum by Dr Hogg in 1840? The first step in trying to understand the story is to ascertain the identity of Dr Hogg. In all the original documentation held in the British Museum, including the Minutes of Trustees meetings and the departmental registers, the name that appears is simply 'Dr Hogg'. At some later point the initials 'J.B' have been added in a different hand to the departmental registers, yet exhaustive research of all original files and documents has failed to find any corroboration for this change. So all we know of our vendor was that he was, emphatically, a doctor.

Jamieson (2009, 99 and 136) suggests that Dr Hogg was Edward Hogg MD, physician, traveller and classicist/Egyptologist (Bierbrier 1995, 205). Sir William Gell's reminiscences (1957) of Sir Walter Scott's stay in Italy in 1832 mention Hogg on several occasions as part of Scott's group (Gell 1957, xix, 15, 17, 21) and state that Hogg was ultimately responsible for safeguarding Gell's manuscript (1957, xxi). During his time in Naples, Scott was treated like royalty by the Italian literati and was all but mobbed by adoring students when he visited the Archaeological Museum in the city (Willis 1835, iii, 97). Scott also visited Pompeii at least twice during February and March 1832 with Gell, a classicist and archaeologist, and also at least once with Dr Hogg (Anderson 1998, 785–6). Interestingly, the highlight for Scott was his lengthy examination of the newly excavated 'Alexander Mosaic' in the House of the Faun (now in the Museo Archeologico Nazionale di Napoli, inv. 10020), which had been discovered only six months before (Gell 1957, 8).

Veronica Tatton-Brown, in an earlier draft of this catalogue, suggested another candidate for Hogg, namely John Hogg (1800–69), who was an English scholar, naturalist and a fellow at Peterhouse, Cambridge. He published many papers on botany and natural history, including a catalogue of Sicilian plants, and also wrote on archaeological subjects, notably Egyptology. It is interesting to read a contemporary account of the purchase of the base: 'Mr. Hawkins [Keeper of the Department of Antiquities] reports that Dr Hogg has consented to accept £30 for the fragments of the beautiful glass vase in his possession and £20 for the Egyptian Antiquities which he permitted to be sold from his collection' (British Museum Department of Antiquities Report respecting Offer for Purchase 26 day of Nov. 1840). This short but informative report tells us that the base was bought from 'Dr Hogg' for the low sum, even for the day, of £30 and also that it was accompanied by several Egyptian artefacts.

Although both John Hogg and Edward Hogg were interested in antiquities and Egypt, we have no record of a collection of antiquities being kept by John Hogg. Edward Hogg, however, was certainly a collector. He had travelled in the Near East and Egypt in 1832–3, just after his time in Naples with Walter Scott. He definitely collected antiquities as he travelled, as a passage in his travel account (Hogg 1835, 310–11) refers to his purchases of artefacts in Egypt. It is also clear from the same passage that he kept in touch with William Gell, a firm friend (Gell 1957, xxi), and others at

Naples, as well as possibly the Auldjo family and maybe even the Neapolitan royal court.

Perhaps the problem over the identity of the different Hoggs can be resolved through examination of their titles and initials. The Oxford Dictionary of National Biography (web resource) charts the career of John Hogg. But this most thorough of biographies makes no mention of a second initial, so the 'B' of J.B. Hogg is a mystery. Moreover, in 1840, when the base of the vase was sold, John Hogg had assumed his post as by-fellow at Peterhouse with the qualification of BA. In 1844, four years after the base was sold, he became an MA at Oxford, but at no time during his career did he receive a doctorate. Edward Hogg, on the other hand was a qualified physician – 'Edward Hogg M.D.', as he titles himself on the frontispiece of his 1835 publication. The balance of probability, we believe, suggests that Dr Edward Hogg, physician, antiquarian and traveller, was the owner of the base of the Auldjo Jug.

We would also suggest that Dr Edward Hogg was 'the present owner' of (part of) the vase in 1834, as described by Menu von Minutoli (1836). Was the reason for von Minutoli's vagueness perhaps the fact that possession of the piece had come about in an unorthodox way?

Edward Hogg travelled with Scott (Gell 1957, 15, 17, 21) and was almost certainly with Scott when he visited Pompeii. Scott's gazing at the Alexander mosaic took place in the House of the Faun, the supposed provenance for the Auldjo Jug, and it is clear that the whole area around it was undergoing 'excavation' at the time. Could Hogg, or even the idolized Scott himself and sometime thereafter Hogg, have come into possession of the lower part of the jug during one of these visits or at another point during their stay in Naples? This would have left only the upper part of the jug to go into the storeroom, from which the prince retrieved it. He may not have been pleased if he had known that the other half had eluded him, unless of course he was fully aware of the fact and had actually given the piece to Scott/Hogg himself.

One thing is clear: the British community at Naples at this time was close-knit (Jamieson 2009, passim). Sir John Auldjo called on Scott in Naples (Gell 1957, 6) and it is highly likely that the Auldjo family knew of the existence of the other piece. They presumably would also have been familiar with its 'present owner', especially if that owner were Hogg (or Scott). In 1836 John Auldjo had returned to London, to Noel House in Kensington. The following year his brother Thomas died of cholera in Naples and in 1840 Thomas's widow Annie and her daughters, including Madeleine, came to reside at Noel House with John Auldjo. Their collection came with them, or at least some of it did, including the neck of the jug. In 1858 when Madeleine died (two years after her mother Annie), she bequeathed the neck to the British Museum, along with 'three terracotta vases'. In fact, the total bequest from Madeleine Auldjo totalled some 200 pieces, ranging from pottery and glass to gold jewellery. Another fragment of a cameo glass vase, a small bottle, was amongst the bequest, 1859,0216.1b (7), as was another fragment of a different cameo glass vessel, now registered as

1859, 0216.1a (8) but wrongly associated with the fragments of the neck of the Auldjo Jug when they entered the Museum.

Interestingly, the contemporary catalogue entry for the neck and handle of the jug reads '1859.2-16.1 Blue glass with patterns in opaque white in relief. Portion of the Auldjo vase [our italics] consisting of the neck and the handle.' Added subsequently in a different hand are the words 'Found at Pompeii Since united to other portions already in Museum. Other parts in Naples.'

The annual Report to Parliament of the British Museum in June 1859, noting all the major acquisitions by the Museum for that year, highlights for the Greek and Roman Department

> a highly interesting specimen of Roman Cameo glass manufacture, being the upper part of a vase, discovered at Pompeii in 1831, similar in fabric and style to the Portland Vase. It is decorated with foliage, fruit and birds, in white bas-relief upon a blue background. The lowest portion [i.e. that part of the vase purchased from Dr Hogg in 1840] … and several intervening fragments, of this vase, have for some years been in the British Museum, and the remainder is now in the Museo Borbonico at Naples. The part now acquired was bequeathed, with the three Terracotta Vases already described, by the late Miss Auldjo.

From the register entry and the report cited above three major contemporary beliefs are clear: first, that the vessel was discovered in 1831, second that it was already known (perhaps widely) as 'the Auldjo vase', and third that it was firmly believed that missing fragments were still in the museum at Naples. It is interesting to note that there was clearly an awareness of the vase's importance, and an idea of its original appearance, long before its reunification in 1859. As early as 1836 Menu von Minutoli published a reconstructed image of the vase at half size (Taf. III, fig. 1). The reconstruction is not quite true: the vase is slightly taller and more rounded than the original. But von Minutoli had clearly seen both halves of the vase. Ashley Pellatt, on the frontispiece of his Curiosities of Glassmaking (1849; Whitehouse 2007, 121, fig. 31), presents the same reconstruction. It is important to remember that the base had already been in the British Museum since 1840, and the remaining members of the Auldjo family were living in London, with their collection including the upper part of the vase. Perhaps Pellatt was allowed to bring the pieces together physically to draw them? Whatever the circumstances around the vessel's implied temporary reunification, its recognized importance, even though in reality it was in two pieces in 1849, is shown in its ranking as a reconstruction in the illustration alongside the Portland Vase and the Blue Vase.

With regard to the missing fragments of the Auldjo Jug, von Minutoli states that 'some unimportant pieces lay unnoticed in the ruins or were mislaid, since the present owner did not obtain them'. The parliamentary reports, perhaps basing their ideas on von Minutoli (above), seem confident that these fragments existed and now resided at Naples. As noted

above, however (p. 43), enquiries at the Museo Archeologico Nazionale di Napoli (the successor to the Museo Borbonico) have so far failed to yield any further information.

Von Minutoli's wording ('some unimportant pieces lay unnoticed in the ruins or were mislaid, since the present owner did not obtain them') suggests that the 'present owner' acquired his portion of the vase at a time when he could reasonably have expected to have gained easy and rapid access to the new discovery. This implies a time soon after the moment of discovery – or perhaps even the time it was made, during excavation. Yet, as noted above (p. 44), there is no record of the discovery of the jug in the House of the Faun. Could Dr Edward Hogg (if he was indeed the 'present owner') have been there at or soon after the discovery of the jug and been given/taken the base fragments? If so, however, why did he not also get the neck and the other pieces? Assuming that the precise information on its findspot, date of discovery and missing fragments was not all fabricated, then where could such information have come from, except from the person who was there at the moment of discovery or who had talked to someone who had good knowledge of the discovery?

Decoration The foliage is closely paralleled by the foliage of the Blue Vase now in Naples (inv. 13521; Whitehouse 1990d, figs 92, 94), also found at Pompeii. Similar high-relief carving of leaves is found on fragments at Toledo, Leiden (personal observation) and Cologne (N.6225; Naumann-Steckner 1989, 79–80, no. 7). A particularly fine and well-accomplished piece of high-relief vegetal carving can be seen in a fragment from Aquileia that preserves the whole profile of a *cantharus* or deep skyphos (Mandruzzato and Marcante 2005, 43, 107, 146, no. 299). This piece, one of the finest surviving vegetal pieces, is covered with vine leaves and bunches of grapes in high relief. With regard to parallels for the birds, a similar bird pecks at foliage or insects on the pyxis from the British Museum (**29**). Elsewhere the Blue Vase has birds amongst its luxuriant foliage and the collection of Toledo has a fragment of the rim of a dish that is decorated with birds (23.1590). These birds are remarkably similar, rather squat and angular with fearsome robust beaks. Rather more elegant birds, one of them very skilfully undercut, appear on a fragment in The Corning Museum of Glass (66.1.57; Whitehouse 1997, 63, no. 71).

In publishing the last piece, Whitehouse refers to parallels in the representation of garlands in other media, notably in silverware and sculptural reliefs. Silverware, we would argue, is by far the more logical and preferable source of comparanda, for example the acanthus tendrils and roundels with pecking birds on the underside of the Orestes silver cup of Augustan workmanship in the British Museum (1960,0201.1).

Form Although silver vessels give the most satisfactory parallels for the decoration of the piece, for the form itself we must look at another metal, bronze. Two bronze jugs from Pompeii (*PAH*, I, 135, inv. 7264, II, 66; I, 182, inv. 3327, II, 66) provide very close parallels for the Auldjo Jug in their proportions, arched handle (shape and section) and bi-lobe mouth. Others

(Tassinari 1993, II, 66–9) are quite similar, demonstrating that the form in metalwork was not uncommon in the first century AD.

Chronology Previous attempts to place the remaining pieces of cameo glass in some form of chronological order tend to put the Auldjo Jug, along with the Blue Vase, somewhat later than the Portland Vase (Harden *et al.* 1987, 59, 75, 79). Yet although they may arguably (though not necessarily) be by a different hand, it is very difficult to argue that they are of a different date. Fuller discussion is given above (pp. 16–18), but, given the similarities in form, technique and decorative schemes, there seems little reason to suggest that the Auldjo Jug, its cousin the Blue Vase and other similarly decorated pieces in Corning and Toledo need necessarily be later than the Portland Vase. There is even the possibility (mentioned above, pp. 19–20) that, with their profuse, high-relief vegetal decoration based very much on later Hellenistic silverware, they might pre-date it.

The Auldjo Jug was made by the dip-overlay method that involved inflating a gather of blue glass adhered to the end of a hollow metal blowpipe, and then dipping the lower portion of it into a crucible of opaque white glass. The decoration was achieved by carving away the opaque white glass when cold, using traditional lapidary techniques. For a full discussion of the process of making glass cameo blanks, see pp. 25–31.

Bibliography Simon (1957), 4.7, pl. 24.2; Nuber (1973), 75–6; Goldstein, Rakow and Rakow (1982), 100, no. 6; Harden *et al.* 1987, 79, no. 34; Painter and Whitehouse (1990b), 149–50, figs 109–10; Whitehouse (1991), 20, no. 6

3
Fragment of an amphora
1976,1003.4
H. 4.8 cm, W. 3.5 cm, D. 13.3 cm, TH. 1.1 cm (blue 0.6 cm, white 0.5 cm).
Provenance and origin unrecorded.
About 15 BC–AD 25

3

Glass The fragment is made of translucent blue glass overlaid with opaque white.

Fragment/form The fragment comes from the lower part of the shoulder and upper body of an amphora. There is brownish, flaking film and some iridescence on both surfaces. The white glass is partly worn away, and there is a V-shaped crack in the blue glass at the neck of the figure. Some bubbles are visible in the blue

glass; internal grinding marks are present all over the back. The threshold between the blue and white glass is well defined and even.

Decoration Shown in white is the upper part of a female figure, with her back to the viewer, her head turned to the right, and her right arm extended forward. Faintly visible near her right armpit are traces of a breast band, or *strophium* (see **17** for discussion). There are no obvious traces of drapery, and her upper arm, extended forward, is undraped. Her hair is in wavy locks undulating around the side of the face and combed into a bun at the back. She is wearing a triangular earring. To her right and level with her forehead is a branch terminating in three fan-shaped clusters of foliage.

Comment The profile suggests that the fragment comes from an amphora similar to either the Portland Vase (**1**) or the Blue Vase (Harden *et al.* 1987, 75–8, no. 33) and with an almost vertical upper wall. The rather straight wall and the quite angular carination could indicate that **3** was indeed more similar in form to the Blue Vase.

The figure, perhaps a maenad, is comparable in size to those on the Portland Vase. The attention to detail in the carving of **3**, such as the waving of the hair and the depiction of the earring (unique in cameo glass as far as we know), suggests that the figure and its composition were originally of high quality.

The branch is from a Mediterranean pine, which has long needles growing in sprays. Trees with similar sprays appear on the Morgan Cup (Whitehouse 1997, 48–51, no. 47), a cameo glass jug from Besançon (Painter and Whitehouse 1990d, 146–9, figs 107–8, no. A6) and a bottle from Torrita di Siena (Painter and Whitehouse 1990d, 145–6, fig. 102, no. A5).

The vessel was made by the dip-overlay method. The decoration was achieved by carving away the opaque white glass when cold, using traditional lapidary techniques.

Bibliography Simon 1957, pl. 18; Weiss and Schüssler 2001, 208, fig. 15

4
Fragment of a jug
1868,0501.136
H. 3.2 cm, W. 4.2 cm, D. (ground line) 13.6 cm, TH. (max.) 0.7 cm (blue 0.3–0.5 cm, white 0.1–0.2 cm).
Provenance unrecorded; bequeathed by Felix Slade, 1868.
About 15 BC–AD 25

4

Glass The fragment is made of translucent dark blue glass overlaid with opaque white. There is brownish weathering on both surfaces.

Fragment/form Curving fragment from the upper wall, above the shoulder of a closed vessel, possibly similar to the Auldjo Jug (**2**).

Decoration Shown in white on the exterior are two pairs of animal legs facing left, leaping from a horizontal ground line. The legs on the left are slender and appear to have hooves, the legs on the right are sturdier and have paws. Below the ground line is a small part of another element, possibly a leaf or another vegetal motif.

Comment The legs belong to two different animals, one a rather slender ungulate (such as a gazelle) and the other a more powerfully built animal with paws, suggesting a big cat such as a lion. If this is correct, the object may have depicted a lion in the act of bringing down a gazelle-like animal.

It is unusual to have decoration above the shoulder line of a cameo glass closed vessel. In most cases the carination at the shoulder seems to have been an obvious cut-off point for the area originally covered by the coating of white glass. In the collections of the British Museum only **4**, the Auldjo Jug (**2**) and a fragment of another vessel (**5**) are decorated in this way. It is interesting that all are likely to have been jugs.

The vessel was made by the dip-overlay method. The decoration was achieved by carving away the opaque white glass when cold, using traditional lapidary techniques.

Bibliography Slade 1871, 25, no. 136; Simon 1957, pl. 18

5
Fragment of a jug
1886,1117.36
H. 6.6 cm, W. 4.0 cm, D. (mid-neck) 7 cm, TH. 0.7 cm (purple 0.7 cm).
Formerly in the Nesbitt collection, most of which was acquired in Rome; given by A.W. Franks.
About 15 BC–AD 25

5

Glass The fragment is made of translucent purple glass overlaid with opaque white. The white, where it occurs, is exceedingly thin. There is brownish weathering with some pitting and iridescence on both surfaces. The threshold between the purple and opaque white glasses is even. Some bubbles are visible in the purple glass.

Fragment/form The fragment preserves part of the neck of a vessel. The neck is cylindrical, splaying at the base.

Decoration Shown in white are parts of two motifs, probably vegetal.

Comment The fragment may come from a jug, either with bi-lobed mouth, such as the Auldjo Jug (**2**), or with a round mouth, such as the pitcher from Besançon (Painter and Whitehouse 1990d, 146–9, no. A6). The decoration on the neck and shoulder appears to consist of a band of vegetal motifs, perhaps acanthus, with curled, hooked foliage. What seems to be a line around the base of the neck is in fact the meeting of two straighter elements of the acanthus motifs. Interestingly, the only ornament below this 'line' is a curved element – again acanthus. It is possible that the whole vase, like the Auldjo Jug (**2**), was covered in vegetal motifs. The presence of decoration above the shoulder of a Roman cameo glass vessel is very unusual (see discussion under **4**). The decoration on **5** is particularly unusual in that it extends most of the way up the neck, marking the highest point reached by any element of cameo decoration of a closed vessel of which we are aware.

Another fragment, identical in its form, colour and decoration to **5**, is in the collections of the Leiden Museum (personal observation). It is almost certainly part of the same vessel.

The vessel was made by the dip-overlay method. The decoration was achieved by carving away the opaque white glass when cold, using traditional lapidary techniques.

Bibliography Simon 1957, pl. 18

6
Fragment of a bottle
1865,1214.105
H. 1.3 cm, W. 1.3 cm, D. (max) 7.6 cm, TH. 0.3 cm (blue 0.2 cm, white 0.1 cm).
Provenance unrecorded; Henry Christy collection, given by his trustees.
About 15 BC–AD 25

6 (3:1)

Glass The fragment is made of translucent dark blue glass overlaid with opaque white. There is brownish weathering in patches and pitting on both surfaces. There are elongated bubbles in the blue glass.

Fragment/form The curvature of the fragment, together with the elongation of the bubbles, suggests that the fragment is from near the shoulder of a small bottle similar, in all probability, to the cameo glass scent bottle in the J. Paul Getty Museum (see fig. 9 on p. 26 above; Whitehouse 2007, 120, no. 30).

Decoration Shown in white is the upper part of a small figure in profile leaning forwards to the left with his cloak, fastened at the neck, flying out behind him. The white of the cloak has largely disappeared. He holds both arms before him as though grasping the reins of a horse.

Comment This figure, though obviously considerably smaller in scale, recalls those on the so-called Charioteer Skyphos formerly in the Constable Maxwell collection and sold on the open market in London in 2004 (Bonham's 2004, lot 12) to a buyer from the Middle East. Though much larger, it also shows a charioteer leaning forward with his cloak flying out behind him (Sotheby's 1987, 54–7, lot 137; Painter and Whitehouse 1990d, 157–8, no. A12). A fragment of a skyphos in The Corning Museum of Glass (66.1.54; Whitehouse 1997, 55, no. 54) shows the upper part of a youthful charioteer with his cloak floating out behind, but he is leaning backwards rather than forwards. That figure is very finely carved (Whitehouse 1997, 55, no. 55) and stylistically quite close to the cupid driving a chariot on a fragment formerly in the Gréau collection (Froehner 1903, pl. LVIII.6) and now in The Metropolitan Museum of Art, New York (17.194.358a), though that cupid is leaning forwards like **6**.

A relevant parallel can be found in silver cylindrical cups, or modioli, showing cupids and Victory in *bigae* (two-horse racing chariots) from the House of the Menander, Pompeii (Museo Archeologico Nazionale di Napoli/MANN, inv. 145510–11). These two cups, described in detail by Stefani (2006a, 202 and figs 284–5), are dated from the late first century BC to early first century AD.

The vessel was made by the dip-overlay method. The decoration was achieved by carving away the opaque white glass when cold, using traditional lapidary techniques. The pitting on the back of the fragment obscures any grinding marks present.

Bibliography Simon 1957, pl. 18

7
Fragment of a bottle
1859,0216.1b
H. 2.7 cm, W. 3.4 cm, D. (shoulder) 5.3 cm, TH. 0.4 cm (blue 0.1–0.2 cm, white 0.05–0.2 cm).
Said to have been found at Pompeii; bequeathed by Miss M.H.H. Auldjo.
About 15 BC–AD 25

7 (1.5:1)

Glass The fragment is made of translucent dark blue glass overlaid with opaque white. Pitting and traces of brownish weathering occur on both surfaces.

Fragment/form The fragment comes from the shoulder and upper body of a small closed form, probably a bottle. The shoulder curves outwards to a fairly sharp carination with the upper part of the ovoid body.

Decoration Shown in white is a vine leaf at the end of a long stem, linked with another, possibly with a ribbon.

Comment The shape of the fragment strongly suggests that it came from a bottle, very similar in shape to the bottle found at Torrita di Siena, now in the Museo Archeologico di Firenze (inv. 70811; Painter and Whitehouse 1990d, 145–7, no. A5 and figs 102–6), and a bottle reputedly found at Estepa near Seville in southern Spain (Painter and Whitehouse 1990d, 161–2, no. A15 and figs 124–5). The bottle (7) would, therefore, presumably have had a long, tapering body with a tall, tubular neck. The presence of the knot on the exterior of a closed vessel might mark a central point either at the front or the back of the piece. It might even be an indication of the presence of a handle, though 7 shows no traces of a handle scar.

The vessel was made by the dip-overlay method. The decoration was achieved by carving away the opaque white glass when cold, using traditional lapidary techniques.

On the inner surface there is a small cross-sectioned bubble, the edges of which have been carefully smoothed. At the corresponding location on the outer surface a bump of white glass – completely uncut – has been left by the engraver. The purpose was to avoid any possibility of accidentally cutting into the bubble in the blue glass thereby ruining the object (see pp. 28–30).

Bibliography Simon 1957, pl. 18

8
Fragment of a closed(?) vessel
1859,0216.1a
H. 2.3 cm, W. 2.3cm, D. 12.6 cm, TH. 0.3 cm (blue 0.2 cm, white 0.1 cm).
Probably from Pompeii; bequeathed by Miss M.H.H. Auldjo.
About 15 BC–AD 25

8 (2:1)

Glass The fragment is made of transparent deep blue glass overlaid with opaque white. The surface of the white glass and the upper surface of the blue are pitted.

Fragment/form An irregular, five-sided fragment. Its curvature suggests that the fragment was probably part of a closed form, perhaps a jug or bottle, though the fragment is too small to be identified with certainty.

Decoration Shown in white is part of a vine leaf, with raised areas (tendrils?) from which the white has disappeared.

Comment This piece was once thought to belong to the Auldjo Jug, but close examination of its thickness and decoration has shown that it does not.

The vessel was presumably made using the dip-overlay method. The decoration was achieved by carving away the opaque white glass when cold, using traditional lapidary techniques.

Bibliography Unpublished

9
Fragment of a closed(?) vessel
1976,1003.10
H. 1.8 cm; W. 1.5 cm; TH. 0.4 cm (blue 0.3 cm, white 0.1 cm).
Provenance and origin unrecorded.
About 15 BC–AD 25

9 (2:1)

Glass The fragment is made of translucent light blue glass overlaid with opaque white. There are patches of brownish weathering and pitting on both surfaces.

Fragment/form The fragment is fairly flat, but the slight curvature and an elongated bubble in the blue glass indicate that it is part of a vessel, perhaps closed, and not a plaque. The fragment is too small, however, to permit identification of the form.

Decoration Shown in white are vegetal motifs, perhaps fruit or flowers.

Comment The fruit almost certainly formed part of a garland.

The vessel was presumably made by the dip-overlay method. The decoration was achieved by carving away the opaque white glass when cold, using traditional lapidary techniques.

Bibliography Simon 1957, pl. 18

Open-form vessels

10

Fragment of a bowl or krater

1956,0305.1

H. 4.1 cm, W. 4.9 cm, D. 15 cm, TH. 0.6 cm (blue 0.2 cm, overlays 0.4 cm).

Found near Rome; given by C.T. (later Sir Charles) Newton, formerly in the collection of Sir William Hamilton.

About 15 BC–AD 25

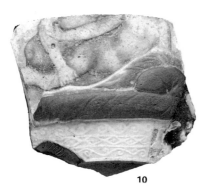

10

Glass The fragment is made of translucent dark blue glass overlaid with another five layers, opaque white, opaque light green, opaque white, opaque green and milky-opaque brownish red. There is brownish, flaking, weathering film on the exterior and some pitting on both surfaces. The weathering film extends over the smoothed edge, as well as over the broken edges, and is particularly visible on the white layer. The thresholds between the six layers, when viewed from the broken edges, are perfectly smooth and even.

Fragment/form The fragment almost certainly formed part of the lower part of a fairly large open vessel with a rounded or hemispherical body. This was perhaps a large bowl or chalice, perhaps similar to contemporary Arretine pieces. The edge along the top of the fragment is very clean and polished, while the other three sides are broken and irregular.

Decoration Shown against the blue background, in five colours, is a scene of two males making love on a couch. A boy reclines forward on the couch, reaching back with his right hand to clasp the arm of another, older figure. This man, evidently crouching in preparation to penetrate the reclining boy, grasps the boy's right thigh. The couch is shown in detail. At bottom right is a turned 'spindle' leg, while to the left of this is an under-cover decorated with a band of interlinking diamond shapes between continuous tendril motifs. Although the front left leg of the couch is not visible, the couch is unlikely to have extended much further than the area preserved by the fragment. A thick mattress, shown in brownish red glass, covers the couch and is folded over to form the headrest. Over this mattress is a green covering, on which the boy lies. To the right of the couch are parts of (two?) elements in white glass.

Comment With the important exception of the Ortiz bottle, the occurrence of erotic scenes is

limited to open vessels, presumably drinking cups, suggesting a similar identification for this piece.

The break along the top of the fragment is perfectly horizontal and polished smooth, contrasting markedly with the other breaks. It is conceivable that such smoothing might have been done in modern times since its discovery, perhaps to investigate the sequence of overlay. Yet, this investigation could have been carried out on a broken surface and, on balance, it seems unlikely that any modern collector would have 'trimmed off' any elements of the main scene. Most significantly, the presence of weathering on much of this smooth surface, identical to that on the outer surface of the vessel, makes it fairly certain that this was done in antiquity. One possible scenario is that this piece, like the Portland Vase, was damaged in antiquity. Unlike the Portland Vase, however, it did not survive substantially intact but was still thought interesting or valuable enough to be retained in a different form or was trimmed to a smaller version of the same form. In this scenario the rough breaks along the bottom and sides would mark its final breakage.

The cover of the couch is very similar to that on the couch on which Mars reclines on a silver cup in Naples (MANN, inv. 145516) from the House of the Menander (Stefani 2006a, 207, fig. 289 left). The pattern in the upper and lower registers of the cover also closely resembles the tendril motif shown on the draped cover on a five-layered piece in The Corning Museum of Glass (62.1.24a; Whitehouse 1997, 51, fig. 48a).

Pellatt's publication of this piece (1849, 140, pl. 5.1) is the first, and it is described as in the possession of W.R. (Sir William) Hamilton, even though Hamilton himself had died in 1803. Pellatt describes the piece as the zenith of ancient glass, the 'ne plus ultra of the chemical and manipulating power of the ancient glass maker'. Interestingly, the illustration of the piece in Pellatt has been altered (perhaps unsurprisingly, given the publication date of 1849) so as to make the subject of the scene more acceptable to a Victorian readership. His illustration omits altogether the older, active male, while the remaining, younger male on the couch has lost his genitals. Having castrated the young man, Pellatt then changes his sex, describing him (1849, 140) as 'a female reclining on a settee'. No such prudery inhibits the drawing of the piece made for Edward Dodwell in 1826/7 (Williams 2004, 61; Gaimster 2000, 14). According to the Museum's records, the piece passed from Sir Antonio Panizzi, Chief Librarian of the British Museum Library, to Sir Charles Newton. Newton was the first Keeper of Greek and Roman Antiquities, a post he held from 1861 to 1886. During these years he must have given the piece to the British Museum, where Victorian and later attitudes on taste and decency consigned it to the Museum Secretum of the British Museum (see Gaimster 2000). It was finally extracted from the Museum Secretum in 1956 and officially registered in the Department of Greek and Roman Antiquities.

Early imperial cameo glass usually has two

coloured layers. Pieces with three or more are very unusual. Two fragments from a cup with a Bacchic scene in The Corning Museum of Glass have six overlays, again of three different colours, namely opaque white, translucent purple and translucent green. The outer layers of translucent green and translucent purple have been worn away, so that the general impression is of opaque white on deep blue (Whitehouse 1997, 51–2, no. 48).

Our scene of homosexual love has close parallels in cameo glass elsewhere and on other fine tablewares. A cameo glass bottle of blue glass with a single white overlay, said to be from Estepa, Spain, and now in the collection of George Ortiz, shows two pairs of lovers, one homosexual and the other heterosexual (Whitehouse 1991, 25, no. 12, and 29–30, pls vi–vii; Clarke 1998, 79–81). The homosexual lovers on the Estepa bottle are in very much the same position as the lovers on **10**. The homosexual scene on our fragment and that of the cameo glass bottle have been compared with similar male-to-male lovemaking scenes on Arretine vases of the early first century AD (Clarke 1998, 72–8). Male-to-male lovemaking is also shown on the Warren Cup (Clarke 1998, *passim*, esp. 61–78; Williams 2006), a silver vessel now in the British Museum (1999,0426.1).

The shape of the Ortiz bottle recalls undecorated toilet bottles of form 9a in the Isings classification (Isings 1957, 24–5), which also have a narrow neck, slender body with a convex profile and a pointed base. Two examples were found in grave 12 of the 'sotto' (lower) cemetery situated in the grounds of the Villa Liverpool at Muralto, near Locarno, Switzerland, and attributed to the period AD 20–50 (Biaggio Simona 1991, v. 1, 138–40).

The Warren Cup has traditionally been dated to the Augustan period (27 BC to AD 14), and perhaps the most convincing argument for the dating of the piece comes from Williams's recent in-depth study. He favours an Augustan date (Williams 2006, 45–7), more specifically around AD 5–15, a date that would fit very well with the production of fine, moulded Arretine ware. The fragment (**10**) is currently displayed together with the Warren Cup and a fragment of Arretine pottery on loan from the Ashmolean Museum (1966.253), Oxford, showing male lovers on a couch. The Arretine sherd shows a very similar coupling in a very similar position. On this sherd is a stamp with a partially preserved name 'TIG[…]', identified as the mark of the potter Marcus Perennius Tigranus. This particular stamp is dated by Kenrick (2000, 323, no. 1412) to around 10 BC–AD 10.

The vessel blank was made by the dip-overlay method. The evenness of the levels of glass suggests that the overlays were produced by multiple dipping in crucibles of molten glass of different colours. The decoration was achieved by partly carving away the upper layers of glass when cold, using traditional lapidary techniques.

Bibliography Pellatt 1849, 140, pl. 5.1; Simon 1957, pl. 18; Whitehouse 1991, 30, pl. viiib

11
Fragment of a skyphos
1976,1003.8
H. 2.9 cm, W. 4.9 cm, D. 11.7 cm, TH. 0.6 cm
(blue 0.5 cm, white 0.1 cm).
Provenance and origin unrecorded.
About 15 BC–AD 25

11

Glass The fragment is made of translucent dark blue glass overlaid with opaque white. There is milky-white weathering film with some iridescence on both surfaces.

Fragment/form The fragment preserves elements of the rim and part of the upper wall of a skyphos. The rim is thickened and rounded, and in part flattened outwards from the lip with a semicircular element surviving from a larger projection. The wall, which is unusually thick, curves outwards below the rim. The semicircular element is almost certainly part of the thumb rest, while the rim is stepped on the interior, a feature quite rare in glass vessels, but one that is seen on fragments of heavier cameo glass skyphoi in other collections such as The Metropolitan Museum of Art, New York, and The Corning Museum of Glass (74.1.72b; Whitehouse 1997, 55, and 329 no. 54).

Decoration Shown in white on the exterior are most of the head and one shoulder of a male figure with his head bent back and part of a curved element in front. There are several horizontal grooves and facets on the interior wall and below the interior of the rim.

Comment Close inspection shows that the figure has a pointed ear, identifying him as a satyr, with perhaps an animal skin over his left shoulder. The object in front of him may therefore be a *lagobolos* (in Latin *pedum*), the knobbed shepherd's cudgel carried by satyrs and maenads, as can be seen hanging in a bag on a tree on one of the Pompeii plaques (Harden *et al.* 1987, 72; MANN, inv. 153651), on a piece from Corning (Whitehouse 1997, 53, no. 50; 66.1.55), brandished by a satyr on a fragment of a drinking cup from Leiden, and on fragments from two plaques in Leiden (personal observation). The cup therefore depicted a Bacchic scene, an extremely common theme in drinking vessels and related items in all media, whether in silver, pottery or glass. It occurs on two important, complete or nearly complete drinking vessels, namely the Morgan Cup in The Corning Museum of Glass (52.1.93; Whitehouse 1997, 48–51, no. 47) and the skyphos in the J. Paul Getty Museum (84.AF.85; Wight 2003; Painter and Whitehouse 1990d, 141–5, nos A3 and A4; Whitehouse 2007, 119, no. 29), of which most of the stem and all the foot are restored. Parallels are almost too numerous to mention, Bacchic

scenes being by far the most popular (figural) decorative theme in the cameo glass of the British Museum and elsewhere.

The vessel was made by the dip-overlay method. The decoration was achieved by carving away the opaque white glass when cold, using traditional lapidary techniques.

On the inner surface of the blue glass is a large elongated bubble that has been cut in cross-section by the internal grinding and has had its edges carefully smoothed. On the exterior surface in the corresponding location, the head of a figure is well centred over the remains of the bubble. The head stands in relatively high relief against the blue background, the cutter having carefully avoided any deep cutting in this area to reduce the risk of ruining the object by accidentally puncturing the void (see pp. 28–30).

Bibliography Simon 1957, pl. 18

12
Fragment of a cup
1886,1117.35
H. 2.9 cm, W. 3.3 cm, D. 10 cm, TH. 0.3 cm (blue 0.1–0.3 cm).
Formerly in the Nesbitt collection, most of which was acquired in Rome; given by A.W. Franks.
About 15 BC–AD 25

12

Glass The fragment is made of milky-opaque dark blue glass overlaid with opaque white. The white is exceedingly thin. There is milky-white weathering film over both surfaces with some pitting.

Fragment/form The fragment preserves the end part of the gently curved upper body of a cup. A white horizontal rib separates the rim from the body.

Decoration Shown in white is a straight-edged wing-like object with another element to the left and a long stalk with angular leaves to the right.

Comment This form is almost certainly a roughly hemispherical but deep cup, similar to the Morgan Cup in The Corning Museum of Glass (52.9.93; Whitehouse 1997, 48–51, no. 47). Cups of this form are sometimes referred to as Hofheim cups, the name of an archaeological site in Germany where they were first described (Ritterling 1913). They were classified by Isings as her form 12 (Isings 1957, 27–30). On the question of the characteristics of the Hofheim cups, see Cool and Price 1994, 64–8. Listed there is the Morgan Cup (Isings 1957, 29–30; most recently Whitehouse 1997, 48–51), which, besides the general shape, shares with 12 the raised white border line.

The design on the fragment is not easy to understand. The plant at the right seems to have a long stalk and rather angular leaves, perhaps part of a vine leaf, not unlike that shown on a fragment of a handled cup in Corning (Whitehouse 1997, 54, no. 52). No satisfactory parallel can be quoted for the wing-like element, although the scale suggests it might be a griffin or other mythological beast, rather than a bird.

Milky-opaque glass is rare in Roman cameo glass. In the British Museum collections there are three other pieces (**13, 27, 28**), the last two probably part of the same vessel. In the rest of cameo glass known to us there are fewer than ten other pieces (see **27** for discussion).

The vessel was made by the dip-overlay method. The decoration was achieved by carving away the opaque white glass when cold, using traditional lapidary techniques.

When viewed from above – that is, from the top of the rim – the threshold of the two glasses is uneven, as seen at the white horizontal band. This is due to unevenness of the surface of the blue glass prior to dipping it into the white glass during the making of the blank.

Bibliography Simon 1957, pl. 18

13
Fragment of a cup
1865,1214.84b
H. 2.9 cm, W. 1.3 cm, D. (max.) 9 cm, TH. 0.3 cm (blue 0.25 cm, white 0.05 cm).
Provenance unknown; Henry Christy collection, given by his trustees.
About 15 BC–AD 25

13

Glass The fragment is made of milky-opaque dark blue glass overlaid with opaque white. The threshold between the blue and the white glass is very even and well defined. Both surfaces are covered by a milky-white film. There is some pitting on the exterior.

Fragment/form The fragment preserves the rim and part of the upper body of a cup or beaker. The rim is upright, thinned by grinding on the outside and slightly rounded at the extremity. There is a horizontal groove on the interior. The upper wall is vertical but begins to curve gently inwards.

Decoration Shown in white is the larger part of a broad vine leaf, its ribs and veins picked out with light incisions.

Comment Unfortunately, the surviving sherd does not permit a realistic estimate of the diameter of the piece. It seems likely, however, that the object was either a cup with a broad, gently carinated body or a taller, narrower form.

Milky-opaque glass is rare in Roman cameo

glass. In the British Museum collections there are three other pieces (**12**, **27** and **28**), the last two probably part of the same vessel. In the rest of cameo glass known to us there are fewer than ten other pieces (see **27** for discussion).

The vessel was made by the dip-overlay method. The decoration was achieved by carving away the opaque white glass when cold, using traditional lapidary techniques.

Bibliography Simon 1957, pl. 18

14

Fragment of a cup
1976,1003.2, H. 2.3 cm, W. 3.8 cm, D. 10 cm, TH. 0.4 cm (blue 0.3 cm, white 0.1 cm). Provenance and origin unknown.
About 15 BC–AD 25

14

Glass The fragment is made of translucent dark blue glass overlaid with opaque white. Viewed from above the rim, the threshold of the blue glass is uneven. The exterior has patches of milky-white weathering film with some iridescence. There are traces of brownish film and pitting on the interior.

Fragment/form The fragment preserves the rim and part of the upper body of a cup or bowl. The rim is fairly upright and rounded with the body curving inwards.

Decoration A ridge, partly in white, separates the rim from the body, below which is a rounded white object.

Comment The identity of the white element below the rib is impossible to determine.

The vessel was made using the dip-overlay method. The decoration was achieved by carving away the opaque white glass when cold, using traditional lapidary techniques. The uneven threshold of the blue glass is due to the irregularities of its surface prior to dipping it into the white glass during the making of the blank.

Bibliography Simon 1957, pl. 18

15

Fragment of a cup
1867.0507.728
H. 3.9 cm, W. 2.5 cm, D. (body max.) 12.8 cm, TH. 0.4 cm (purple 0.3 cm, white 0.1 cm). Provenance unrecorded; Blacas collection no. 886.
About 15 BC–AD 25

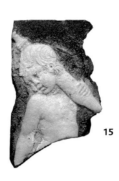

15

Glass The fragment is made of translucent brownish purple glass overlaid with opaque white. There are patches of brownish weathering and pitting on both surfaces and some iridescence on the exterior.

Fragment/form The curvature viewed from the edges, together with the internal grinding, shows that this fragment came from a rather large straight-sided cup or bowl. The top edge has been ground and is not the original, yet variations in the shape of the bubbles suggest that the top of the fragment was very near the rim of the vase.

Decoration Shown in white, on the outside, is the head and upper torso of a youthful male figure, perhaps Cupid, in three-quarter view and moving to the right with his head looking back and down over his right shoulder; in his left hand is a sword in a scabbard, which he carries over his shoulder.

Comment It is possible that the figure may be part of a scene showing cupids stealing the armour of Mars (Dyfri Williams, pers. comm.). On one of the silver cups from the House of the Menander, Pompeii (MANN, inv. 145516), dating to the Augustan period, cupids carry (rather than steal) the arms of Mars as he seduces Venus (Stefani 2006a, 206–7 and figs 289 a–c).

The vessel was made using the dip-overlay method. The decoration was achieved by carving away the opaque white glass when cold, using traditional lapidary techniques.

Bibliography Simon 1957, pl. 18

16

Fragment of a cup
1976,1003.5
H 5.7 cm, W. 2.7 cm, D. (body max.) 10.5 cm, TH. 0.3 cm (blue 0.2 cm, white 0.1 cm). Provenance and origin unrecorded.
About 15 BC–AD 25

16

Glass The fragment is made of semi-transparent pale blue glass overlaid with opaque white. There is brownish weathering film and pitting on the exterior and patches of whitish weathering on the interior. The white is worn away on the right arm.

Fragment/form The curvature of the fragment, the presence of grinding marks all over the back and the shape of the bubbles suggest that this fragment is from the lower portion of a bottle.

Decoration Shown in white on the outside is the upper part of a female figure bending to the left and holding out in both hands an object, a box or, more probably, a basket made of wicker. She appears to have removed the cover of the basket, revealing something that protrudes from it. She has her hair tied back in a hair-bag, or *sakkos*, and wears a loose Greek-style robe, or *peplos*, buttoned on the left shoulder and falling down in loose folds over the right.

Comment The basket that the girl is holding can almost certainly be identified as a *liknon*, the broad shallow wicker basket that formed part of the mysterious rituals of the god Bacchus/Dionysus. The basket was broad, shallow and open at one end and was originally used for winnowing (separating wheat from chaff). According to legend, Bacchus had been carried in a *liknon* when he was a baby, and subsequently it became an important part of the Bacchic/Dionysiac initiation ceremony. Covered by a cloth, it was carried by an attendant to the initiand. It contained cakes, fruit and the sacred phallus, all revealed as the cloth was lifted from the top of the basket. It seems extremely likely, therefore, that the woman pictured is the initiand, and that the object protruding form the basket is the sacred phallus. The dishevelled state of her clothing alludes to the ecstatic and sexually charged atmosphere.

The cupid on the bottle from Torrita di Siena (Museo Archeologico di Firenze, inv. 70811; Painter and Whitehouse 1990d, fig. 102) carries

a veiled *liknon* on his head, while the attendant on side A of the Getty skyphos (J. Paul Getty Museum, California, 84.AF.85; Painter and Whitehouse 1990d, fig. 100; Wight 2003, 39 and fig. 6) proffers a *liknon* to the seated female. The piece of wooden furniture recently discovered in the Villa of the Papyri at Herculaneum (Guidobaldi and Esposito 2009, fig. 51) features high-relief carving, one element of which shows a cupid bearing a *liknon* and exposing its contents at a shrine. A stone relief now in the Munich Glyptothek (inv. 455; Kuttner 1995, fig. 100) shows a rural shrine in which a *liknon* on a column is depicted in detail, filled with fruit. From it emerges a large, prominent phallus.

The vessel was made using the dip-overlay method. The decoration was achieved by carving away the opaque white glass when cold, using traditional lapidary techniques.

Bibliography Simon 1957, pl. 18

17
Fragment of a cup
1976,1003.7
H. 3.4 cm, W. 3.6 cm, D. (body max.) 9.5 cm, TH. 0.4 cm (blue 0.2 cm, white 0.2 cm).
Provenance and origin unrecorded.
About 15 BC–AD 25

17

Glass The fragment is made of translucent dark blue glass overlaid with opaque white. There is brownish weathering and pitting on the exterior and patches of white weathering on the interior.

Fragment/form The roughly triangular fragment with a gentle curve probably came from a cup.

Decoration Shown in white from behind is the upper torso of a female figure from neck to knees seated to the right in three-quarter view. Her right arm is bent forwards, but her left is not visible. She wears a breast band (*strophium*, also known as a *fascia* or *fascea*). Her dress is draped so as to form bunched folds around her waist and cover her thighs.

Comment It is common for both men and women to appear in various states of undress on cameo glass vessels. Perhaps the most famous collection of nudes and semi-nudes in cameo glass is the group of figures on the Portland Vase, who, according to any interpretation, are significant figures whether of history or mythology. The *strophium* that the woman wears (also worn by the female shown on **3**) consisted of a long piece of fabric that could either be wrapped around and over the breasts, flattening them, or could be wrapped under the breasts to lift and support them

(Croom 2000, 91–3; Sebaste and Bonfante 1994, 235).

Clarke (1998) brings together many representations of females – all apparently human – wearing the garment. Females wearing the *strophium* are represented in all media, including the female on one side of the cameo glass Ortiz bottle (Clarke 1998, pl. 3), a woman on a wall painting from the House of the Centenary, Pompeii (Clarke 1998, pl. 7), and a female on a fragment of an Arretine krater now in Boston (Clarke 1998, fig. 24).

A *strophium* is also worn by the voluptuous lady shown on the interior of an open-vessel fragment in the Martin von Wagner Museum in the University of Würzburg, southern Germany (Weiss and Schüssler 2001, 204–9, Abb. 1–4, 5a–b). The tradition of wearing the *strophium* is clearly long-lived, as shown by the apparel of the female athletes on an early fourth-century AD mosaic at Piazza Armerina, Sicily (Carandini *et al.* 1982, figs 73–5). Comparison with numerous other examples of scantily clad females suggests that the female portrayed is probably, though not certainly, mortal. There is the possibility that she is a maenad at rest.

The vessel was made using the dip-overlay method. The decoration was achieved by carving away the opaque white glass when cold, using traditional lapidary techniques.

Atypically, the few visible bubbles in the glass of **17** are all spherical – there is no elongation as would be expected. Yet the threshold of the blue and white glass is even, and the walls of the vessel are relatively thin.

Bibliography Simon 1957, pl. 18; Weiss and Schüssler 2001, 215, fig. 22

18
Fragment of a cup
1886,1117.33
H. 1.9 cm, W. 2.4 cm, D. (body max.) 12.2 cm, TH. 0.2 cm (blue 0.1 cm, white 0.1 cm).
Formerly in the Nesbitt collection, most of which was acquired in Rome; given by A.W. Franks.
About 15 BC–AD 25

18

Glass The fragment is made of semi-transparent pale blue glass overlaid with opaque white. There are traces of brownish weathering film and pitting on both surfaces.

Fragment/form The irregularly squared fragment is from the wall of an open vessel.

Decoration Shown in white is the lower torso of a seated figure. The tunic is bunched below the waist and falls down in folds over his legs.

Comment Bunched folds of drapery at the waist are a typical feature of characters on cameo glass, as on **17** and of course on several

figures (**C**, **F** and **G**) on the Portland Vase (**1**). The bunching of the folds below the waist is also paralleled by the drapery of Augustus on the scabbard of the 'Sword of Tiberius' in the British Museum (1866,0806.1; Walters 1899, 157, no. 867; Walker 1991, 32, fig. 35), dating from about 15 BC, and by the drapery of Mars on silver cups from the House of the Menander, Pompeii (Stefani 2006a, 206–7, nos 289–90).

The vessel was made using the dip-overlay method. The decoration was achieved by carving away the opaque white glass when cold, using traditional lapidary techniques.

Bibliography Simon 1957, pl. 18

19
Fragment of a cup
1865,1214.84a
H. 3.3 cm, W. 1.9 cm, D. (body max.) 9.9 cm, TH. (max.) 0.3 cm (blue 0.2 cm, white 0.05–0.1 cm).
Provenance unknown; Henry Christy collection, given by his trustees.
About 15 BC–AD 25

19

Glass The fragment is made of translucent dark blue glass overlaid with opaque white. There are brownish patches and pitting on both surfaces, and iridescence on the exterior.

Fragment/form The curvature of the fragment and the shape of bubbles in the glass suggest that this fragment is from the lower portion of an open vessel, perhaps a cup or bowl.

Decoration Shown in white is the lower part of an animal's hind leg and hoof facing left with other elements, perhaps rocks or another hoof, below.

Comment The animal's leg is fairly straight and is probably the hind leg of a deer, an animal represented on two other pieces of cameo glass in the British Museum, **4** and **47**. If the tentative identification of another hoof to the bottom right is correct, then there might have been a frieze of animals around this part of the vase, as on the Blue Vase (Harden *et al.* 1987, 75–8, no. 33).

The vessel was made using the dip-overlay method. The decoration was achieved by carving away the opaque white glass when cold, using traditional lapidary techniques.

Bibliography Simon 1957, pl. 18

20
Fragment of a modiolus
1982,0404.1
H. 3.9 cm, W. 2.1 cm, D. (body max.) 10.6 cm,
TH. 0.5 cm (blue 0.2 cm, white 0.3 cm).
Possibly Slade collection.
About 15 BC–AD 25

20

Glass The fragment is made of translucent
dark blue glass overlaid with opaque white.
There are patches of brownish weathering and
pitting on both surfaces with some iridescence
on the exterior.

Fragment/form The fragment preserves the
mid-body and part of the convex moulded base
of a modiolus. This was a cylindrical drinking
vessel, similar to a modern mug.

Decoration Shown in white on the exterior is
part of a pillar standing on a square base. The
pillar is inscribed with horizontal lines and
hieroglyphs. Below this, indeterminate
elements form, perhaps, part of a plinth.

Comment The hieroglyphs on the narrow part
of the shaft suggest that the pillar may be an
obelisk, such as that seen on the Getty bottle
(JPGM 85.AF.84, see fig. 9 on p. 26 above;
Whitehouse 2007, 120 and fig. 30). However,
the horizontal lines on the pillar indicate that it
could perhaps be identified as a Nilometer,
used for measuring the changing water levels
of the Nile. In either case **20** clearly shows an
Egyptianizing scene (see also **21–4** and **41**).

The best example in cameo glass of the
cylindrical modiolus, much larger and finer
than **20**, is in The Metropolitan Museum of Art,
New York (17.174.47a), with a rustic scene of a
Bacchic shrine. Close parallels for the form in
silver are provided by two examples from the
House of the Menander, Pompeii (Stefani
2006a, 202, nos 284–5, inv. 145510–11), showing
two-horse chariots (*bigae*) driven by cupids.

A variant of the shape has a more conical
form, still with a simple flat base but with
flaring walls and a wide, often offset rim.
Guzzo (2006, 84–5) cites in particular MANN,
inv. 25368, describing this form as a *calathus*.
Interestingly, the same form in Arretine ware is
described as a modiolus (Ettlinger 1990,
170–71, form R3). Ettlinger dates the form to the
'early to mid-Tiberian' period, i.e. AD 15–25
(approximately).

The vessel was made using the dip-overlay
method. The decoration was achieved by
carving away the opaque white glass when
cold, using traditional lapidary techniques.

Bibliography Simon 1957, pl. 18

21
Fragment of an open form
1868,0501.8
H. 2 cm, W. 1.4 cm, TH. 0.15 cm (purple 0.1 cm,
white 0.05 cm).
Provenance unrecorded; bequeathed by Felix
Slade, 1868, formerly in the Uzielli collection.
About 15 BC–AD 25

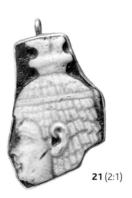

21 (2:1)

Glass The fragment is made of translucent
purple glass overlaid with opaque white. There
is extensive pitting and several elongated
diagonal bubbles on the forehead, cheek and
hair.

Fragment/form The fragment has a small
lateral curvature, and the thickness of the wall
strongly indicates that it was an open vessel,
but the piece is too small to allow a full
identification.

Decoration Shown in white is a female
Egyptian head, with hair (or wig) in at least
seven layers of locks, bound with a band or
diadem. Surmounting the head is the lower
part of a crown, comprising a plinth, above
which were other elements (perhaps a solar
disc or feathers).

Comment The presence of the crown suggests
that the female is either a goddess or a queen.
The absence of the upper elements of the crown
makes closer identification impossible.

Internal grinding marks, together with the
curvature seen from the side and above,
confirm that this is a vessel fragment. The
elongated bubbles are consistent with those
seen in blown-glass blanks, though their
orientation – uniformly skewed approximately
45° to the right (viewed from the front) – is
unusual (a more vertical orientation is typical).
The thickness of the wall is similar to that of the
Morgan Cup (about 4–5 mm).

The vessel was made using the dip-overlay
method. The decoration was achieved by
carving away the opaque white glass when
cold, using traditional lapidary techniques.

Bibliography Slade 1871, 3, no. 8

22
Fragment of a skyphos with incuse decoration
1999,0803.1
H. 5.3 cm, W. 3.2 cm, D. (body max.) 10.5 cm,
TH. 0.5 cm (lower blue 0.1 cm, white 0.3 cm,
upper blue 0.1 cm).
Formerly in the Sangiorgi collection, sold at
Christie's, New York, 3 June 1999, 61, no. 137
(part).
About 15 BC–AD 25

22

Glass The fragment is made of translucent blue
glass overlaid with opaque white and
translucent blue. There is extensive black
weathering on the white glass and partly over
the blue. There is some iridescence and much
pitting on the outer surface.

Fragment/form The fragment preserves much
of the curved wall and the beginnings of the
upright rim of a cup or skyphos.

Decoration This fragment is unique amongst
all the British Museum pieces and is extremely
rare in surviving cameo glass, because of its
incuse decoration. This was achieved by cutting
through the initial upper blue layer in order to
reveal the design cut into the white, central
layer. The bottom layer of blue served as a
background and deep colour field for the
decorative scene. As well as being in an unusual
form, the decoration itself is of very high
quality.

Bailey (2007) discusses the picture at length.
The main scene shows a male figure on the
right, almost certainly a king, kneeling on a
plinth or step and offering to a deity an
Egyptian U-shaped, *wesekh* collar (ceremonial
collar) with one surviving floral terminal. The
right hand and wrist of the king are preserved,
as are his knees, partly covered by a decorated
shendyt (ceremonial kilt). The strap at the front
of the kilt is decorated with four motifs,
including a rosette and a *uraeus* (sacred
serpent). His upper body is clothed. Of the deity
standing on the left, only one hand survives,
holding a sceptre. Sceptres are held by both
male and female deities, so no closer
identification is possible.

At the top of the fragment in fairly light
relief, having lost most of the white glass, is a
motif that can be identified as a feathered sun-
disc, flanked by *uraei*. This was probably part of
a band of such motifs forming a border to the
main scene and underlining the rim of the
vessel.

Comment This is one of only three known examples of an incuse-decorated cameo glass vessel. In this it differs from plaques with white sandwiched between blue and the design then carved in relief in an upper white layer, of which type the British Museum possesses several examples (**49–51**, **54** and **56–60**). It is an interesting point that the other incuse example, in The Metropolitan Museum of Art, New York (17.194.370), also shows an Egyptianizing scene, though of uncertain meaning. It is, however, heavily formed and lacks the fine detail of **22**. The third piece (now untraceable) was exhibited in London in 1895 (Burlington 1895, no. 27). It showed a 'standing goddess … and the head of the goddess Hathor' and was described as extremely fine.

The Egyptianizing scene in this volume recalls other vessels and plaques in this volume, notably **21– 4** and **41**. The pose of the figure and his costume are very closely paralleled by kneeling figures of assistants on platforms, supported by lotus flowers, on the obsidian cups from Stabiae (MANN, inv. Stabiae 396–7; De Caro 2006, 212–14). The figure on **23** wears a broad decorated collar that is in some ways similar to that on **22**, though without visible terminals.

The vessel was made using the dip-overlay method with white opaque glass sandwiched between two layers of translucent blue. The decoration was then cut through the upper blue layer into the white. The white layer thins towards the top of the fragment, and elongated bubbles on the outer blue layer show that the original vessel was stretched. The white layer is also thinner at the top because the inner blue layer would have been dipped into the white glass only as far as was initially necessary and gravity would have forced the white layer downwards. An added (unintentional?) effect of the thickened white layer is to give a thicker, lighter background to the scene, creating almost the effect of a glow.

Bibliography Sangiorgi 1914, 48, no. 156; Bailey 2007; Christie's (New York) Auction Catalogue, 3 June 1999, 61, lot no. 137 (part)

23
Fragment of cup
EA 16600
H. 2 cm, W. 2.4 cm, D. (body max.) 9.9 cm, TH. 0.4 cm (blue 0.3 cm, white 0.1 cm).
Provenance unrecorded; acquired in the early nineteenth century.
About 15 BC–AD 25

23

Glass The fragment is made of translucent dark blue glass overlaid with opaque white.

Fragment/form The curvature of the fragment suggests that it is from the wall of an open vessel, perhaps a cup.

Decoration Shown in white is the neck, body to the waist and most of the arms of a person in three-quarter view to the right. The right arm is bent up across the body and the left arm is held forwards and is almost certainly also bent. She or he wears a garment falling in vertical folds with buttoned elbow-length sleeves, finishing above the elbow. This seems to be a Greek-style *chiton* rather than an Egyptian-style garment. She or he also wears a broad collar decorated with rosettes and edged with beads, and a broad bracelet with hatched design on the right wrist.

Comment Cooney (1976, 36, no. 330) regarded the fragment as Ptolemaic and noted that the costume is 'elaborate and unusual'. He suggested that the fragment came from a scene showing a king making sacrifices, yet if the identification of the clothing as a *chiton* (above) is correct, then the figure must be female and portrayed in a Hellenized way. This blend of Egyptian and Hellenistic is also visible in the Getty bottle, where classical cupids inhabit a landscape that includes an obelisk decorated with hieroglyphics (see fig. 9 on p. 26 above; Whitehouse 2007, 120, fig. 30).

Egyptian influence is undeniably apparent in the decorated broad collar, and the figure may therefore represent a female royal figure or even a deity. A similar broad collar is worn by a female, perhaps Hathor, Isis or a queen, presenting a squatting figure of the goddess Maat on a cameo glass fragment in Karlsruhe that was found in early imperial contexts at the Rhine frontier fort at Walldürn (Simon 1957, 46 and n. 4, pl. 14.1). A vessel fragment in a private collection illustrated in Weiss and Schüssler (2001, 248, Abb. 29 a–b) shows an Egyptian character wearing an ornate collar. The piece is very unusual in that it comprises three coloured glasses, white, blue and, most unusual of all, brown.

An elaborate *wesekh*, or broad collar, is being raised up towards the image of a deity on the cameo glass piece in the British Museum collection with incuse, or sunk, relief decoration (**22**). With regard to Cooney's (1976, 36) dating of the piece as Ptolemaic, however, there is no reason to believe that this piece, in spite of its association with the then Department of Egyptian Antiquties, should be different in either its origins or date, from the other pieces in this catalogue.

The vessel was made using the dip-overlay method. The decoration was achieved by carving away the opaque white glass when cold, using traditional lapidary techniques.

Bibliography Cooney (1976), 36, no. 330; Weiss and Schüssler (2001), 223 and n. 93

24
Fragment of a cup
1999,0927.1
H. 3 cm, W. 4 cm, D. (body max.) 11.4 cm, TH. 0.35 cm (blue 0.3 cm, white 0.05 cm).
Formerly in the Sangiorgi collection; bought from Christie's, New York, 3 June 1999, 61, lot 137 (part).
About 15 BC–AD 25

24

Glass The fragment is made of translucent deep blue glass overlaid with opaque white. There are traces of brownish weathering on both sides.

Fragment/form The fragment preserves the lower part of the wall. The curvature suggests that the fragment comes from a cup or bowl.

Decoration Pictured in white is part of a reed boat, decorated with two rosettes. It is propelled by a figure whose right foot and part of an ankle-length garment survive. A pole is shown diagonally across the boat and in the water. The foot of a companion is visible to the left behind the punter. Underneath to the right is a lotus pod, and two other vegetal motifs appear to the left under the boat.

Comment The reed boat and punter are in full Egyptian style and appear in other media. Examples in mosaic include those in the lower part of the immense Nilotic mosaic in the Museo Archeologico at Palestrina, near Rome (Dunbabin 1999, 50 and 47), and a comic representation of three pygmies in a reed boat on a central motif, or *emblema*, from the House of the Menander, Pompeii (De Caro 2006, 158). A terracotta 'Campana' plaque in the British Museum (1805,0703.317) also shows a comic representation of punting in a reed boat.

The break in the punting pole coincides with a broken bubble and it is possible that the damage occurred when the decorator removed the unwanted white overlay on either side of it.

The vessel was made using the dip-overlay method. The decoration was achieved by carving away the opaque white glass when cold, using traditional lapidary techniques.

Bibliography Sangiorgi (1914), 48, no. 156; Christie's (New York) Auction Catalogue, 3 June 1999, 61, lot no. 137 (part)

25
Fragment of a skyphos(?)
1860,0928.13
H. 2.6 cm, W. 4.8 cm, D. not measurable, TH.
0.8 cm (blue 0.8 cm).
Provenance unrecorded; bought through A.W.
Franks on the continent.
About 15 BC–AD 25

25

Glass The fragment is made of translucent
greenish blue glass overlaid with opaque white.
The white glass is exceedingly thin and has, to a
large extent, weathered away, remaining only
on the ivy leaf. There is white weathering in
patches with some iridescence and pitting on the
exterior surface. Similar patches of
weathering and pitting occur on the interior.

Fragment/form The fragment preserves part
of an open vessel, probably a skyphos. Viewed
from above, the wall thickness rapidly
increases from left to right.

Decoration Shown in white on the exterior is
a pattern of ivy leaves and tendrils.

Comment The thickness of the wall might at
first indicate a closed vessel, but the thickening
of the glass to one side is similar to that seen on
some skyphoi, indicating the proximity of a
handle. It is likely, therefore, that the piece
formed part of a skyphos. The white glass of the
scroll design has largely disappeared, but the
'ghost' of the design in the blue glass illustrates
that it was originally finely executed.
 This fragment was mislaid in 2002.

The vessel was made using the dip-overlay
method. The decoration was achieved by
carving away the opaque white glass when
cold, using traditional lapidary techniques.

Bibliography Simon 1957, pl. 18

26
Fragment of a cup
1868,0501.137
H. 4 cm, W. 4 cm, D. (body max.) 10.5 cm,
TH. 0.25 cm (bluish green 0.1 cm, white 0.15 cm).
Provenance unrecorded; bequeathed by Felix
Slade, 1868.
About 15 BC–AD 25

26

Glass The fragment is made of semi-
transparent bluish green glass overlaid with
opaque white. There are patches of brownish
white weathering and pitting on both surfaces.

Fragment/form The fragment preserves part
of the wall of a vessel. The curvature and the
variation in the wall thickness suggest that it
may come from the upper portion of a bowl
or cup.

Decoration Shown in white on the exterior are
branches and leaves, perhaps laurel or olive.

Comment In several collections there are
fragments very like **26**, and they seem to form a
group of cups that are very similar in concept
and execution. Given that the type of long, thin
leaf that appears on the cups cannot be
identified with certainty (though olive seems
the most likely candidate), they are referred to
as 'spear-leaf' cups. In the Gorga collection,
Rome, and in Leiden there are numerous
similar fragments, those at Leiden comprising
parts of at least five such vessels (personal
observation). One piece at Leiden preserves
much of the body. It is broad and fairly shallow
with a curved wall.
 All examples seem to share the light-
coloured base glass and all have a thin, light
feel. The colours used in these cups are nearly
always pale blue or pale green. Rather than
attaching any chronological significance to the
group (i.e. that their lighter, less accomplished
execution might in some way indicate a later
period of production), it is perhaps more useful
to see them as a separate manufacturing batch,
made perhaps by the same glassmakers and
carvers as made the main work on the blue
group. It is certain, we would argue, that they
were intended for a slightly different market.
The people who bought the spear-leaf cups
were probably not the same people who bought
the Morgan Cup and related pieces.
 The vegetal decoration seen on these cups
has parallels in Arretine ware. Mould
fragments found during excavations at Santa
Maria in Gradi (Arezzo) in 1883 (Paturzo 1996,
passim) produced vessels decorated with long
horizontal leaves, very similar in form and
arrangement to those seen on cameo glass
fragments. One of the moulds was signed
'BARGAT' (= Marcus Perennius Bargathes),
whose output at Arezzo is dated by Philip
Kenrick (2000, nos 1404–6) to AD 1–30. Sherds
of Arretine ware decorated just like the spear-
leaf cups are found in several collections, for
example in the Ashmolean Museum, Oxford
(Brown 1968, pl. 13, no. 55), and Rome (Vannini
1988, 25 and 62–3, cat. nos 23–4.) The examples
in the Museo Nazionale, Rome, are typical of
the production of M. Perennius Tigranus, dated
by Kenrick (2000, 323–4, nos 1411–16) to 15
BC–AD 10.

The vessel was made using the dip-overlay
method. The decoration was achieved by
carving away the opaque white glass when
cold, using traditional lapidary techniques.

Bibliography Slade 1871, 25, no. 137; Simon
1957, pl. 18

27
Fragment of a dish or bowl
1976,1003.9
H. 3 cm, W. 4.2 cm, TH. (max.) 0.85 cm
(turquoise 0.7 cm max., white 0.15 cm max.).
Provenance and origin unrecorded.
About 15 BC–AD 25

27

Glass The fragment is made of opaque white
glass overlaid with milky-opaque turquoise
blue and opaque white. The threshold between
the coloured layers is flat and well defined.
There are traces of brownish weathering film
on both surfaces, as a result of which the back is
slightly rough. The white glass is partly worn
away.

Fragment/form The roughly rectangular
fragment preserves part of the floor of an open
form, perhaps a dish or bowl, with a raised
'button' on the underside.

Decoration Shown in white on the upper side
of the floor is a ground line, perhaps
representing a masonry step or podium. On this
structure, to the right, is the lower part of a
chubby, youthful male figure, standing or
walking to the right. At the left are the lower
legs of a draped female figure. Behind her is
part of a column or tree. Between the two
figures is an insect with large decorated wings,
presumably a butterfly, flying to the right.
Below the butterfly is a long tapering object
lying on the podium. It has both vertical and
horizontal striations, and curved elements
issuing from one end (rendered nearly invisible
by the loss of the white glass over them).

Comment The figure on the right is likely to be
Cupid, and the association of Cupid with a
butterfly might suggest that the decoration
shows an element of the story of Cupid and
Psyche. Psyche – in Greek the word for a
butterfly and also for spirit or soul – was a
Greek princess who fell in love with Cupid.
After many trials and tribulations (mainly
caused by the opposition of Cupid's mother
Aphrodite to the affair) their union was finally
blessed by Jupiter/Zeus. Since Psyche is nearly
always shown in Roman art with butterfly's
wings or as a butterfly, the standing female
could be the disapproving Aphrodite.
 Cupid's iconographic relationship with the
butterfly is not always a happy one for the poor
insect (LIMC III, 1, 969–71, and III, 2, 684–5).
Cupid is portrayed doing terrible things to the
butterfly, such as burning it on an altar (LIMC
III, 1, 970, no. 102), shooting it with his arrows
(LIMC III, 1, 969, no. 96) or even nailing it to a
tree (LIMC III, 1, 969, no. 97). In the scene
shown in **27** the rapport seems happier. The
long object on the podium is, we believe, a
torch made of sticks or rushes. The torch, with
its bright but dangerous fire, is a symbol of love,
extremely well suited to a setting containing

Cupid and a butterfly (Psyche?). The fact that it is lying on the ground might be an indication of difficult times for love.

The initial, striking feature of **27** is the unusual nature of its base glass. Its colour, a turquoise green, is unusual enough, but it is also milky-opaque glass, perhaps made by adding white glass to a standard glass mixture. Use of this type of glass is rare in the cameo pieces known to us. There are three other pieces in the British Museum, two cups (**12**, **13**) and the wall of a bowl (**28**). Elsewhere, as far as we know, there are only seven other milky-opaque examples, including plaque fragments in the Rijksmuseum van Oudheden (Leiden), The Toledo Museum of Art and the Thorvaldsen Museum, and vessel fragments in Toledo, The Corning Museum of Glass and the Gorga collection in Rome (Università la Sapienza).

The scarcity of milky-opaque cameo glass makes it extremely likely that **27** and **28**, sharing the same unusual glass colour and the similar distribution of bubbles and pitting, were part of the same vessel. If so, it would be an example of a vessel that was decorated on both the interior (i.e. the floor of **27**) and the exterior of the wall (**28**). Double-sided pieces are known from the British Museum – the possible oscillum (**61**) – from the Römisch-Germanisches Museum, Cologne (N. 6382a; Naumann-Steckner 1989, 82–3, no.12), and from Toledo (25.1566b), but **27/8**, in opaque glass, is unique.

It seems unlikely that the carver would have left the vessel to balance on the button base, so we should perhaps assume the presence of a ring-foot (now lost). The vessel was probably made using the dip-overlay method, but there is a slight possibility that it was cast. The decoration was achieved by carving away the opaque white glass when cold, using traditional lapidary techniques. The 'button' on the back was probably formed by cold working, which involved cutting the glass around to leave the button in relief, though it was possibly made by cutting its shape into the flat surface of the refractory mould in which the glass layers were cast.

Bibliography Simon 1957, pl. 17; Weiss and Schüssler 2001, 204, n. 15

28
Fragment of a dish or bowl
1868,0501.138
H. 2.6 cm, W. 3.0 cm, D. (body max.) 16.8 cm, TH. (max.) 0.4 cm (turquoise blue 0.1–0.3 cm, white 0.1 cm).
Provenance unrecorded; bequeathed by Felix Slade, 1868.
About 15 BC–AD 25

28

Glass The fragment is made of milky-opaque turquoise blue glass overlaid with opaque white. The exterior surface is dull, with traces of brownish weathering. There are patches of similar weathering on the interior and pitting on both surfaces.

Fragment/form The curvature suggests that this is a fragment of a vessel, perhaps a medium-sized cup or small bowl.

Decoration Shown in white on the exterior of the piece is the bough of a tree, dividing in two near the bottom and part branching out towards the top. At the right edge of the fragment is a very small part of another element.

Comment Given the scarcity of milky-opaque cameo glass it is highly likely that this piece was originally part of the same vessel as **27**. In this case it would constitute a vessel with carved decoration on both sides. Cameo glass vessels with a body of milky-opaque glass are in themselves very rare (for discussion see **27**), but the combination with double-sided decoration makes **27/8** unique amongst cameo glass pieces known to us.

The vessel was probably made using the dip-overlay method, but there is a slight possibility that it was cast. The decoration was achieved by carving away the opaque white glass when cold, using traditional lapidary techniques.

Bibliography Slade 1871, 25, no. 138; Simon 1957, pl. 18

29
Fragment of a pyxis
1868,0501.134
H. 3.6 cm, W. 3.5 cm, D. 11.1 cm, TH. 0.4 cm (blue 0.3 cm, white 0.1 cm).
Provenance unrecorded; bequeathed by Felix Slade, 1868.
About 15 BC–AD 25

29

Glass The fragment is made of translucent dark blue glass overlaid with opaque white. There is brownish weathering with slight iridescence on both surfaces.

Fragment/form The fragment preserves part of the rim and wall of a fairly shallow vessel with a curved wall. The cut-back upper edge of the rim with small raised rear edge (now broken away) resembles lid seatings found on vessels in pottery and glass. The vessel is very probably a pyxis (a cylindrical lidded box).

Decoration Shown in white on the exterior is a bird in profile facing right, catching an insect in its beak. Above the insect are parts of two stems with double rows of small oval leaves.

Comment The bird, with its squat angular form, may be compared with the birds on the Auldjo Jug (**2**), the Blue Vase (Harden *et al.* 1987, 75–8, no. 33), a fragment in The Corning Museum of Glass (Whitehouse 1997, 63, no. 72) and the birds on a rim fragment of a dish in Toledo (23.1590). The insect is difficult to identify because the white glass, presumably very thin when it was new, has almost completely disappeared. It does not have the large, spotted wings that usually characterize a butterfly (see **27** above), so it is likely to be a wasp or bee.

The smoothed upper surface of the rim with the narrow projection at the interior indicates that this was in all probability seating for a lid, in which case the vessel was almost certainly a pyxis. Although contemporary monochrome, mosaic glass and gold-band examples are not unusual (for example, Harden *et al.* 1987, 42, no. 18; Grose 1989, 335, no. 587, 338, nos 602–4), we know of only two pyxides in cameo glass. Apart from **29** there is a rim fragment in Leiden (personal observation), part of a fairly deep, straight-walled vessel, with decoration of foliage and fruit.

The vessel was probably made using the dip-overlay method, but there is a slight possibility that it was cast. The decoration was achieved by carving away the opaque white glass when cold, using traditional lapidary techniques.

Bibliography Slade 1871, 24, no. 134; Simon 1957, pl. 18

30
Fragment of a dish or bowl (or patera?)
1976,1003.1
H. 3.4 cm, W. 4.5 cm, D. (foot ring) approx. 11.8 cm, TH. (bottom) 0.6 cm (blue 0.3 cm, white 0.3 cm).
Provenance and origin unrecorded.
About 15 BC–AD 25

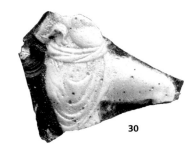
30

Glass The fragment is made of translucent dark blue glass overlaid with opaque white. Both glasses are rather bubbly. There are iridescence and pitting on the exterior surface and traces of brownish weathering film on the underside.

Fragment/form The fragment preserves the lower part of the floor of an open vessel. On the underside is a foot ring with a flat extremity, offset from a slightly rounded bottom. The foot is largely chipped away.

Decoration Shown on the inside, in white, are elements of the torso and upper legs of a male figure, standing to the right, with his left leg bent. His tunic is draped around the waist and

falls in semicircular folds to cover his thighs. Although only his lower body survives, he can be identified as a satyr by his tail, which emerges from the back of his tunic.

Comment This piece is decorated on the interior, indicating that it came from an open vessel such as a dish or plate, or even a patera like the cameo glass vessel from Pompeii in the Museo Archeologico Nazionale di Napoli (inv. 13688; Painter and Whitehouse 1990d, 153–4, no. A9; Asskemp *et al.* 2007, 257–8, no. 6.39, and 162, fig. 1). Other patera fragments include a base/floor sherd in Cologne (N. 6221; Naumann-Steckner 1989, 75–6, no. 3) and a handle with a ram's head terminal at Toledo (23.1586). The satyr is standing to the right with his left leg bent, suggesting that he is climbing up or resting his leg on something. Alternatively, he could be dancing or, very appropriately, treading grapes. His position relative to the foot ring suggests that he was accompanied by at least one other figure on the floor of the vessel. The bunching of the folds around his waist and consequent shortening of the garment are seen elsewhere in cameo glass, for example on the boy leading a goat to sacrifice on a fragment in Paris and on the young satyr fastening the canopy on the Morgan Cup (Painter and Whitehouse 1990d, 153–4, no. A9; Whitehouse 1997, 48–51, no. 47).

As all of the bubbles are spherical, it is likely that the blank was made by a casting process. This could have been done by pouring (or ladling) the glasses one on top of the other into an open refractory mould as for the blanks for cameo plaques, though in this case the bottom of the mould was slightly concave. Before the white glass was added, a tool (perhaps a convex plunger) was used to spread the blue glass over the mould in order to make the upper surface concave. Alternatively, it is possible that a blue and white glass blank was slumped over a form to create the shape. However, as the bubbles are all spherical, this seems less likely than the casting process described above. The decoration was achieved by carving away the opaque white glass when cold, using traditional lapidary techniques, and the foot and final form of the vessel were also formed by cold working.

Bibliography Simon 1957, pl. 18

31
Fragment of a dish or bowl (or patera?)
1976,1003.6
H. 4.3 cm, W. 2.6 cm, TH. 0.3 cm (blue 0.1 cm, white 0.2 cm).
Provenance and origin unrecorded.
About 15 BC–AD 25

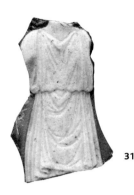

31

Glass The fragment is made of semi-transparent blue glass overlaid with opaque white. There are traces of brown weathering and pitting on both surfaces.

Fragment/form The fragment is concave, with decoration on the upper, concave surface, suggesting that it could form either the wall or the floor of a vessel. The small area of circular grinding marks near the top, wear scratches near the bottom and the lack of any width-ways internal curvature suggest strongly that it came from the floor of an open vessel.

Decoration Shown in white on the upper side (i.e. the floor of the vessel) is part of the torso of a female figure. She wears a *peplos*, a Greek-style garment buttoned on the shoulders, with an overfold to the waist falling down in vertical and semicircular folds. She moves to the left, with her left knee flexed in movement and with her head turned back. To the left of the figure are several lines, which are cracks through breakage.

Comment The *peplos* that the figure wears was no doubt originally knee length, as suggested by the long parallel folds on either side. She is in similar pose to the standing female attendant on the Morgan Cup (Whitehouse 1997, 48–51, no. 47), who carries a jug behind her and a tray in front. No. **31** may also, therefore, be part of a Bacchic scene. Another attendant in a very similar pose appears on a fragment at Toledo (1923.1564).

The vessel was probably a bowl or a small dish. It might have been a patera, as suggested for **30**, but its light colour and thin wall set it apart from other examples (see discussion in **30**).

The spherical bubbles throughout imply that the blank was cast by successively pouring two layers of glass into an open refractory mould with a slightly concave bottom, as **30**. The decoration was achieved by carving away the opaque white glass when cold, using traditional lapidary techniques.

Bibliography Simon 1957, pl. 18; Weiss and Schüssler 2001, 204 n. 15, 210, figs 18a–b

32
Fragment of a dish or platter
1886,1117.34
H. 3.0 cm, W. 2.8 cm, D. 26 cm, TH. 0.3 cm (blue 0.2 cm, white 0.1 cm).
Formerly in the Nesbitt collection, most of which was acquired in Rome; given by A.W. Franks.
About 15 BC–AD 25

32

Glass The fragment is made of translucent mid-blue glass overlaid with opaque white. The threshold between the two layers of glass is flat and well defined. All bubbles are spherical. There is brownish white weathering film on the upper surface and patches of brownish white weathering and pitting on the polished flat back.

Fragment/form The triangular fragment preserves part of the rim of a large dish or plate, with a notched or beaded white border.

Decoration Shown in white are several elements, perhaps leaves and stems. There is the possibility that the large, pointed element, top left, is in fact a bird rather than a leaf.

Comment The diameter and thinness of the piece suggest it formed the border of a large dish or plate. Such large dishes, as opposed to smaller dishes and bowls, were not common in cameo glass. Regarding the notching on the rim, three out of the four dish fragments in The Toledo Museum of Art have the same decoration (23.1590, 23.1601, 23.1607), though it appears on the inner white edge, not on the outer as **32**. A fragment in The Corning Museum of Glass (66.1.67; Whitehouse 1997, 47, no. 46) has notching around the inner and outer edges of the rim and around the outer edge as well. A piece in Cologne (N. 6224; Naumann-Steckner 1989, 79, no. 6) has a more formal bead-and-reel inner ridge above a dotted border.

The vessel was made using the dip-overlay method or perhaps a casting process. The decoration was achieved by carving away the opaque white glass when cold, using traditional lapidary techniques.

Bibliography Simon 1957, pl. 18; Weiss and Schüssler 2001, 224 n. 97

33
Fragment of a dish or platter

1879,0522.46
H. 6.2 cm, W. 5.3 cm, TH. 0.4 cm (blue 0.3 cm, white 0.1 cm).
Excavated in Capri; given by Greville John Chester.
About 15 BC–AD 25

33

Glass The fragment is made of translucent dark blue glass overlaid with opaque white. There is milky-white weathering and some pitting on both surfaces.

Fragment/form The modest but extant curvature of the fragment suggests that it is not from a plaque but, rather from a flattish vessel, perhaps a dish or tray, of considerable diameter. The evidence of the cutting marks on the back, the alignment of the bubbles in the blue glass and the variation in the thickness of the vessel wall do not allow for further identification.

Decoration Shown in white on the exterior are part of a vine leaf and a small part of the stalk of another leaf.

Comment Other open vessels in cameo glass, such as the dishes at Toledo and Corning and the paterae at Naples, Cologne and the British Museum have fairly flat bases and flattish rims. The curvature in **33** suggests that the fragment does not come from the base but from the broad, slightly curved rim of a large dish or platter.

The presence of this large vessel on Capri is interesting, given that the island is the findspot for another other large vessel, a huge purple glass dish or 'table top' now in The Metropolitan Museum of Art, New York (81.10.347). It is said to be from the Villa Iovis, the residence of the Emperor Tiberius on the island. Assuming the provenance to be true (and the attractiveness of a well-known findspot for antiquities should always be borne in mind), then the presence of cameo glass in an imperial context has implications for its perceived value in its contemporary environment.

The vessel was made using the dip-overlay method or perhaps a casting process. The decoration was achieved by carving away the opaque white glass when cold, using traditional lapidary techniques.

Bibliography Simon 1957, pl. 18

Plaques

34

Roundel cut from a plaque: the Portland Vase disc

1945,0927.2
D. 12.2 cm, TH. blue 0.4 cm (max.), TH. white 0.15 cm (max.), W. (groove on underside) 0.8 cm, W. (groove on outside of edge) 0.15 cm.
Probably from Rome.
About 15 BC–AD 25

Glass The disc is made of translucent blue glass overlaid with opaque white. There is no iridescence on the decorated side but some pitting. There is iridescence on the undecorated back, which extends over both the broad groove on this side and also into the small groove on the outer extremity. There is a slight difference in appearance between the weathering in the two grooves, but close examination shows them to be the same. The difference in appearance can be put down to a greater degree of weathering stain remaining in the grooves after modern cleaning. This suggests very strongly that both these grooves were made on the disc in antiquity, before the vase and its 'new' base were buried.

The disc has been broken and mended. One major break runs straight to the left of the figure's head. A second break, more curved and less immediately visible, passes through the head and proper left shoulder. This break seems to post-date the other and is not visible in James Tassie's cast made in 1782 (p. 35).

Fragment/form The disc is perfectly rounded, with a broad, shallow groove around the outer edge of the underside and another, smaller groove around the extremity which gave a moulded profile to the improvised base.

Decoration Shown in white is the upper part of a young man in profile gazing to the right; the forefinger of his right hand is raised towards the chin. He wears a distinctive, eastern-style, folded-over 'Phrygian' cap and a short-sleeved tunic over a long-sleeved undergarment; a cloak, fastened at the throat with a circular brooch, billows out behind him. Behind and above the figure are a branch and foliage.

Comment

Relationship to the vase The disc appears to have been added as a new base to the truncated Portland Vase (1), almost certainly in antiquity (Gudenrath, Painter and Whitehouse 1990, 21–3, 38–9, figs 24–7; Gudenrath and Whitehouse 1990, 118–21). It evidently does not belong to the original composition of the Portland Vase, since it differs in colour, composition and style. In any case the original form of the vase is now acknowledged to have been an amphora with a pointed base, similar to the Blue Vase in Naples (see p. 31 above, summarized in Gudenrath and Whitehouse 1990, 108–9 and fig. 70). The disc as it stands is complete, except for a small chip on the undecorated underside. It is clear, however, that the disc itself was cut down from a much larger composition, almost certainly a plaque similar to (though larger than) those from Pompeii now in Naples (MANN, inv. 153651–2; Painter and Whitehouse 1990d, 154–7, figs 118–19) and the Carpegna plaque, originally from Rome and now in Paris (Musée du Louvre, Bj 1779; Painter and Whitehouse 1990d, 160–61, fig. 123).

History Nicolas-Claude de Peiresc, to whom we owe the first mention of the Portland Vase in 1600/1601, also provides the first unequivocal evidence for the attachment of this disc to its base. In a letter of 1626 to the Flemish painter Peter-Paul Rubens, he writes that he has received drawings of the vase that included the figure on the base (Jaffé 1989, 557–8, no. 9). We can, therefore, be sure that in the early seventeenth century the disc was attached to the vase with the carved scene facing outwards. It was removed from the bottom and replaced by a plain blue disc by John Doubleday in 1845 (Painter and Whitehouse 1990a, 69) during his restoration of the Portland Vase, and was not put back as the base of the vase by J.H.W. Axtell during his restoration in 1948. Thus, since 1845 the Portland Vase disc has been displayed separately, and since 1948 it has been possible to examine the grozing on the bottom of the vase, which has been closely scrutinized in recent years by Harden, Gudenrath and others (cf. Harden 1983, 45–8; Gudenrath, Painter and Whitehouse 1990a, 22, fig. 9). One of the many pieces of new information to emerge from Gudenrath's research was his discovery (Gudenrath and Whitehouse 1990, 120) that the disc, as we now see it, is too large for the base aperture of the vessel and that it may have been the intention of the person who repaired the vase to cut away more of the lower body of the vase than was actually done.

The Tassie casts reveal the condition of the vase and the attached base disc in 1781 or 1782 (Haynes 1995, 151–2; Gudenrath, Painter and Whitehouse 1990, 23). They show one crack in the body of the vase and another across the base disc. If positioned logically with the cracks beginning at the same point, then the figure of the young man would be aligned squarely with the seated male figure **E** on side B of the vase identified by Painter and Whitehouse (1990c, 135) as Paris. On the Tassie casts these cracks (and therefore the two figures) are no longer in alignment. This suggests that, after the episode of damage that caused these cracks, there was further damage and the disc was taken off and put back into place on a different alignment. We do not know how long before 1626 the bottom of the vase was originally broken and the disc attached, though it is almost certain to have happened in antiquity (Gudenrath, Painter and Whitehouse 1990, 21; Gudenrath and Whitehouse 1990, 121).

Identification of the man Frowning slightly, he holds a curved finger to his mouth, a timeless gesture expressing, perhaps, concentration, indecision or concern. Rubens identified the figure as Paris, Prince of Troy, whose choice of Venus/Aphrodite at the contest of the goddesses led to the Trojan War (Rooses and

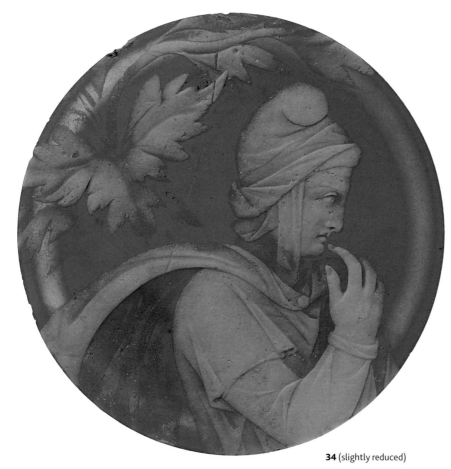

34 (slightly reduced)

Ruelens 1909, 128, letter dcccii; Möbius 1967/8, 26 and n. 46; Jaffé 1989, 558, no. 27), and this interpretation of the pensive young man in his Asiatic costume has been generally accepted ever since (Harden *et al.* 1987, 66–7, no. 30; Gudenrath, Painter and Whitehouse 1990, 22). The importance of the decision he is about to take is mirrored in his body language. The rest of the scene may originally have shown the other protagonists (Venus/Aphrodite, Minerva/Athena and Juno/Hera).

For both the mythological interpretation of the Portland Vase (illustrating the story of Peleus and Thetis) and the historical interpretation (the rise of Rome and of Augustus and the fall of Troy), the contest at which Paris adjudicated is particularly apt as it took place at the wedding of Peleus and Thetis and precipitated the Trojan War. It has been suggested, surely correctly, that Paris was chosen for this very reason (Painter and Whitehouse 1990c, 136) and that this choice must have been made in antiquity (Gudenrath and Whitehouse 1990, 118–21), thus supporting the early date for the original repair/replacement of the base.

Workmanship and the original plaque The quality of the carving of the disc is very fine, probably the finest surviving example of a cameo plaque and, relatively speaking, as high as that of the Portland Vase with which it is associated. Interestingly, its scale is also in a different class from all other cameo glass plaques. The head of Paris, at 4 cm, is one third larger than those of Bacchus or Ariadne on the complete Pompeian plaques. Assuming that the figure of Paris were shown in full, this would then give him a height of approximately 23–4 cm as opposed to the 17–18 cm of Bacchus. The plaque would, presumably, be correspondingly larger – perhaps 27–8 × 40 cm. Yet **34** at 0.3 cm thick is much thinner than either of the Pompeian plaques (0.7–1.0 cm). The impression is of a grander, finer composition.

It seems unlikely that a complete plaque – certainly not one of such accomplishment – could or would have been cannibalized in early modern times. Surviving intact would have been difficult enough, and if, as with the Carpegna plaque, it had been known since the seventeenth century (Painter and Whitehouse 1990d, 160–61 and fig. 123), it would have been recognized as a masterpiece in its own right, hardly as scrap to be used as a repair.

The plaque from which the disc was cut was made using the casting process. Layers of different-coloured glass were successively ladled or poured into a shallow, flat-bottomed, open refractory mould. The decoration was achieved by carving away the opaque white glass when cold, using traditional lapidary techniques. The blue side and edge were also carefully cold-worked, no doubt by turning the disc using a lathe-like machine while pressing tools against the glass to abrade away, then polish the glass.

Bibliography Simon 1957, 4, Taf. 5,2; *Journal of Glass Studies*, vol. 32 (1990); Dawson 1995; Jenkins and Sloan 1996; Walker 2004; Brooks 2004; Haynes 1995; Hind 1995; Daumas 1998; Eisenberg 2003 and 2004; Whitestone 2007, 116–17

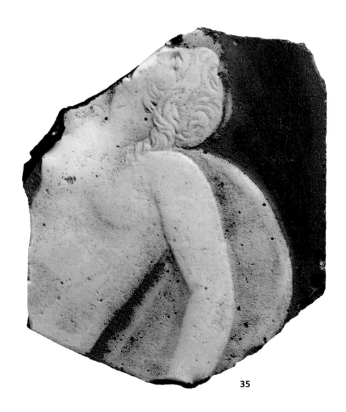

35

35
Fragment of a plaque
1976,1003.14
H. 9.5 cm, W. 8.3 cm, TH. (max.) 0.65 cm (purple 0.5 cm, white 0.15 cm max., but elsewhere exceedingly thin).
Provenance and origin unrecorded.
About 15 BC–AD 25

Glass The fragment is made of translucent reddish purple glass overlaid with opaque white. There is brownish white weathering and pitting on the white glass and pitting on both surfaces of the purple glass.

Fragment/form The fragment was part of a rectangular plaque. One edge has been flattened, though it is not original.

Decoration Shown in white are the head and upper body of a woman reclining to the right; flying out behind her is her cloak, against which lies her bent left arm. The upper part of her right arm stretches up in front of her head, with the poorly preserved lower arm and hand angled down behind. She has long hair falling forwards in wavy locks on either side of her neck. Her breasts are small and simply indicated.

Comment The woman on **35** is extremely similar to the female on the cameo glass plaques from Pompeii (MANN, inv. 153651–2; Painter and Whitehouse 1990d, 155–7 and figs 118–19), identified with some certainty as Ariadne, the consort of Bacchus. Her pose is identical to that of Ariadne on plaque 153652, suggesting that they show the same person, and that the plaque, when complete, may have shown a scene very similar to the Pompeii example. The hair of the woman in **35** is very like that of the females on the Portland Vase and, apart from her lack of a headband, is identical to that of Ariadne on plaque 153652. The similarity of pose and the treatment of the figures suggest that the plaques may have come from the same workshop.

The flattened side is extremely unlikely to be a true edge. Every surviving edge fragment of a plaque known to us has an edge that is uneven and rounded in section. The presence of multiple scratches all over the surfaces and side are probably linked to the process of trimming the broken edge.

The flat back appears not to have been ground and has a slightly rough, pitted surface. Bubbles visible in the white glass are spherical, while some in the purple glass are elongated. This suggests that the plaque was cast. After the purple glass was poured or ladled into the flat open refractory mould, it was forced to spread outwards using a tool, perhaps a rolling pin, thus distorting the bubbles while rapidly hardening the glass. Whether the white glass was similarly treated cannot be determined. If it was, it remained soft long enough for the distorted bubbles to become round again, due to the surface tension of the soft glass surrounding the bubble. The decoration was achieved by carving away the opaque white glass when cold, using traditional lapidary techniques.

Bibliography Simon 1957, pl. 17

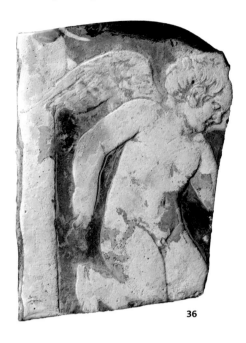

36

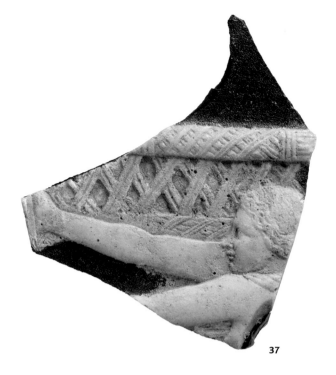

37

36

Fragment of a plaque
1923,0401.1203
H. 8 cm, W. 5.8 cm, TH. 0.45 cm (blue 0.4 cm,
white 0.05 cm).
Provenance and origin unrecorded.
About 15 BC–AD 25

Glass The fragment is made of translucent
dark blue glass overlaid with opaque white.
There are no visible bubbles in either layer. The
upper surface is covered by flaking, brownish
white film, with some iridescence on both
surfaces.

Fragment/form The roughly rectangular
fragment was part of a rectangular plaque.
There is one original edge surviving, slightly
uneven, like the edges of the plaques from
Pompeii. The very flat back may have been
ground smooth, but it is too weathered to say
with certainty.

Decoration Shown in white is a winged figure
of Cupid looking down in three-quarter view to
the right. His right leg is bent up behind him
and only the top of the left leg is preserved. His
right arm hangs down behind him and the
upper part of his left arm is visible, held down
in front. Behind him, partly covered by his
wing, is either the frame or, if it is part of the
decoration, perhaps a pillar or a tree.

Comment The presence of Cupid indicates that
the plaque, like the two complete plaques from
the House of Fabius Rufus, Pompeii (MANN,
inv. 153651–2; Harden *et al.* 1987, 70–3, no. 32),
showed a scene of (almost certainly, Bacchic)
love. Yet even if the nature of the plaque is
fairly certain, the exact role of Cupid is more
difficult to ascertain. His pose and his
downwards gaze make it likely that he was in
the air, like Cupid on the Portland Vase on p. 35
and the cupids on the plaques from Pompeii. It
is conceivable that **36**, like Cupid on the
Portland Vase, was holding a torch or a bow.
The face and wings of **36** are quite different
from those of the cupids on the Pompeii
plaques, and have much more in common with

Cupid on the Portland Vase and the cupids
emerging from the sea on the large dish
fragment in The Metropolitan Museum of Art,
New York (17.194.358).

The plaque was made using the casting process.
Layers of different-coloured glass were
successively ladled or poured into a shallow,
flat-bottomed, open refractory mould. The
decoration was achieved by carving away the
opaque white glass when cold, using traditional
lapidary techniques.

Bibliography Walters 1926, 378, no. 4037

37

Fragment of a plaque
1976,1003.18
H. 8.4 cm, W. 7.5 cm, TH. 0.7 cm (purple 0.5 cm,
white 0.2 cm max.).
Provenance and origin unrecorded.
About 15 BC–AD 25

Glass The fragment is made of translucent
purple glass overlaid with opaque white. There
is a well-defined and flat threshold between the
purple and white glass, and all the bubbles are
spherical. There is brownish white weathering
film with some iridescence and pitting on the
upper surface. The surface of the back is
somewhat rough with brownish weathering
film and pitting.

Fragment/form The fragment formed part of a
plaque, almost certainly rectangular.

Decoration Shown in white is the upper part of
a young man facing left, with short hair and
with his arms stretched out in front of him. He
holds a pole in his right hand (only a small part
of which survives), and his posture suggests
that he may have grasped it in his left hand, too.
His cloak, around his neck, may be flying out
behind him or falling down his back. Behind
and above his head, and possibly resting on his
shoulder, is an object with spirally wound
upper and lower borders, separated by
latticework or basketwork.

Comment Too little of this originally
rectangular plaque survives to interpret the
scene, and the identity of the object of which
the latticework/basketwork is part cannot be
determined. The apparent straining of the arms
might suggest that the young man was doing
more than simply grasping the pole, but it is
unclear as to whether he is pulling or pushing
it. If the pole was attached to the latticework
object, then he may have been supporting or
carrying one end of it, possibly with a second
figure supporting the other end. One possibility
(of perhaps many) is that the man is helping to
carry a piece of furniture or some kind of basket
(for agricultural produce).

The plaque was made using the casting process.
Layers of different-coloured glass were
successively ladled or poured into a shallow,
flat-bottomed, open refractory mould. The
decoration was achieved by carving away the
opaque white glass when cold, using
traditional lapidary techniques.

Bibliography Simon 1957, pl. 17

38

38

Fragment of a plaque
1976,1003.19
H. 5.9 cm, W. 7.5 cm, TH. 0.5 cm (purple 0.4 cm, white 0.1 cm).
Provenance and origin unrecorded.
About 15 BC–AD 25

Glass The fragment is made of translucent deep purple glass overlaid with opaque white. All bubbles are spherical, and there is a well-defined, flat threshold between the two coloured layers. The upper surface of the purple glass is shiny with patches of brownish weathering film, which also appear on the white glass. The surface of the back is somewhat rough and dulled with whitish, weathering patches and slight pitting.

Fragment/form The roughly triangular fragment formed part of a plaque, almost certainly rectangular.

Decoration Shown in white on the left is the head and upper torso of a satyr turned to the front. His head is in profile to the right, with his hair in a knot. He possibly wears an animal skin on his chest. On his left shoulder he is carrying a goat, the forepart of which is visible. The goat turns its horned head back to look towards the satyr. To the right of the scene is an unusually smooth, curving, tree trunk, and there may be part of a branch above the goat's head.

Comment The depiction of a satyr shows that the plaque, in common with the vast majority of other known cameo plaques, featured a Bacchic scene. The shaggy hair and the topknot is seen on other satyrs, for example on the skyphos in the J. Paul Getty Museum (Harden *et al.* 1987, 68–9, no. 31) and on the patera from Pompeii with the satyr as the central motif (Painter and Whitehouse 1990d, 152–4, figs 116–17). It is not restricted to satyrs and is used, for example, on the cupids on the Blue Vase (Harden *et al.* 1987, 74–8) and on the charioteer – perhaps also a cupid – on the fragment in The Metropolitan Museum of Art, New York (17.194.374).

The plaque was made using the casting process. Layers of different-coloured glass were successively ladled or poured into a shallow, flat-bottomed, open refractory mould. The decoration was achieved by carving away the opaque white glass when cold, using traditional lapidary techniques.

Bibliography Simon 1957, pl. 17; Weiss and Schüssler 2001, 211 and n. 37

39

Fragment of a plaque
1976,1003.15
H. 4.2 cm, W. 3.8 cm, TH. 0.7 cm (blue 0.65 cm, white 0.05 cm).
Provenance and origin unrecorded.
About 15 BC–AD 25

39 (1.5:1)

Glass The fragment is made of translucent dark blue glass overlaid with opaque white. There are patches of brownish white weathering film and pitting on both surfaces. The back is flat, with a somewhat granular surface. The indentation in the figure's forehead marks the position of a large burst bubble. The fragment is grozed around the head.

Fragment/form The fragment formed part of a plaque.

Decoration Shown in white is the bearded head of an elderly man, in profile to the left. His beard and receding hair are arranged in wavy locks.

Comment The elderly man shown on 39 is very likely to be Silenus, the tutor and companion of the god Bacchus/Dionysus. The image – of an extremely high level of craftsmanship – seems too formal and sculptural to represent a living person, so it is very likely to be a sculpted bust or 'herm'. The Silenus on a herm on the bottle from Torrita di Siena provides a close parallel (Painter and Whitehouse 1990d, 145–7, fig. 10, no. A5; Casini 1992, tav. LVa). Another similar herm (though on a much smaller scale) is found on a fragment in The Corning Museum of Glass (66.1.55; Whitehouse 1997, 53, no. 50).

In silver tableware there are numerous good parallels for Bacchic herms and masks: for example, on two skyphoi from the House of the Menander, Pompeii (MANN, inv. 145508–9; Stefani 2006a, 200–201, cats 282–3), on two canthari from the House of Inachus and Io (MANN, inv. 25380–81; Lista 2006, 170–71, cats 217–18) and on a cup decorated in very rich and high relief from the Hildesheim treasure (Biroli Stefanelli 1991, 272, no. 93 and figs 169–71).

The plaque was made using the casting process. Layers of different-coloured glass were successively ladled or poured into a shallow, flat-bottomed, open refractory mould. The decoration was achieved by carving away the opaque white glass when cold, using traditional lapidary techniques.

Bibliography Simon 1957, pl. 17

40

Fragment of a plaque
1976,1003.3
H. 1.8 cm, W. 1.6 cm, TH. 0.4 cm (purple 0.2 cm, white 0.1 cm).
Provenance and origin unrecorded.
About 15 BC–AD 25

40 (2:1)

Glass The fragment is made of translucent purple glass overlaid with opaque white. There are traces of brownish weathering and pitting on both surfaces.

Fragment/form The fragment is very small and difficult to interpret, but its flat back suggests it belonged to a plaque.

Decoration Shown in white on the left is a face, turned right, looking at the remains of another face (probably female), turned left.

Comment The confronted faces are in a proximity that implies intimacy. The presence of a helmet on the male figure may identify him as a warrior, a hero or a god. The scene may originally have represented Mars, god of war, with his consort Venus, goddess of love.

The back is perfectly flat though rough, with no sign of grinding. This, together with spherical bubbles in the glass, suggests that the blank was made by casting the two glasses, the white over the purple, in a flat, open refractory mould. The decoration was achieved by carving away the opaque white glass when cold, using traditional lapidary techniques.

Although the fragment is very small, its flat upper surface and rough underside indicate that it is part of a plaque rather than a vessel. Furthermore, the flatness of the back suggests that the mould may have been made of stone.

Bibliography Simon 1957, pl. 18 (inverted)

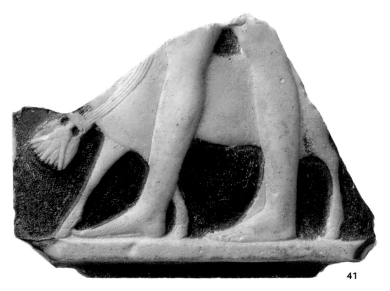

41

42

41

Fragment of a plaque
EA 16630
H. 6.5 cm, W. 9.5 cm, TH. 0.75–1.00 cm (purple
0.7–0.8 cm, white 0.05–0.2 cm).
Provenance and origin unrecorded.
About 15 BC–AD 25

Glass The fragment is made of translucent
purple glass overlaid with opaque white. The
surfaces of both the purple and the white glass
are pitted with some brownish and iridescent
patches.

Fragment/form The fragment preserves the
corner of a rectangular plaque with part of the
lower and left-hand edges preserved. The
fragment thickens towards the top and there is
a thin ledge on the front at the bottom
paralleled by a groove on the back.

Decoration Shown in white are the legs of a
man, perhaps a priest or attendant, walking to
the left on a thick, raised, white ground line.
Just visible above his knees is a fragment of the
hem of his tunic or kilt. Behind him and also
walking to the left is a (young?) bull, wearing a
band or sash around its neck, with a tassel
made of lotus flowers tied together. Most of the
body and the legs of the bull are preserved.

Comment The theme of a sacrificial bull
wearing a lotus is traditional in Egyptian art.
Drawing on these earlier traditions, Cooney
(1976, 36) quoted a parallel for this sacrificial
theme in a stone sculpture, which dates from
early in the Ptolemaic period (later fourth
century BC). He regarded the cameo glass
fragment itself as early Ptolemaic 'or very
slightly earlier' (i.e. fourth to third centuries
BC). We believe that such an early dating of a
piece of cameo glass, as well as the implication
of an Egyptian, specifically Alexandrian,
manufacture, is now untenable. There seems
no reason to separate this plaque from the
others discussed here, whether in terms of
tradition, chronology or place of manufacture.

A wall painting from the House of the
Orchard, Pompeii, of a garden scene includes a
pinax, or decorative plaque, set in a frame. The
pinax shows a bull with exactly the same type of
pendant around its neck, almost certainly about
to be sacrificed in connection with the rites of
the goddess Isis (Bragantini 2006, 166, fig. 6).

In one respect, however, the plaque is
unusual. Given the proportions and the spacing
of the figures, it is likely that the right-hand edge
was not far beyond the present break. If so, then
it is conceivable that this plaque, in contrast to
most other cameo glass plaques known, focused
on a small number of subjects and, importantly,
was originally in portrait (i.e. vertical) format.
The exact function of the plaque, as with all
cameo plaques, remains uncertain, though the
groove on the back may have facilitated the
insertion of the plaque into another object, for
example a display frame or a piece of furniture
such as a box or chest. The plaque is in purple
glass, the preferred colour for all the large
plaques and other unusual pieces (see above,
p. 33). The piece was interesting enough to catch
the eye of Apsley Pellatt when he wrote his
Curiosities of Glassmaking in 1849. He describes
it (Pellatt 1849, 139) as a 'Curious specimen of
ancient cased Glass, of the same class as the
Portland Vase'.

The plaque was made using the casting process.
Layers of different-coloured glass were
successively ladled or poured into a shallow,
flat-bottomed, open refractory mould. The
decoration was achieved by carving away the
opaque white glass when cold, using
traditional lapidary techniques.

Bibliography Pellatt 1849, 139 and pl. 3;
Cooney 1976, 36, no. 33, pl. 1; Tatton-Brown
1991, 65, fig. 78; Tait 1991, 65, fig. 78; Weiss and
Schüssler 2001, 223 and n. 93

42

Fragment of a plaque
1923,0401.1204
H. 7.2 cm, W. 7.8 cm, TH. bottom 0.5 cm (blue
0.3 cm, white 0.2 cm), TH. side 0.4 cm (blue 0.3
cm, white 0.1 cm).
Provenance and origin unrecorded.
About 15 BC–AD 25

Glass The fragment is made of semi-
translucent, dark blue glass overlaid with
opaque white. There is brownish white, flaking
weathering film on the upper surface and in
patches on the back. There is iridescence and
pitting on both surfaces. All the visible bubbles
are spherical.

Fragment/form The irregular, four-sided
fragment formed part of a rectangular plaque.
The pose of the figure in the scene suggests that
the lower edge of the fragment seems to be
close to the original edge of the plaque. Yet
neither this edge, nor the left-hand edge is in
fact original.

Decoration Shown in white are the lower legs
of a male figure walking to the right on a white
ground line. Between the legs and partly
covering the forward left one is the lower part
of an unidentified object, narrowing to a point.
Behind the figure is an uneven, vertical shape,
possibly the trunk of a tree.

Comment This figure is walking in a natural
way like the young man (**A**) on the Portland
Vase, although here his left foot is ahead of his
right. The toes of the man's right foot are very
finely carved, as are those of the left foot of
figure **A** on the Portland Vase and the toes of
several of the figures on the Pompeii plaques.
Not enough survives of the pointed object to
permit any firm conclusion about its identity.
Walters (1926, 379) took it to be drapery, but
the lack of any folds, and the odd way in which
any garment would have to hang to be in this
position, make this unlikely. Another
possibility, given the implied size of the object
and its pointed end, is that it is a wine amphora.
No similar scene has been identified, and the
identification cannot be made with any
certainty, but the presence of a wine amphora
would certainly not seem out of place, given
that Bacchic iconography is seen so frequently
on cameo glass. If the object was indeed an
amphora, then it is very likely, in view of the
evidence from other complete and fragmentary
plaques, that the feet and legs may belong to a
satyr.

The flat back is too weathered to detect any
grinding marks. All visible bubbles are
spherical, indicating a casting process. Layers
of different-coloured glass were successively
ladled or poured into a shallow, flat-bottomed,
open refractory mould. The decoration was
achieved by carving away the opaque white
glass when cold, using traditional lapidary
techniques.

Bibliography Walters 1926, 379, no. 4038;
Simon 1957, pl. 17

43

male, since other naked figures portrayed from behind in a similar way in cameo glass include the man on the multiple-layered fragment in Corning (Whitehouse 1997, 51–2, no. 48a). Others might argue that the apparent widening of the body at the buttocks, and the lack of a pronounced musculature or iliac ridge at the hip, suggests that the figure is more likely to be female. If so, she may be a deity, perhaps Venus or one of the Graces.

The back of the piece is flat and shows some signs of having been ground, although the marks form no discernible pattern. The numerous bubbles in the greenish colourless glass are spherical, indicating a casting process. Layers of different-coloured glass were successively ladled or poured into a shallow, flat-bottomed, open refractory mould. The decoration was achieved by carving away the opaque white glass when cold, using traditional lapidary techniques.

Bibliography Simon 1957, pl. 17

43
Fragment of a plaque
1976,1003.16
H. 10.5 cm, W. 9 cm, TH. 0.5 cm (colourless 0.4 cm, white 0.1 cm).
Provenance and origin unrecorded.
About 15 BC–AD 25

Glass The fragment is made of almost colourless glass with a slight greenish tint, overlaid with opaque white. There is brownish white film over the white upper surface and patches of film and pitting on both colourless glass surfaces.

Fragment/form The fragment comes from a plaque, almost certainly rectangular. The left edge of the fragment is straight and smooth, though its position in relation to the scene suggests it is not ancient.

Decoration Shown in white is the rear of a naked torso, from the middle of the back to the buttocks. The torso is seen in three-quarter view, probably facing the viewer's right and leaning slightly in that direction. To the right are traces of the figure's right arm or drapery.

Comment It is conceivable that this figure is

44
Fragment of a large plaque
1976,1003.13
H. 10.6 cm, W. 14.3 cm, TH. 1.3 cm (purple 0.9 cm, white 0.4 cm max.).
Provenance and origin unrecorded.
About 15 BC–AD 25

Glass The fragment is made of translucent deep purple glass overlaid with opaque white. There is brown weathering film and iridescence on the upper surface. The back is nearly flat and has been ground, leaving marks in the same way as on the inside of cameo glass vessels, in this case the pattern being broad arcs (see drawing, p. 90).

Fragment/form The irregularly shaped fragment comes from a large and almost

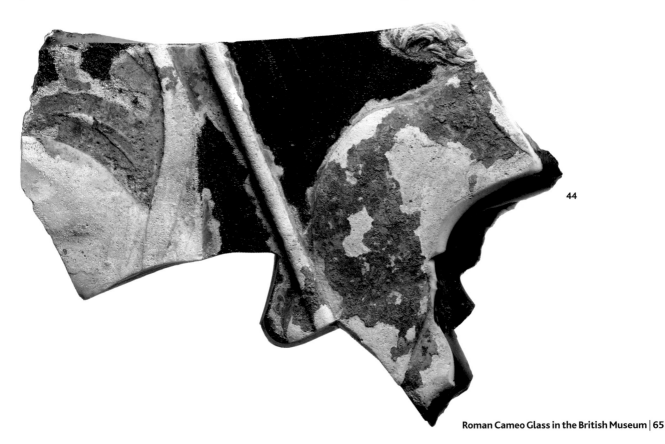

44

certainly rectangular plaque. Considerations of thickness and colour suggest that **44**, **44a** and **45** are elements of the same plaque.

Decoration Shown in white on the upper surface are parts of two figures. On the left is part of a draped figure, the drapery billowing. On the right are the lower torso and upper thighs of a figure. Between the two figures is a pole-like object.

Comment The figure on the right has a tail, and this, combined with the comically fierce angle at which he is thrusting his buttocks, identifies him as a satyr. This pose, less extremely held, finds a parallel in the right-hand satyr on the Carpegna plaque in the Musée du Louvre, Paris (Painter and Whitehouse 1990d, 160–61 and fig. 123). If, then, the scene is Bacchic, this might suggest that the seated or reclining figure on the left is Ariadne or a maenad, if female, or Bacchus himself, if male. The pole-like object can now, surely, be interpreted as a *thyrsus* (the long staff topped by a pine cone, sometimes with ivy or pine leaves, carried by Bacchus and his followers). The figures are depicted in high relief, much higher than that of the Pompeii plaques and are well carved, reflecting the large scale (and high quality) of the plaque.

Two more fragments in the British Museum (**44a** and **45**), together with fragments of a large plaque in the Gorga collection, Università la Sapienza, Rome, and one fragment in the Thorvaldsen collection, Copenhagen, have the same proportions, colour, theme and sculptural quality as this piece. We believe it is likely that they form part of the same plaque, or of a small number of plaques of extremely similar size and feel. The Greek-inscribed fragment (**45**) makes explicit a religious and possibly Bacchic link.

Nearly all of these 'sculptural' plaques, together with fragments of different themes but of equally large scale at The Corning Museum of Glass (66.1.60, 72.1.12; Whitehouse 1997, 44 and 46, nos 40–41) and other large-scale pieces such as the 'table top' (81.10.347) and the architectural edging plaque (18.145.38) in The Metropolitan Museum of Art, were made in purple glass. It is likely, we believe, that there was some form of 'prestige' production in purple glass intended for the upper end of the market. In some cases (the 'table top' from Capri and – perhaps – the Portland Vase) these may have been meant for the imperial family itself.

It is assumed that the difference in colour had some significance, but the grouping of certain plaques and vessels according to glass colour would have had little meaning if the glass was not going to be seen. This raises some questions about the plaques in particular and how they were meant to be viewed.

From the examination of many hundreds of fragments of glass, it is clear that the different colours are not easily differentiated unless they are lifted to the light. The rich purple and dark blue backgrounds, when placed on a normal surface with light reflecting from them, look almost identical – so why did the Roman craftsmen bother to make the different colours? Why is there a clear grouping of larger, more prestigious pieces in purple glass if they all look the same when placed on an opaque ground? The answer may be that they were not always, if at all, intended to be seen in this way.

It is possible that they were inserted into decorative schemes on a wall – a common use of small tableaux in wall painting – but this would leave them largely devoid of any meaningful difference in colour. Certainly, against a dark background the white would be thrown into relief, but the background colour, though perhaps discernible, would be less important. In addition, none of the plaque fragments seen by us has any trace of fixative, though this may have disappeared over time.

For this reason we believe that these plaques were perhaps not always meant to be seen against a solid background, such as a wall. Similarly, they are perhaps unlikely (in their primary use, at least) to have been inserted into large, elaborate furniture. Instead, we believe that they might have been set into some form of structure or frame that allowed light to pass through the plaque, revealing the rich colour of the background. This could have been a stand as seen on Pompeian wall paintings of internal rooms and external spaces such as gardens (Asskemp *et al.* 2007, 104, Abb. 11), or it could have been a screen with more than one plaque set into it, as perhaps was the case with the plaques from Pompeii (Harden *et al.* 1987, 71–2). Whether the illumination was provided by natural daylight or by lamps or torches, the background colour was an essential part of the plaque and had to be seen.

Given the thickness of the fragments and the depth, scale and quality of their carved decoration, the plaque from which these fragments came was probably larger and more accomplished than the Pompeii plaques. In common, however, with the Pompeian plaques (Harden *et al.* 1987, 70–73, no. 32), the fragments in the British Museum have no trace of plaster or fixative visible on the back, making it again likely that they were originally mounted in frames on stands or screens.

The few visible bubbles in the layers of glass are spherical, indicating the casting process; the layers of different-coloured glass were successively ladled or poured into a shallow, flat-bottomed, open refractory mould. The decoration was achieved by carving away the opaque white glass when cold, using traditional lapidary techniques.

Bibliography Simon 1957, pl. 17; Weiss and Schüssler 2000, 226, nn. 105–6

44a
Fragment of a large plaque
2005,0803.6
H. 4 cm, W. 5.9 cm, TH. 1.2 cm (purple 0.9 cm, white 0.3 cm).
Provenance and origin unrecorded.
About 15 BC–AD 25

44a

Glass The fragment is made of translucent deep purple glass overlaid with opaque white. Brown film and iridescence are evident on the upper surface, and pitting and iridescence on the underside.

Fragment/form The irregular four-sided fragment formed part of a large plaque. Considerations of thickness and colour suggest that **44**, **44a** and **45** are almost certainly elements of the same plaque.

Decoration Shown in white is a small part of an element, perhaps a figure(?).

Comment The plaque was made using the casting process. Layers of different-coloured glass were successively ladled or poured into a shallow, flat-bottomed, open refractory mould. The decoration was achieved by carving away the opaque white glass when cold, using traditional lapidary techniques.

Bibliography Unpublished

45
Fragment of a large plaque
1868,0501.143
H. 9.3 cm, W. 11 cm, TH. 0.9 cm (purple 0.75 cm, white 0.15 cm).
Provenance unrecorded; bequeathed by Felix Slade, 1868, formerly Thibaut collection.
About 15 BC–AD 25

Glass and technique The fragment is made of translucent purple glass overlaid with opaque white. The back is rough and not particularly flat. The opaque white glass seen from the right edge is slightly countersunk into the surface of the wine-coloured glass.

Fragment/form The roughly rectangular fragment preserves the lower edge and part of the scene of a large, rectangular plaque. There is brownish white weathering film, iridescence and pitting on both surfaces, with considerable iridescence along the bottom of the upper surface. Considerations of thickness and colour suggest that **44**, **44a** and **45** are almost certainly elements of the same plaque.

Decoration Shown in white is a plinth and three or four horizontal striations. Below, extending across the whole of the surviving fragment, is an incomplete inscription in Greek, '[Π]ΙΘΥꞶΝ ΤΟΠΟ[…]', evidently giving the name of a place (Greek *topos*).

Comment Inscriptions are very unusual on cameo glass; the only other surviving example known to us is a fragment in the Römisch-Germanisches Museum, Cologne, formerly in the collection of Adalbert von Lanna, Prague (N. 1009; Naumann-Steckner 1989, 73–4, no. 1), which is inscribed '[…]ΙΑΙ ΔΙΟΝΥCΟC N[…]'. In Lanna 1909, vol. II, Taf. J, a third fragment with a Latin inscription, of which '[…]O VITAE BI[…]' can be read, may show a Bacchic female figure and seems to have a crab in the outer register, perhaps a zodiacal reference. This piece was also in the Lanna collection. The inscription on **45** appears to include some form of the noun ΤΟΠΟC, which

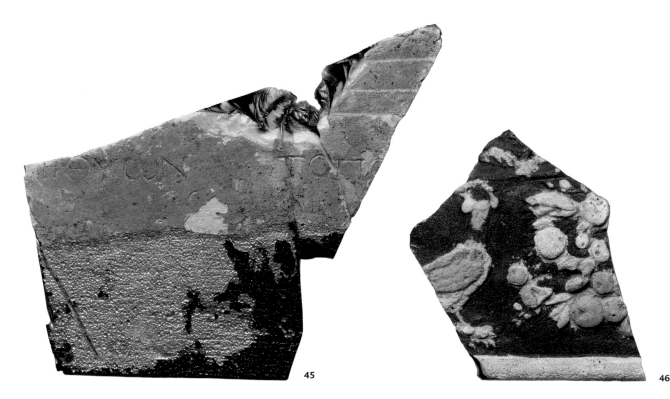

45

46

means 'place' and so the words may refer to the place where the scene depicted on the plaque occurred. Dr Alan Johnston suggests the restoration ΕΠΙΘΥΩΝ, 'sacrificing', and a possible reading of the second word is ΤΟΠΩ, a form of the dative, 'at the place'. This might suggest two other missing words, the first in the nominative giving the name of the sacrificer, the last, in the genitive, giving the name of the deity to whom the ΤΟΠΟΣ was sacred. That deity was almost certainly Bacchus, since not only is he explicitly mentioned in the only other surviving inscribed piece (above), but most plaques with recognizable themes feature iconography connected with him and his cult.

Above the broad band bearing the Greek inscription are several smaller horizontal bands. It is possible that these formed part of a formal masonry structure, perhaps the support for a figure or figures, or a building, such as a temple, shrine or altar, given the nature of the inscription. A fragment in Vienna preserves part of a (sacred?) serpent in an architectural setting – perhaps a shrine (Simon 1957, Taf. 16.9). Alternatively, they could be part of a naturally stepped rocky outcrop, as on the Portland Vase (1). Such stepped, rocky plinths are shown on a number of cameo glass vessels and plaques. Note in particular the steps on the Carpegna plaque (Painter and Whitehouse, 1990d, 160–61, no. A 14; Whitehouse 1991, 25, no. 10) and also the rocky outcrops on which Ariadne reclines on one of the Pompeii plaques (Harden *et al.* 1987, 70, no. 32a), on the Portland Vase and on the Getty skyphos (Harden *et al.* 1987, 68, no. 31). Given the Bacchic nature of much of the iconography of cameo glass, the rustic atmosphere that the natural outcrops help to create seems very appropriate.

The edge of the plaque is uneven, and this, together with the highly iridescent area along the edge, which was surely not meant to be seen, suggests that it had some sort of frame enabling it to be displayed, perhaps with the light behind it (see discussion in **44** above).

The plaque was made using the casting process. In this instance, immediately after the purple glass had been formed flat, opaque white glass was poured or ladled onto its surface. The newly added glass, which did not reach the lower edge of the purple glass, was then flattened with a tool. The downward pressure caused the white glass to be forced into the purple glass, giving rise to the countersunk appearance visible from the right edge. The decoration was achieved by carving away the opaque white glass when cold, using traditional lapidary techniques.

Bibliography Slade 1871, 35, no. 143

46
Fragment of a plaque
1868,0501.133
H. 5.5 cm, W. 5.5 cm, TH. 0.5 cm (purple 0.4 cm, white 0.1 cm).
Provenance unrecorded; bequeathed by Felix Slade, 1868, formerly Thibaut collection.
About 15 BC–AD 25

Glass and technique The fragment is made of translucent purple glass overlaid with opaque white, opaque yellow and translucent deep green. Enamel-like weathering, black patches and pitting occur on both surfaces, with some iridescence on the back, leaving it grainy in texture. The threshold between the layers of coloured glass is uneven and tapers down towards the lower edge (see drawing, p. 90).

Fragment/form The roughly rectangular fragment preserves the lower edge of a rectangular(?) plaque.

Decoration A cock with folded wing moves to the right with its head turned back. The back of the cock's body is missing. To the right in front of it are branches laden with quinces or apples, a pear and a pomegranate, and above it are traces of foliage, possibly festoons or garlands.

A ground line is marked in white. The decoration is mostly in white, but yellow and green are added for the cock's chest and wing and for some of the fruit.

Comment This is, to our knowledge, the only example of a plaque in which more than two colours were used. It should be noted, however, that the two additional colours (yellow and green) were added separately as needed and were not, as is normally the case with cameo glass, applied in complete layers. Nevertheless, though damaged, the piece is quite unusual and it is interesting to note that the background colour is purple, the colour of many of the larger or more spectacular plaques in the British Museum (**44**, **44a** and **45**) and elsewhere (see discussion in **44**).

Although cockerels could be venerated in the ancient world and are seen in ancient tableware in a ritual context, for example on the silver cups from Moregine (MANN, inv. 86775–6; Mastroroberto 2006a, 236–7, nos 410–11), the cockerel on **46** may be a purely decorative device. Not enough of the plaque remains to be certain of its true theme.

The plaque was made using the casting process. In this instance, after being poured or ladled into a flat refractory mould, the purple glass was tooled to spread it over a larger area, thus distorting the bubbles in the glass. When the opaque white glass was added immediately thereafter, some of it flowed – or was forced by tooling – over and beyond the edge of the purple glass, thus leaving the downward-tapering threshold visible from the broken edge. The decoration was achieved by carving away the opaque white glass when cold, using traditional lapidary techniques. In addition, small amounts of opaque yellow and transparent green glass were added as required and shaped by tooling.

Bibliography Slade 1871, 24, no. 133; Simon 1957, pl. 17

47

Fragment of a plaque

1976,1003.20
H. 2.2 cm, W. 4.2 cm, TH. 0.6 cm (purple 0.4 cm, white 0.2 cm max.).
Provenance and origin unrecorded.
About 15 BC–AD 25

47

Glass The fragment is made of translucent purple glass overlaid with opaque white. There is brownish weathering film, iridescence and pitting on the upper surface. The back is flat and rough, with some pitting and brownish weathering. The threshold between the two layers of coloured glass is flat and well defined. All the visible bubbles are spherical.

Fragment/form The roughly rectangular fragment comes from a plaque, probably rectangular.

Decoration Shown in white is a grazing deer moving to the left. The front of the head, the back, tail and hooves are missing.

Comment This collection includes the hind legs of a deer on two other vessels, **8** and **9**.

The plaque was made using the casting process. Layers of different-coloured glass were successively ladled or poured into a shallow, flat-bottomed, open refractory mould. The decoration was achieved by carving away the opaque white glass when cold, using traditional lapidary techniques.

Bibliography Simon 1957, pl. 17

48

Fragment of a plaque

1976,1003.23
H 4 cm, W. 4 cm, TH. 0.5 cm (brown 0.4 cm, white 0.1 cm max.).
Provenance and origin unrecorded.
About 15 BC–AD 25

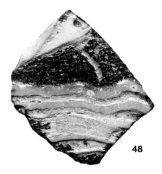

48

Glass The fragment is made of translucent olive brown glass overlaid with opaque white. There are brown patches, iridescence and extensive pitting and cracking on both surfaces. The back is flat and rough. The threshold between the two coloured layers is mostly flat and well defined, except where the white fills a slight depression in the brown. The bubbles are somewhat elongated.

Fragment/form The roughly square fragment formed part of a plaque, probably rectangular.

Decoration Shown in white is a series of wavy lines perhaps representing water (the sea?). Above is part of an element, perhaps (if the sea identification is correct), a sea creature.

Comment The wavy lines may be compared with the representation of the sea on a fragmentary plate in The Metropolitan Museum of Art (17.194.358), which depicts a chariot rising from the sea accompanied by cupids. The lines of **48** are much more pronounced.

Brown glass is normally restricted to small oval portrait panels such as those in The Corning Museum of Glass (70.1.16; Whitehouse 1997, 42, no. 37) and in the Römisch-Germanisches Museum, Cologne (Glas 6222). Apart from the two plaques (**48, 49**), it appears, as far as we know, only once, in a vessel fragment in a private collection (in Germany?) illustrated in Weiss and Schüssler (2001, 248, Abb. 29 a–b). This shows an Egyptianizing scene with brown and white layers on a blue background.

The plaque was made using the casting process. Layers of different-coloured glass were successively ladled or poured into a shallow, flat-bottomed, open refractory mould. The decoration was achieved by carving away the opaque white glass when cold, using traditional lapidary techniques. In this instance the elongated bubbles indicate that the soft glass was spread outwards to cover the surface of the mould more fully. The tool used could have been a type of rolling pin or perhaps a spatula.

Bibliography Simon 1957, pl. 19

49

Fragment of a plaque

1886,1117.41
H. 3 cm, W. 6 cm, TH. (max.) 0.4 cm (brown 0.4 cm).
Formerly in the Nesbitt collection, which was mainly acquired in Rome; given by A.W. Franks.
About 15 BC–AD 25

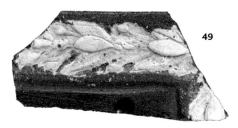

49

Glass The fragment is made of translucent dark olive brown glass (appearing black) overlaid with opaque white. The white glass is exceedingly thin. There is brownish white weathering film on the white decoration and on the back, which is flat and has a grainy texture. Viewed from the edge (see drawing, p. 90), the threshold of the decorative border is slightly countersunk below the mean upper surface level of the brown glass.

Fragment/form The roughly rectangular fragment comes from a rectangular plaque with one edge preserved. The decorated border area is marked off from the main field by a shallow groove.

Decoration Shown in white is a continuous band of laurel(?) or myrtle(?) berries and leaves around the border.

Comment Cameo glass plaques normally have fairly plain borders, characterized by an uneven edge and irregular interface of the white and coloured glass. Other than **49**, there are few fragments of cameo glass panels with a decorative border to the main scene. In the British Museum **46** has a garland of fruit and flowers with a central motif of a cockerel. A (side?) fragment in Leiden has a border of egg and dart (personal observation), while another side piece in Toledo (1923.1538) has a border of squared motifs next to the white panel edge (which could, however, be part of the design).

A fragment in the Museo Civico Archeologico in Aquileia has a bead-and-reel pattern, within which is a group of ivy leaves and tendrils (Mandruzzato and Marcante 2005, 43, 115 and 152 no. 343). A fragment of a dark blue tray now in the Museo Civico Archeologico in Bologna (Meconcelli Notarianni 1979, 34, no. 21) looks much closer in feel to **49** and is edged with white glass, from which has been carved, on the outer edge, an egg-and-dart border. The bunting above the scene on the Carpegna plaque in the Louvre (Painter and Whitehouse 1990d, 160–61 and fig. 123) seems to be a (largely modern) addition. Given its shape and scale, the architectural fragment from The Metropolitan Museum, New York, which shows an eagle in an inhabited acanthus scroll (18.145.38), almost certainly constituted a full border in its own right, and so cannot really be counted as a plaque fragment. A fragment of a similar architectural border is in the Gorga collection (personal observation).

The plaque was made using the casting process. Layers of different-coloured glass were successively ladled or poured into a shallow, flat-bottomed, open refractory mould. In this instance the countersunk threshold of the border decoration could have been achieved by one of at least two methods. In either case, after the brown glass had been ladled into a rectangular refractory mould, a shallow trough where the border was intended was formed by pressing or dragging a tool into or along the soft glass. Opaque white glass may then have been added and spread outwards and downwards, to fully cover the surface of the brown glass and to fill the trough. It is difficult to know what form the central decoration would have taken. There may have been painted decoration, for example. Alternatively (since we cannot be absolutely sure that there was cameo decoration in the centre of this plaque), the opaque white glass may have been poured or ladled directly only into the trough. After the object had been annealed, the edge was finished by partially grinding away glass.

Bibliography Simon 1957, pl. 19

50
Fragment of a plaque
1868,0501.135
H. 2.2 cm, W. 3.0 cm, TH. 0.7 cm (purple 0.5 cm,
white 0.2 cm max.).
Provenance unrecorded; bequeathed by Felix
Slade, 1868.
About 15 BC–AD 25

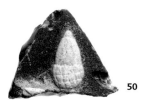

50

Glass The fragment is made of translucent
purple glass overlaid with opaque white. There
is brownish weathering film on both surfaces.
The back is flat and slightly rough. All visible
bubbles are spherical.

Fragment/form The triangular fragment
comes from a plaque, almost certainly
rectangular.

Decoration Shown in white is an acorn with
traces of a branch or leaf.

Comment Acorns occur among the garlands
on the Blue Vase from Pompeii (Harden *et al.*
1987, 75–8, no. 33).

The plaque was made using the casting process.
Layers of different-coloured glass were
successively ladled or poured into a shallow,
flat-bottomed, open refractory mould. The
decoration was achieved by carving away the
opaque white glass when cold, using
traditional lapidary techniques.

Bibliography Simon 1957, pl. 19

51
Fragment of a plaque
1868,0501.140
H. 1.9 cm, W. 3.0 cm, TH. 0.65 cm (blue 0.5 cm,
white 0.15 cm).
Provenance unrecorded; bequeathed by Felix
Slade, 1868.
About 15 BC–AD 25

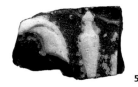

51

Glass The fragment is made of translucent
dark blue glass overlaid with opaque white.
There are patches of brownish weathering film
on both surfaces. The back is flat with a grainy
texture. The threshold between the two layers
of coloured glass is well defined, if slightly
uneven.

Fragment/form The roughly rectangular
fragment comes from a plaque.

Decoration Shown in white is part of a lotus
flower with a spear-headed central petal.

Comment Lotus flowers or palmettes of similar
fleur-de-lis type are found on a fragmentary
plaque of cameo glass in The Corning Museum
of Glass (Whitehouse 1997, 46, no. 44). They also
appear on other types of tableware, for example
on Arretine pottery of the Augustan period (25
BC to AD 10). They appear on finished vessels and
moulds, for example a mould for a deep bowl in
the Museum of Fine Arts, Boston (Chase,
Comstock and Vermeule 1975, 103–4, no. 122, pl.
xxviii), and several moulds in the Museo
Nazionale Romano (Vannini 1988, tavv. V–VIII).

The plaque was made using the casting process.
Layers of different-coloured glass were
successively ladled or poured into a shallow,
flat-bottomed, open refractory mould. The
decoration was achieved by carving away the
opaque white glass when cold, using traditional
lapidary techniques.

Bibliography Simon 1957, pl. 19

52
Fragment of a plaque
1886,1117.30
H. 2.3 cm, W. 5 cm, TH. 0.5 cm (blue 0.4 cm,
white 0.1 cm).
Formerly in the Nesbitt collection, most of
which was acquired in Rome; given by A.W.
Franks.
About 15 BC–AD 25

52

Glass The fragment is made of translucent,
deep blue glass overlaid with opaque white.
The surface of the blue glass is ground smooth
and is slightly pitted through weathering. The
opaque white is matte with pale brownish film
in patches and pits.

Fragment/form The narrow, rectangular
fragment formed part of a plaque.

Decoration Shown in white are elements that
may indicate drapery and/or part of the legs of
a figure, seated or standing in front of a stepped
structure.

Comment The plaque was made using the
casting process. The decoration was achieved
by carving away the opaque white glass when
cold, using traditional lapidary techniques.

Bibliography Simon 1957, pl. 19

53
Fragment of a three-layered plaque
1886,1117.43
H. 3.9 cm, W. 3.3 cm, TH. 0.6 cm (lower white
0.3 cm, blue 0.2 cm, upper white 0.1 cm).
Formerly in the Nesbitt collection, most of which
was acquired in Rome; given by A.W. Franks.
About 15 BC–AD 25

53

Glass The fragment is made of translucent
dark blue glass, sandwiched between two
layers of opaque white. The back of the plaque
appears to have been ground and polished.

Fragment/form The fragment comes from a
rectangular plaque. One original edge survives.
Both surfaces are covered by yellowish brown
weathering film. There is a raised, squared
border at the edge.

Decoration Shown in white are vegetal motifs,
comprising part of an acanthus leaf on the left
and a stem or branch on the right.

Comment This is the first of a series that has
the blue background colour backed by opaque
white glass to enhance the appearance of the
cameo-cut design by reflecting light. The
majority of examples with this white backing
also show vegetal motifs (**53– 8**). In fact,
considerations of decoration, thickness and
condition, and the three-layered structure
strongly suggest that **53– 8** once formed part of
the same plaque.

The plaque was made using the casting process.
Layers of different-coloured glass were
successively ladled or poured into a shallow,
flat-bottomed, open refractory mould. The
decoration was achieved by carving away the
upper layer of opaque white glass when cold,
using traditional lapidary techniques. In this
instance the pattern of glass displacement
around the bubble in **53**, as seen at the
threshold between the blue glass and the
opaque white glass, shows the order of
construction of the layers of coloured glass,
which differs from the norm. The first layer to
be formed was the relatively thin opaque white
front. Next came the layer of translucent blue
glass, to be followed immediately by the thick,
opaque white backing layer.

Bibliography Simon 1957, pl. 19

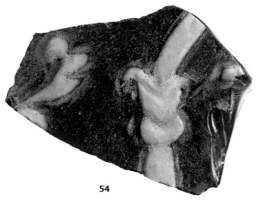

54

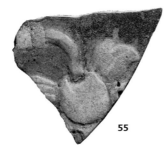

55

54
Fragment of a three-layered plaque
1886,1117.38
H. 5.1 cm, W. 7 cm, TH. (max.) 0.6 cm (lower white 0.2 cm, blue 0.3 cm, upper white 0.1 cm). Formerly in the Nesbitt collection, most of which was acquired in Rome; given by A.W. Franks.
About 15 BC–AD 25

Glass The fragment is made of translucent dark blue glass, sandwiched between two layers of opaque white. There is brownish white weathering film and some pitting and iridescence on both surfaces. The back is flat and ground smooth. The thresholds of the three layers are well defined and flat. All visible bubbles are spherical.

Fragment/form The roughly rectangular fragment comes from a rectangular(?) plaque.

Decoration Shown in white at the left are part of an acanthus leaf and at the right a stem with a bract separating the upper and lower parts. There are traces of another element to the right of the stem.

Comment The depiction of stems with prominent bracts can be seen on three other cameo glass plaques in this collection (**55– 7**). Considerations of decoration, thickness and condition, and the three-layered structure strongly suggest that **53– 8** once formed part of the same plaque.

The plaque was made using the casting process. Layers of different-coloured glass were successively ladled or poured into a shallow, flat-bottomed, open refractory mould. The decoration was achieved by carving away the upper layer of opaque white glass when cold, using traditional lapidary techniques.

Bibliography Simon 1957, pl. 19; Weiss and Schüssler 2001, 225 and n. 98, fig. 26

55
Fragment of a three-layered plaque
1886,1117.31
H. 3.6 cm, W. 4.3 cm, TH. 0.4 cm (lower white 0.2 cm, blue 0.15 cm, upper white 0.05 cm). Formerly in the Nesbitt collection, most of which was acquired in Rome; given by A.W. Franks.
About 15 BC–AD 25

Glass The fragment is made of translucent dark blue glass sandwiched between two layers of opaque white. There is a milky-white film on both surfaces. The back is flat and smooth. At the curving edge a cross-sectioned bubble is visible (see drawing, p. 90).

Fragment/form The triangular fragment is from a rectangular(?) plaque.

Decoration Shown in white are elements perhaps representing either fruit (quince/apple?) with leaves or a large stemmed flower with a circular centre and several flamboyant petals.

Comment Considerations of decoration, thickness and condition, and the three-layered structure strongly suggest that **53– 8** once formed part of the same plaque.

The plaque was made using the casting process. Layers of different-coloured glass were successively ladled or poured into a shallow, flat-bottomed, open refractory mould. The decoration was achieved by carving away the upper layer of opaque white glass when cold, using traditional lapidary techniques.

Bibliography Simon 1957, pl. 19

56
Fragment of a three-layered plaque
1886,1117.39
H. 2.8 cm, W. 3.8 cm, TH. 0.55 cm (lower white 0.2 cm, blue 0.25 cm, upper white 0.1 cm). Formerly in the Nesbitt collection, most of which was acquired in Rome; given by A.W. Franks.
About 15 BC–AD 25

56

Glass The fragment is made of translucent dark blue glass sandwiched between two layers of opaque white. There is brownish film and iridescence on the decorated side. The back is not perfectly flat but was ground and polished. Seen from the edge, the threshold between the opaque white back and the blue glass, while well defined, undulates, reflecting the slight

unevenness of the back. However, the threshold between the blue and outer opaque white layer is perfectly flat.

Fragment/form The roughly rectangular fragment comes from a plaque.

Decoration Shown in white are most of a lotus flower and part of a rounded petal at the left edge.

Comment The central petal of this lotus flower is more like a stalk for linking with another flower, suggesting that the design may have been similar to that on **54**. Considerations of decoration, thickness and condition, and the three-layered structure strongly suggest that **53– 8** once formed part of the same plaque.

The plaque was made using the casting process. Opaque white was poured or ladled into an open, not perfectly flat, refractory mould and then spread outwards to become thinner by tooling. Blue glass was added and smoothed perfectly flat. Finally, another layer of opaque white was added and smoothed to fully cover the blue glass. The decoration was achieved by carving away the upper layer of opaque white glass when cold, using traditional lapidary techniques.

Bibliography Simon 1957, pl. 19; Weiss and Schüssler 2001, 226, note 105

57
Fragment of a three-layered plaque
1886,1117.32
H. 2.2 cm, W. 3.2 cm, TH. (max.) 0.5 cm (lower white 0.3 cm, blue 0.1 cm, upper white 0.1 cm max.).
Formerly in the Nesbitt collection, most of which was acquired in Rome; given by A.W. Franks.
About 15 BC–AD 25

57

Glass The fragment is made of translucent dark blue glass sandwiched between two layers of opaque white. There are brownish weathering patches on both surfaces. The back is flat, ground and polished. The thresholds between the different layers of coloured glass are flat and well defined.

Fragment/form The roughly rectangular fragment comes from a plaque.

Decoration Shown in white is part of an acanthus leaf.

Comment Considerations of decoration, thickness and condition, and the three-layered structure strongly suggest that **53– 8** once formed part of the same plaque.

The plaque was made using the casting process. Layers of different-coloured glass were

successively ladled or poured into a shallow, flat-bottomed, open refractory mould. The decoration was achieved by carving away the upper layer of opaque white glass when cold, using traditional lapidary techniques.

Bibliography Simon 1957, pl. 19

58

Fragment of a three-layered plaque
1976,1003.22
H. 3.3 cm, W. 5.5 cm, TH. 0.4 cm (lower white 0.25 cm, blue 0.1 cm, upper white 0.05 cm).
Provenance and origin unrecorded.
About 15 BC–AD 25

58

Glass The fragment is made of opaque bright blue glass sandwiched between two layers of opaque white. There is a brownish weathering film and pitting on both surfaces. The back is very rough, though mostly flat. The thresholds between the different layers are very uneven. The bubbles are all spherical.

Fragment/form The roughly triangular fragment comes from a plaque.

Decoration Shown in white are elements of two indeterminate, vegetal motifs. One is perhaps a lotus flower with a spear-headed central petal, similar to that on **55**.

Comment Two edges are weathered and smoothed in a manner that indicates that the fragment may have been worn, perhaps in plough soil. Considerations of decoration, thickness and condition, and the three-layered structure strongly suggest that **58** once formed part of the same plaque as **53– 7**.

The plaque was made using the casting process. In this instance the opaque white areas on the upper surface seem not to be remnants of a full covering that has been cut away but are locally applied and fused into the surface of the blue glass before the precise decoration was carved. The decoration was achieved by carving away the upper layer of opaque white glass when cold, using traditional lapidary techniques.

Bibliography Simon 1957, pl. 19

59

Fragment of a five-layered plaque
1886,1117.40
H. 2.5 cm, W. 3.7 cm, TH. 0.7 cm (lower white 0.05 cm, next blue 0.1 cm, central white 0.2 cm, next blue 0.15 cm, uppermost white 0.2 cm max.).
Formerly in the Nesbitt collection, most of which was acquired in Rome; given by A.W. Franks.
About 15 BC–AD 25

59

Glass The fragment is made of opaque white glass overlaid with translucent blue, opaque white, translucent blue and opaque white. There are patches of brownish weathering on the outer and inner white surfaces. The back is flat and has been ground smooth. The thresholds of all five layers are flat and well defined. All bubbles are spherical.

Fragment/form The roughly rectangular fragment, broken on all sides, comes from a plaque.

Decoration Shown in white are vegetable motifs – branches and leaves or flowers on the left.

Comment To our knowledge, this is the only fragment of a plaque made of five layers.

The plaque was made using the casting process. In this case the cast and layered opaque white was covered by a thin layer of translucent blue, then a thicker layer of opaque white, another thin layer of translucent blue and, finally, opaque white, which was carved away to form the design. In the surviving fragment the decoration is carved in the uppermost (white) layer only. Although the third layer (also white) may have been intended to back the colour of the blue layer above it, the functions of layer four (blue) and layer five (white) are not clear. It is very unlikely that light would have penetrated to them, so they would have remained invisible. There is the possibility, however, that the major part of the decorative scheme of the plaque (which has not survived) was incuse, i.e. cut down into the layers, as in the vessel fragment (**22**). If so, this combination of standard cameo and incuse decoration would be unique.

Bibliography Simon 1957, pl. 19

60

Fragment of a three-layered plaque
1868,0501.107c
H. 1.4 cm, W. 2.2 cm, TH. (max.) 0.4 cm (lower white 0.05 cm, blue 0.2 cm, upper white 0.15 cm).
Provenance unrecorded; bequeathed by Felix Slade, 1868.
About 15 BC–AD 25

60
front
(2:1)

60
back

Glass The fragment is made of translucent dark blue glass, sandwiched between opaque white. There is brownish white weathering film and some pitting and iridescence on the lower white surface. The front is decorated, while the back and sides are polished smooth. The thresholds of the three layers are well defined and flat. All visible bubbles are spherical.

Fragment/form The fairly even rectangular fragment comes from a rectangular plaque. The decorated side of the sherd is its original, weathered state; the back and the bevelled sides have been highly polished.

Decoration Shown in white on the front are parts of three vegetal elements, one of which is sharply angled.

Comment The piece was originally part of a three-layered plaque, decorated on one side with (exclusively?) vegetal motifs, similar to other plaques in this collection (**53– 8**). In contrast to these fragments, however, **60** was reused after breakage. The polishing of the underside and the bevelling of the sides suggest that the piece was intended to be used as some form of inset or inlay or perhaps in jewellery. It may be in its finished form, but it is conceivable that the piece as we now see it is a blank, intended to receive further decoration. The patterns of weathering (or rather the total lack of the same on the bevelled and polished surfaces) and the nature of the change itself, indicate that the adaptation of the sherd took place after its rediscovery, probably during the nineteenth century.

The plaque was made using the casting process. Layers of different coloured glass were successively ladled or poured into a shallow, flat-bottomed, open refractory mould. The decoration was achieved by carving the opaque white glass when cold.

Bibliography Unpublished

Miscellaneous forms

61
Fragment of a double-sided form (oscillum?)
1886,1117.29
H. 3.9 cm, W. 3.8 cm, TH. (max.) 0.9 cm (blue 0.7–0.8 cm, white 0.05 cm on each side).
Formerly in the Nesbitt collection, most of which was acquired in Rome; given by A.W. Franks.
About 15 BC–AD 25

61

Glass The fragment is made of translucent dark blue glass sandwiched between two layers of opaque white. There are patches of brownish weathering on both surfaces. The two layers of opaque white glass on either side of the blue glass are of similar thickness. The bubbles in the thick blue glass are all spherical.

Fragment/form The triangular fragment formed part of a double-sided plaque.

Decoration The piece is decorated on both sides. One side is completely covered by white glass showing folds of drapery, while the design on the other side is difficult to interpret but perhaps shows part of a draped body.

Comment Although some vessels have decoration on both sides – for example the bowl, **27/8**, and pieces from the Römisch-Germanisches Museum, Cologne (N. 6382a; Naumann-Steckner 1989, 82–3, no. 12), and Toledo (25.1566b) – **61** may be the only example of a plaque in Roman cameo glass to be decorated in this way. Assuming that both surfaces were intended to be visible, it is possible that the fragment is part of an oscillum, a disc-like object usually of marble or terracotta and decorated on both sides, that was suspended from trees or from colonnaded porticoes, and would spin (Latin *oscillare*) in the breeze.

This fragment is unusual in that the white glass appears on either side of the blue base glass. As both sides have been provided with decoration, it is impossible to say which was poured or ladled first. The spherical bubbles in the blue glass indicate a casting process. The decoration was achieved by carving away the layers of opaque white glass when cold, using traditional lapidary techniques. The piece was possibly re-cut in antiquity.

Bibliography Simon 1957, pl. 19

62
Oval medallion with portrait
1868,0501.926
H. (with mount) 6.1 cm, W. 5.3 cm, TH. white 0.6 cm, TH. mount 0.8 cm.
Excavated in Cumae, southern Italy; bequeathed by Felix Slade, 1868.
About 15 BC–AD 25

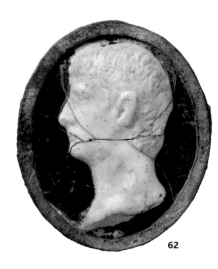

62

Glass Although the frame potentially makes full investigation of the glass difficult, shining a strong light source through a broken area of the back of the frame reveals that the glass is deep purple overlaid with opaque white. The purple glass has traces of slightly iridescent weathering. The white glass is dull, somewhat pitted and slightly discoloured. The cameo is split into two large and four smaller pieces by cracks that are stained by corrosion products from the metal frame.

Fragment/form The oval cameo glass portrait is preserved in its original copper alloy frame or setting. There is substantially intact gilding over the upper surface of the frame.

Decoration Shown in white and carved in very high relief (up to 0.6 cm) is the head of a male, turned left. His hair is shown in short locks, slightly curled, with a fringe. His head is unadorned and the figure is portrayed heroically.

Comment The scale and quality of the piece makes it very probable that it depicts a member of the imperial family. The hairstyle places it

firmly in or around the Augustan period (later first century BC and early first century AD). The most likely candidates, therefore, are Drusus (38–9 BC), brother of the future Emperor Tiberius and the son of the Empress Livia by her first husband, or, perhaps more likely, Germanicus (16 BC–AD 19), the son of Drusus and the grandson of Augustus. Both men were adored by the Roman people and were possible candidates for the imperial throne, but died before Augustus and Tiberius, respectively. Such a portrait, showing the prince in a heroic, idealized pose, is likely to have been produced in commemoration of his death. Production of such a cameo plaque, either on the death of Drusus (9 BC) or that of Germanicus (AD 19), would fit very well the date range, 15 BC–AD 25, that we have proposed for the production of early cameo vessels and plaques.

The portrait is similar (though a mirror image) to the piece in The Corning Museum of Glass identified by David Whitehouse (1997, 42, no.37) as Augustus. Other examples of glass cameos with metal frames include those formerly in the Sangiorgi collection (Christie's 1979, 62–3, lots 140–44).

It is interesting that the piece is in purple glass. As noted above (see discussion in **44**), most of the larger or more significant plaques in the British Museum and elsewhere are in purple glass. It is not surprising to find an imperial portrait in this colour.

The plaque was made using the casting process. The decoration was achieved by carving away the upper layer of opaque white glass when cold, using traditional lapidary techniques.

Bibliography Unpublished

63
Fragment of a disc, perhaps a base or a blank
1886,1117.28
D. about 8.5 cm, TH. (max.) 0.5 cm (blue 0.4 cm, white 0.1 cm).
Formerly in the Nesbitt collection, most of which was acquired in Rome; given by A.W. Franks.
About 15 BC–AD 25

63

Glass The fragment is made of translucent blue glass overlaid with opaque white.

Fragment/form The fragment preserves approximately one third of an irregularly rounded disc, with a raised centre.

Comment This could, perhaps, be the base of a *lagynos*, a broad-bodied, narrow-necked bottle (Gudenrath and Whitehouse 1990, 120–21). Another possibility is that it is the unfinished blank of a portrait as **62**.

The plaque was made using the casting process. Layers of different-coloured glass were successively ladled or poured into a shallow, flat-bottomed, open refractory mould. The decoration was achieved by carving away the opaque white glass when cold, using traditional lapidary techniques.

Bibliography Simon 1957, pl. 18

64
Fragment (of a plaque?)
2005,0803.5
H. 1.8 cm, W. 2.2 cm, TH. 0.4 cm (deep blue 0.3 cm, opaque white 0.1 cm).
Provenance and origin unrecorded.
About 15 BC–AD 25

64

Glass The fragment is made of translucent deep blue glass overlaid with opaque white.

Fragment/form The irregularly shaped fragment almost certainly comes from a plaque. Both surfaces and all edges are smoothly eroded.

Decoration Shown in white are traces of very indeterminate decoration.

Comment The decoration is worn very thin, revealing the blue layer all over. Such erosion may have occurred on a beach or in established plough/garden soil. The plaque was probably made using the casting process.

Bibliography Simon 1957, pl. 19

Strips

A small group (**65– 9**) comprises narrow strips, perhaps edging pieces, test pieces or blanks. Two such carved pieces are extant. One in Cologne (Glas 72, 153) has a sacred motif featuring a snake, a tripod and other designs. In Boston (inv. 13, 212) another plaquette shows a hunter in a landscape shooting a stag. A third piece (now untraceable), apparently showing a Bacchic scene, was illustrated by Menu von Minutoli (1836, Taf. 1, fig. 7). In the case of the Cologne piece, there are stylistic grounds to question its *Romanitas*, while some of the pieces it was auctioned with (Zahn 1929, Taf. 18, nos 374–6) can, we believe, be identified as fakes – perhaps part of a group best represented in the collections of The Toledo Museum of Art (personal observation). The Boston piece, though fine, is of a similar scale and feel. We believe, therefore, that there are grounds to doubt the *Romanitas* of the carved strips.

The bevelled edge of **65** is noteworthy, while **66** and **67** both have their long edges intact. While it is likely that **65**, **67** and **68** were cut and smoothed down from a larger element, **66** with convex underside appears to have been made in its present shape. No. **66** is also the only example of a strip in purple glass. Nos **65** and **68** both have indents on the upper surface – perhaps an indication of working, while **67** has an almost continuous line on the upper side.

65
Fragment of a strip
1869,0306.32
H. 1.9 cm, W. 2.9 cm, TH. 0.4 cm (deep blue 0.3 cm, opaque white 0.1 cm).
Formerly in the Christy collection.
About 15 BC–AD 25

65

Glass The strip is made of translucent deep blue glass overlaid with opaque white.

Fragment/form The fragment comes from a rectangular strip. The two long sides are original. One edge has been carefully chamfered, the other grozed.

Comment The strip was made using the casting process.

Bibliography Unpublished

66
Fragment of a strip
2005,0803.2
H. 1.9 cm, W. 4.2 cm, TH. 0.5 cm (deep purple 0.3 cm, opaque white 0.2 cm).
Provenance and origin unrecorded.
About 15 BC–AD 25

66

Glass The strip is made of translucent deep purple glass overlaid with opaque white. The purple glass has patches of vivid iridescence; the surface of the purple glass is also pitted and has transverse depressions.

Fragment/form The fragment comes from a rectangular strip. Both long edges are original.

Comment The strip was made using the casting process. The depressions may be from the surface onto which the glass was poured. Both edges are smooth and rounded as if cast into a long, thin mould.

Bibliography Unpublished

67
Fragment of a strip
2005,0803.3
H. 1.4 cm, W. 3.6 cm, TH. 0.3 cm (deep blue 0.2 cm, opaque white 0.1 cm).
Provenance and origin unrecorded.
About 15 BC–AD 25

67

Glass The strip is made of translucent deep blue glass overlaid with opaque white. The underside of the blue glass is smooth and glossy though a little scratched. There is a groove on the upper surface of the white glass, possibly formed by burst bubbles.

Fragment/form The fragment comes from a rectangular strip. The two long sides are original edges.

Comment The strip was made using the casting process.

Bibliography Simon 1957, pl. 19

68
Fragment of a strip
2005,0803.1
H. 3.2 cm, W. 2.1 cm, TH. 0.5 cm (dark blue 0.3 cm, pale blue 0.2 cm).
Provenance and origin unrecorded.
About 15 BC–AD 25

68

Glass The strip is made of translucent dark blue glass overlaid with opaque pale blue glass. There is thin, pale brownish weathering film on the pale blue glass and very slight iridescence on the deep blue. There is a small, wedge-shaped depression in the surface of the light blue, which does not reveal the dark layer. The back is flat and smooth but covered with fine scratches, apparently not from rotary polishing.

Fragment/form The fragment forms part of a rectangular strip. The two long edges are original.

Comment The strip was made using the casting process.

Bibliography Simon 1957, pl. 19

69
Fragment of a strip
2005,0803.4
H. 1.9 cm, W. 1.7 cm, TH. 0.3 cm (deep blue 0.2 cm, opaque white 0.1 cm).
Provenance and origin unrecorded.
About 15 BC–AD 25

69

Glass The strip is made of translucent deep blue glass overlaid with opaque white. The underside of the blue glass is pitted and has traces of pale brown weathering film. The surface of the white glass is pitted and matte.

Fragment/form The small squarish fragment comes from a rectangular strip. One of the edges is original.

Comment The strip was made using the casting process. One of the edges is rounded, perhaps from the tray into which it was poured.

Bibliography Simon 1957, pl. 19

Late cameo glass

Unlike most early Roman cameo glass, which is deep blue with an opaque white overlay, late Roman examples are colourless or almost colourless and they have a transparent or translucent coloured overlay; and while the decoration of Julio-Claudian cameos is in low relief, the ornament on the majority of late Roman cameos (such as **71**, **73** and **74**) is flat. The colour scheme and cutting of late Roman cameo glass are exemplified by the best-known example: the dish from Stein am Rhein, which is decorated with a hunting scene in reddish purple on a colourless background (Guyan 1975). The dish was buried in the second half of the fourth century.

While the majority of late Roman cage cups were made entirely of colourless glass, some have coloured overlays; indeed, the Trivulzio cage cup and the cup from Köln-Braunsfeld are overlaid with three different colours (Harden, Hellenkemper, Painter and Whitehouse 1987, 185–6 and 238–41, nos 134–5). No. **70** is a fragment of a cage cup with a blue overlay. By common consent, cage cups were made between the late third and mid- to late fourth century.

70
Fragment of a cage cup
1953,1022.3
H. 5.5 cm, W. 3.5 cm, TH. 2.05 cm (colourless 1 cm, blue 0.9 cm, wall of vessel 0.15 cm). Provenance and origin unrecorded. Fourth century AD

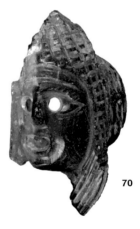

70

Glass The fragment is made of colourless glass overlaid with transparent royal blue. The bubbles in the glass are spherical.

Form Evidently, the fragment formed part of a vessel with openwork decoration (see below).

Decoration This consists of the greater part of an actor's tragic mask seen from the side. The mask is hollow. It has a tall wig with long side tresses. The eyes and mouth are fully pierced. The hair is cross-hatched and the left eyebrow is indicated by a row of short parallel lines. The junction of the colourless and the blue glasses bisects the nose and the mouth.

Comment The fragment is part of a cage cup made of colourless glass with a blue overlay. The mask was hollowed out from the back, presumably by grinding. The closest parallel for the fragment occurs on the openwork decoration of the Masks and Columns Cage Cup (Harden *et al.* 1987, 243, no. 137), which includes four tragic masks with tall, hatched wigs and completely pierced eyes and mouths. However, unlike here, they are shown full-face.

By comparing **70** with other fourth-century cage cups, including the Lycurgus Cup in the British Museum (P&E 1958,1202.1), it can be seen that the blank of **70** was made by glassblowing. Because of the great wall thickness (approximately 2 cm), on completion of the shaping phase of the glass-blowing process, the glass remained sufficiently soft to allow the bubbles to assume the uniformly spherical shape that we see in the fragment. Because of the evenness of the threshold where the colourless and blue glasses meet, and considering the substantial size of the blank, we believe the dip-overlay method was used.

Bibliography Harden and Toynbee 1959, 205–6, no. A7

71
Fragment of a cup
1953,1022.4
D. 10.5 cm, H. (three fragments together) 4.5 cm, W. (three fragments together) 6 cm, TH. 0.25 (colourless 0.15 cm, blue 0.1 cm). Provenance and origin unrecorded. Fourth century AD

71

Glass The fragment is made of almost colourless glass with a green tinge, overlaid with transparent light blue.

Form The object consists of three joining fragments from the rim and upper wall of a cup. The rim is slightly everted with a horizontal rib at the bottom.

Decoration Beneath and parallel to the rib are three letters of a Greek inscription in blue on a colourless background: '[…]CΠA[…]' It is equally possible that the last letter is Λ.

Comment The letters are evenly spaced and appear to be part of a single word, the identity of which has eluded us.

The object resembles a fragment of a cup in The Corning Museum of Glass (84.1.2; Whitehouse 1997, 65, no. 76). The latter has the same form and two letters of a Greek inscription in transparent light green over almost colourless glass, '[…]ZH[…]', which probably formed part of the common salutation '[ΠIE] ZH[CAIC]' (Drink! May you live!).

Harden and Toynbee (1959, 205–6, n. 4) were surely correct to dismiss the possibility that **70** and **71** came from the same vessel, despite the fact that they bear consecutive accession numbers. As they noted, **70** is from a cage cup and no known cage cup has an inscription that is raised but is not openwork, although a transparent yellowish green fragment in the Römisch-Germanisches Museum, Cologne (N6211), has a raised but not openwork representation of Bacchus and his panther in blue above traces of an openwork cage. But, in any case, the colours of **70** and **71** are not identical and the sides of the vessels are of different thicknesses.

The blank was made by glassblowing using the dip-overlay method. The uniformly fire-polished rim, together with the horizontal and increasingly stretched bubbles above the inscription, indicates that the blank was attached to a pontil to create a furnace-finished rim. All exterior surfaces are cold-worked, those above the inscription having been lathe-turned.

Bibliography Whitehouse 1990, 194–5

72

72
Fragment of a cup or bowl
1870,0606.11
H. 6 cm, W. 9.5 cm, D. 12.3 cm, TH. 1.65 cm
(colourless body 0.15 cm, colourless below
garland 0.3 cm, colourless below letters 0.6 cm,
green 0.3 cm, blue 0.3 cm).
Given by the executors of Felix Slade, formerly
in the Piot collection.
Fourth century AD

Glass The fragment is made of colourless
glass overlaid with two horizontal stripes:
transparent bright green above and
transparent blue below. The bubbles in
the two glasses are spherical.

Form The object is part of the rim and wall of a
cup or shallow bowl-like vessel, the side of
which becomes thinner towards the bottom.

Decoration The decoration consists of a
horizontal green garland with elongated leaves
above two letters of a Greek inscription in blue:
'[…]IC[…]' The letters are 1.9–2 cm high.

Comment If the cup or bowl was intended for
drinking, the inscription may have been '[ΠΙΕ
ZHCA]IC' (Drink! May you live!). However, the
shape of the fragment indicates that the letter
preceding IC was some 2 cm behind them, and
so other explanations may be preferable.

As **70**, the blank was probably made by
glassblowing, the coloured glasses added as
bands or 'wraps' in the manner of the cage cups
from Köln-Braunsfeld in western Germany
(Harden *et al.* 1987, 240–41) and Trivulzio, near
Novara in north-west Italy (Harden *et al.* 1987,
238–9).

Bibliography Unpublished

73
Fragment of an open vessel
1868,0501.142
H. 4.5 cm, W. 2.3 cm, D. (body max. 9.3 cm),
TH. 0.8 cm (colourless total 0.3 cm, wall 0.1 cm,
underneath blue 0.2 cm, blue 0.2 cm).
Given by the executors of Felix Slade.
Fourth century AD

73

Glass The fragment is made of colourless glass
overlaid with transparent blue. The bubbles in
the glass are spherical.

Form The fragment came from an open vessel,
either a dish or a bowl, but it is too small to
allow one to suggest either the form or the
dimension of the complete object. However, the
width of the rectangular decorative element
indicates that it might have been fairly large
(see below).

Decoration The relief-cut decoration consists
of parts of two elements: a leaf and an
unidentified motif. The leaf, which grows out
of the end of a stem, has veins shown by linear
cuts. The unidentified element is rectangular
and has bevelled sides. It might be the vertical
part of a letter such as 'I' or 'T', but this is
doubtful.

Comment The rectangular element is 0.8 cm
wide. To judge from photographs, this is wider
than the broadest parallel-sided motifs on the
dish from Stein am Rhein, which has a diameter
of 22.2 cm, including a tree trunk (0.4 cm) and
ground lines (just over 0.2 cm) (Guyan 1975),
and considerably wider than the letters on cage

cups. Whether the element is part of a letter or
not, its size suggests that the fragment came
from a relatively large object and/or the
decoration may have been ponderous.

The blank was made by glassblowing using the
dip-overlay method. All exterior surfaces are
cold-worked.

Bibliography Unpublished

74
Fragment of an open vessel
1868,0501.141
H. 4.8 cm, W. 3.5 cm, TH. 0.3 cm (colourless 0.2
cm, green 0.1 cm).
Given by the executors of Felix Slade.
Fourth century AD

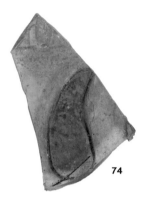

74

Glass The fragment is made of greenish
colourless glass overlaid with transparent
green. The bubbles in the glass are spherical.

Form The fragment came from an open vessel,
perhaps a bowl, but it is too small to allow one
to suggest either the form or the dimensions of
the complete object. Presumably decorative
element 1 (see below) was horizontal, but even
this is uncertain.

Decoration The relief-cut decoration consists
of parts of three elements: (1) a band of
colourless motifs, either a decorative frieze or
an inscription; (2) a green comma-shaped
motif; and (3) a tiny remnant of an
indeterminate green motif.

Comment So little survives that it would be
futile to speculate about the nature of the
decoration. Comma-shaped motifs appear to
be uncommon – possibly very uncommon – on
late Roman decorated glasses. Indeed, perhaps
the closest parallel for the motif on glass occurs
on a colourless relief-cut amphora of the late
first century AD, found at Cologne and
preserved in that city's Römisch-Germanisches
Museum (Glas 967; Harden *et al.* 1987, 191,
no. 101).

The blank was made by glassblowing using the
dip-overlay method. All exterior surfaces are
cold-worked.

Bibliography Unpublished

Egyptianizing 'layered' glass

There is a group of seven fragments in the collections of the British Museum (75– 81) that stand out because of their manufacturing technique, their appearance and their subject. Interestingly, they also have a fairly clear provenance, with three of the seven coming from the Nesbitt collection (77, 79, 81) formed mostly in Rome, one piece from the Christy collection (75), and a fifth from the collections of Slade (76). Other fragments of similar type are found in the Thorvaldsen Museum, Copenhagen, The Toledo Museum of Art and The Metropolitan Museum of Art, New York (on loan from a private collection), but the group in the British Museum is the largest known.

In classic cameo glass the design is created by cutting and carving away an upper layer of glass (usually white) to reveal a darker (usually blue) layer underneath. The 'layered group' (75– 81) was made, starting with an underlayer, by adding glass, often several separate elements or layers, selectively, only to particular parts of the piece. It is worth noting that, in at least one instance, a piece of 'true' cameo glass, namely the plaque fragment showing a cockerel and fruit (46), was also decorated, in part, with applied layers of glass. Examination of the pieces in the layered group reveals that colours are often embedded in the base glass or simply placed on it. Often there are several additions visible and these are then sculpted separately. In addition, the layers of glass are often very deep, much deeper than most standard cameo glasses. The use of heavily carved incision is also characteristic of the group.

Not only the technique but also the colours are unusual and quite different from the palette of colours used in the vast majority of cameo glass. Alongside the more expected white and blue glasses are examples of yellow, red and green. Red is found on two pieces as a background colour (78, 79). Moreover, most examples of the British Museum layered group are made of glass that is milky opaque, i.e. glass that has been mixed with white glass (see discussion in 27). The glass of one piece is marbled, with veins of darker colour (79).

All examples known to us seem to have been part of flat-based plaques, used as decorative elements, perhaps for furniture or boxes/ caskets. As yet no examples of vessel fragments are known in this technique. As for decorative themes, 79 preserves most of a vine leaf, a popular image on classic cameo glass and on silverware. A fragmentary plaque on loan to the Metropolitan Museum shows two cupids holding the ends of a garland. Some of the pieces in the British Museum (76, 78 and possibly 77) and the piece in the Thorvaldsen Museum showing a sphinx have a strong Egyptian influence. Some people have seen in this an argument for the origin of this group in Egypt itself.

Given, however, that many known pieces come from collections that seem to have been wholly or mostly formed in Rome, an origin there seems much more likely. In the British Museum three of the seven pieces were part of the Nesbitt collection and have a probable Rome provenance (77, 79, 81). Yet, in spite of sharing (we believe) a place of origin with the classic cameo production, the layered pieces are quite distinct in appearance, colour and (we would argue) function. It is very likely that they were the product of a different workshop or craftsman from those of the classic cameo pieces. Some go further, linking this group to the well-known body of Ptolemaic glass decorative elements, suggesting a dating of the second to first centuries BC. But there are some very important differences between the two groups. Ptolemaic pieces are generally *opus sectile*, i.e. they are formed of separately coloured elements, fitted flush together to make a decorative pattern in glass. The layered group fragments, on the other hand, have glass of different colours, fused, layered and sometimes cold-worked, with a base glass of a different colour, often brick red, against which the decoration is shown.

Layered glass is quite distinct from early imperial cameo glass both in form and presumably in function. If layered glass was primarily a wall decoration, then one of the few possible sources of comparanda is provided by the huge quantities of fragments of glass *opus sectile* wall panels discovered in the ruins of the villa of Lucius Verus, on the Via Cassia near Rome (Saguì *et al*. 1995; Whitehouse 1997, 32–4). Its construction was probably completed by the time of the emperor's joint reign with Marcus Aurelius in the AD 160s. But even if the layered plaques were used in some form as wall decoration, they are very different in feel and colour to the pieces from the Via Cassia villa.

Moreover, there is no concrete evidence to suggest a findspot for layered glass at the villa. On the contrary, if the British Museum pieces had been discovered there, we would expect to see many more in the collections of Gorga, who bought so many of the plaque elements from the villa, enough to cover many square centimetres (Whitehouse 1997, 33). But close examination of the Gorga cameo glass with Lucia Saguì, curator of the collection, revealed not a sherd of the layered glass. We now believe that layered glass need not be linked to this other group of distinctive glass, neither in its findspot, nor in its chronology. Given the similarity of themes shown on these pieces and on mainstream cameo glass, especially Egyptianizing or vegetal motifs, we should like to revise the dating of the layered glass to the same period as that of the true cameos, i.e. the later first century BC and early first century AD.

Again, it should be stressed that the layered glass is not part of the mainstream of early Roman glass, but it is related. It is not formed primarily by carving away one layer to reveal another. On reflection, however, we decided that, even though their technique was different, the spirit of the pieces, in particular the use of a background colour and worked layers of different colours of glass to make a decorative scheme by throwing figures into relief, has justified their having a subsidiary place in this catalogue of cameo glass in the British Museum.

75

Fragment of a layered glass plaque
1865,1214.104
H. 2.6 cm, W. 4.1 cm, TH. 0.9 cm (green 0.6 cm, white 0.3 cm).
Provenance unrecorded; Henry Christy collection, given by his trustees.
Perhaps about 15 BC–AD25

75

Glass The fragment is made of glass of three colours: milky-opaque green glass overlaid with opaque blue and opaque white. There is milky-white and brown weathering, extensive pitting and some iridescence on both surfaces.

Fragment/form The fragment comprises an entire element (quarter?) of a four-part(?) rectangular plaque or inlay. All the edges appear to be original. The upper edge of the piece is quite smooth and two small holes have been bored into this surface.

Decoration Shown in white is the lower part of the legs of a figure standing on a low platform or ridge. The left leg is shown frontally with the foot foreshortened. The right leg and foot are turned to face the viewer's left. The green background is edged on both sides by blue glass.

Comment The holes in the top edge of the piece appear too uniform and evenly spaced to be broken bubbles, such as appear on the back, so it is possible that they served to join the piece to another pre-formed element. The pose somehow suggests that the figure is male, and the position of the legs shows that he was standing rather than walking. The state of the sides and bottom edges indicates that the plaque was originally in portrait format, and may only have shown one figure in isolation, perhaps framed in an architectural scheme.

Formed by casting, the milky-opaque green glass was poured – or pieces of green glass were melted – into a shallow rectangular, open refractory mould. Before the green glass was added, narrow lengths of blue glass were placed along the left and right sides of the mould. The two glasses fused together thoroughly. Only then was the opaque white glass introduced over the green, either in preheated pieces or ladled or poured, but in any event only where it was required. Finally the design was carved when the whole was cold.

Bibliography Simon 1957, pl. 19

76

Fragment of a layered glass plaque
1868,0501.7
H. 2.8 cm, W. 2.7 cm, TH. 1.3 cm (orange 0.4 cm, cobalt blue 0.9 cm).
Provenance unrecorded; bequeathed by Felix Slade, formerly Thibault collection.
Perhaps about 15 BC–AD 25

76

Glass The fragment is made of three colours of glass. Opaque orange glass is overlaid with semi-opaque cobalt blue and in places with opaque turquoise blue. All three glasses are dull. The orange glass has a light brownish weathering film. The deep blue glass is pitted and has traces of more light brown weathering. The turquoise blue glass has light brownish grey weathering.

Fragment/form The roughly triangular fragment formed part of a plaque or inlay.

Decoration The fragment preserves in cobalt blue the upper part of a male(?) from shoulders to waist, turned right. The proper right arm is bent and appears to be holding something (now missing). At the shoulders the turquoise blue glass seems to form drapery or a collar.

Comment The presence of a ritual collar and the pose of the arms suggests that the scene may well be Egyptianizing. Diagonal slashes on the scarf/collar recall those on the yellow element (fin?) of **77** and on the collar/wing of the cat/sphinx in the Thorvaldsen Museum (personal observation).

The glass used in **76** is completely opaque, but it is not milky-opaque glass.

The piece was cast and layered, then carved when cold. Details of its manufacturing technique are broadly the same as for **75**.

Bibliography Simon 1957, pl. 19

77

Fragment of a layered glass plaque
1886,1117.45
H. 3.8 cm, W. 3.5 cm, TH. 1.3 cm (blue 0.5 cm, green 0.8 cm).
Formerly in the Nesbitt collection, most of which was acquired in Rome; given by A.W. Franks.
Perhaps about 15 BC–AD 25

77

Glass The fragment is made of four colours of glass. Opaque blue glass is overlaid with opaque green, and the opaque yellow and white are added alongside the green. There are patches of brownish white weathering film and several large pits on both surfaces (some of which appear to be broken bubbles). The flat back has been ground smooth.

Fragment/form The roughly triangular fragment, broken on all edges, formed part of a plaque or inlay.

Decoration The fragment preserves part of an element in green, with five deeply incised parallel grooves. The added yellow glass forms a narrow border on one side and a much broader, slightly diagonal element marked with parallel diagonal lines on the other side. Below this is an area of white glass that, in section, can clearly be seen to have been applied before the green.

Comment Because of the small and incomplete nature of the piece, its original orientation is uncertain. If viewed horizontally, however, this surviving element might represent the central part of the body of a green fish with stripes and a yellow dorsal fin and underbelly. Given the Egyptian feel of much of this group, it is possible that the fish was once part of a Nile scene. The white section, broken off at the right-hand side, might represent the beginning of the head.

Cast and layered: technique as **75**.

Bibliography Simon 1957, pl. 19

78

Fragment of a layered glass plaque
1976,1003.12
H. 5 cm, W. 3.8 cm, TH. 0.9 cm (red 0.45 cm, green 0.45 cm).
Provenance and origin unrecorded.
Perhaps about 15 BC–AD 25

78

Glass The fragment is made of three different-coloured glasses. Opaque brick red glass is overlaid with opaque dark green glass and a few small patches of translucent dark blue glass appearing black along the bottom edge, on the left side of the green and halfway up on the right side. There is brownish weathering film on both surfaces. The back is flat and rough. The threshold between the two coloured layers is uneven, but well defined.

Fragment/form The irregular rectangular fragment probably comes from a plaque or inlay. The top edge is original.

Decoration Shown in green is an element on a red background, with numerous concentric ribs, flaring from a narrower base.

Comment One of the most likely identifications of the element is a lotus-style capital. If so, the fragment may well have been part of a decorative scheme that featured architectural elements (and other motifs such as figures?), perhaps in a landscape. It would also be reasonable to assume that at least part of this scheme had an Egyptian flavour. The cutting of the details of the capital is very deep, and the dark green layer is heavier and deeper than any layer normally used in classic cameo glass.

Cast and layered: technique as **75**.

Bibliography Simon 1957, pl. 17

79

Fragment of a layered glass plaque

1886,1117.44

H. 4.5 cm, W. 5.1 cm, TH. 1.3 cm (red 0.6 cm, green 0.7 cm).

Formerly in the Nesbitt collection, most of which was acquired in Rome; given by A.W. Franks.

Perhaps about 15 BC–AD 25

79

Glass The fragment is made of opaque brick red glass overlaid with opaque dark green glass that is marbled with darker and lighter stripes. The green glass is covered by brown weathering film and there are smooth patches of the same film on the red glass, together with some pitting. The back has been ground flat in two nearly parallel planes. The threshold is well defined but very uneven.

Fragment/form The irregular, angular fragment, which is broken on all edges, formed part of a plaque or inlay.

Decoration Shown in green is a large, heavy vine leaf carved on a red background. The top left and bottom right elements of the leaf have broken away.

Comment The vine leaf on **79** suggests that some of the iconography of the layered group could have been Bacchic, as in classic cameo glass. Brick red glass as a base colour is also seen in **78** and in the fragment showing the sphinx from the Thorvaldsen Museum (personal observation). Its use seems to be restricted to this particular group.

The piece was cast and layered, then carved when cold. Details of its manufacturing technique are broadly the same as for **75**. The very uneven threshold suggests the possibility that a piece or pieces of red glass were melted in an open refractory mould, and then, before the surface was completely smooth, green glass fragments were added and fused to the red glass.

Bibliography Simon 1957, pl. 19

80

Fragment of a layered glass plaque

1976,1003.11

H. 2.6 cm, W. 5.3 cm, TH. (max.) 1.0 cm (blue 0.5 cm, yellow 0.5 cm, green 0.4 cm).

Provenance and origin unrecorded.

Perhaps about 15 BC–AD 25

80

Glass The piece is made of opaque green glass, fused with opaque dark blue and overlaid with opaque yellow. There is brown weathering film and some pitting on the upper surface. The back and sides have been ground smooth.

Fragment/form The fragment forms part of a rectangular frieze, with a concave almost semicircular section. The long sides seem to be original. It is broken at both short ends.

Decoration Shown in green are two acanthus leaves with a blob of yellow glass applied between, representing a bud or flower. At the top of the plaque is an unidentified element in fused blue glass.

Comment The piece is very thin, and so it seems probable that it was part of the border for a larger decorative scheme. This perhaps took the form of small plaques or a frieze, and may have included elements such as the 'fish' (**77**), which uses the same colours as **80** and **81**.

Cast and layered. Because of the removal of glass from the back and long sides by cold working, it is not possible to determine the original shape of the glass at the completion of the hot-working process. However, it is evident that the three different glasses were not built up one on top of the other, each being perfectly flat. The green and blue glasses have been fused together side by side – at no point are they laminated. In addition, the green glass was given its concave upper shape before the application of the yellow glass. The threshold between the green and yellow glasses lies below the level of the elevated green features to either side, indicating that the yellow was added as a small appliqué exactly where it was needed for incorporation into the final design scheme.

Bibliography Simon 1957, pl. 18

81

Fragment of a layered glass plaque

1886,1117.46

H. 2.1 cm, W. 3 cm, TH. 0.6 cm (blue too weathered to measure).

Formerly in the Nesbitt collection, most of which was acquired in Rome; given by A.W. Franks.

Perhaps about 15 BC–AD 25

81

Glass The fragment is made of opaque green glass, overlaid with translucent light green, opaque blue and opaque yellow glass. There is milky-white and brown weathering on the decorated surface.

Fragment/form The roughly rectangular fragment comes from a rectangular edging plaque or inlay. The long upper and lower edges are original, but both short ends are broken.

Decoration Shown in green is part of an acanthus leaf or leaves, with blue and yellow elements possibly representing buds.

Comment The fragment was cast and layered with green on green, with blue added on top of the dark green and yellow, alongside the upper light green layer. The manufacturing technique is generally the same as that used for **75**.

Bibliography Simon 1957, pl. 19

Drawings

The following drawings – numbered according to catalogue entry and at a scale of 2:3 unless indicated otherwise – show decoration, internal grinding and bubbles.

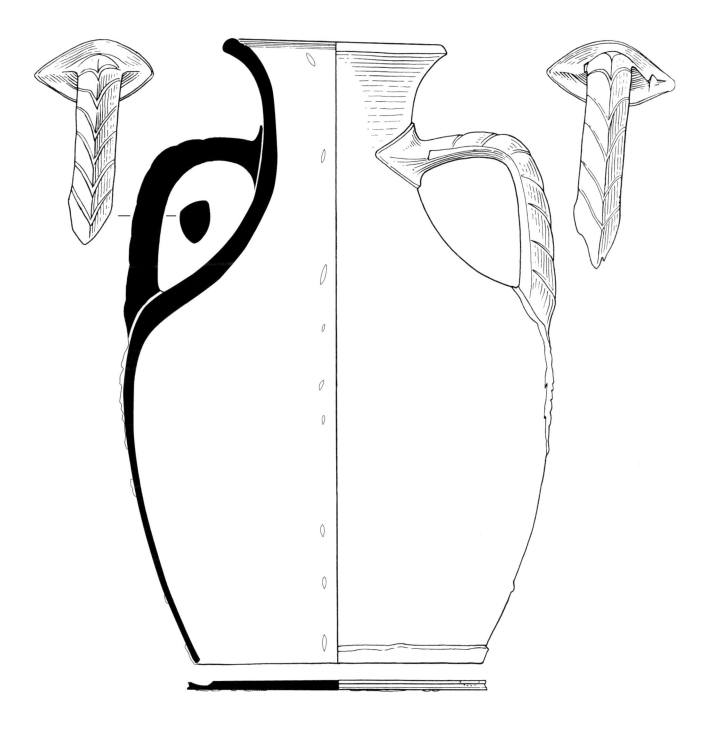

For decoration, see page 35

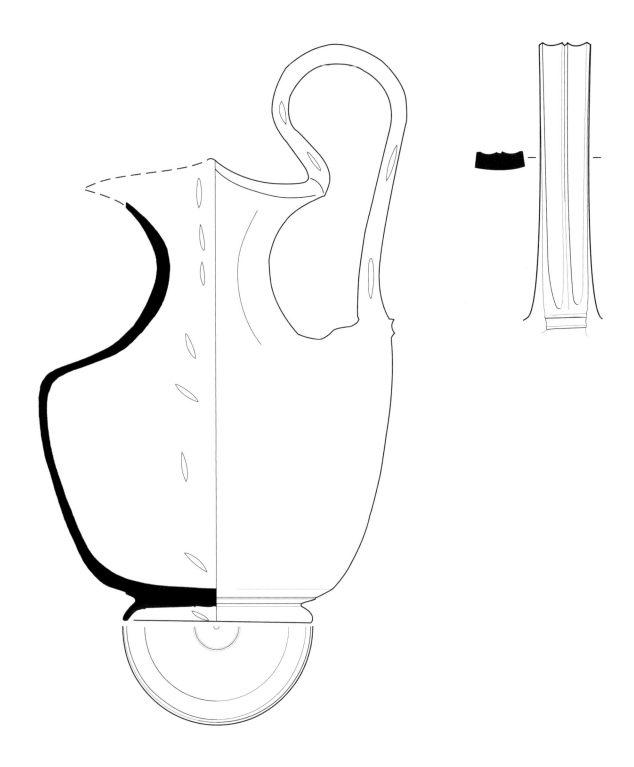

For decoration, see page 45

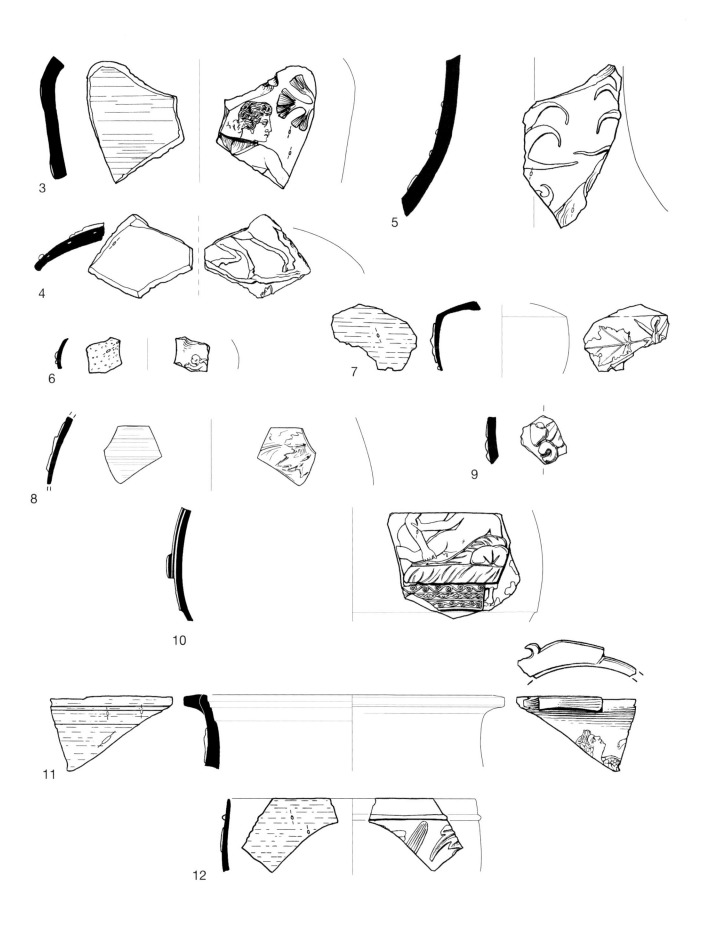

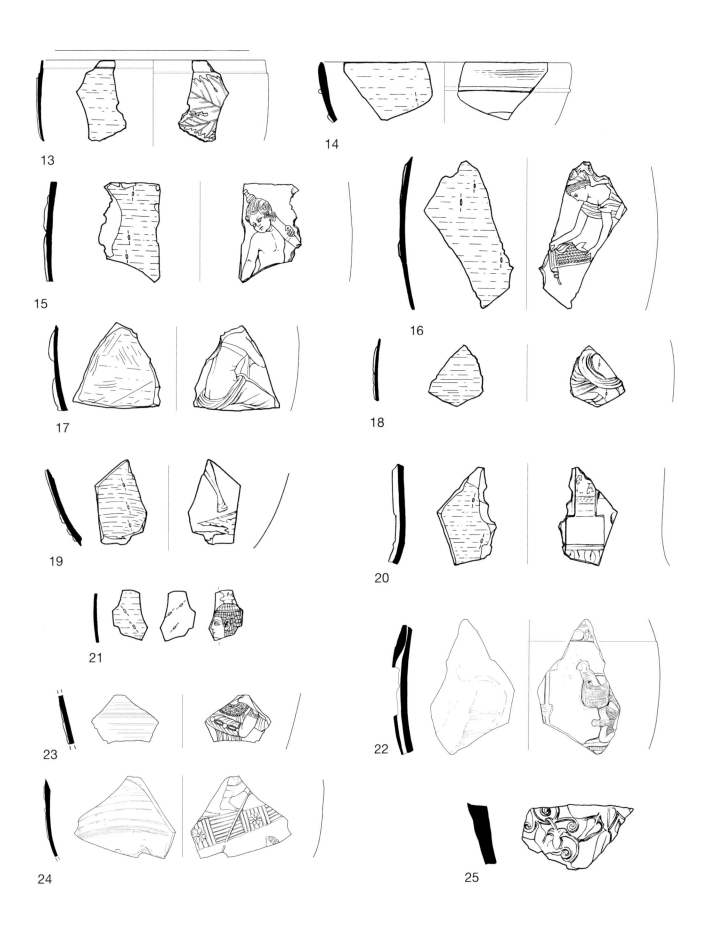

13

14

15

16

17

18

19

20

21

22

23

24

25

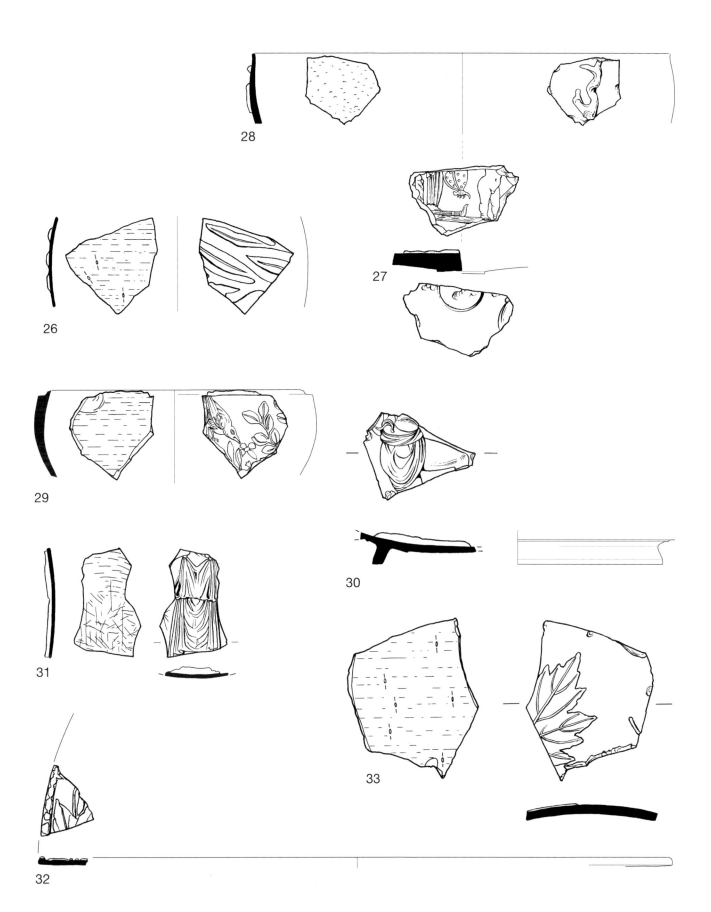

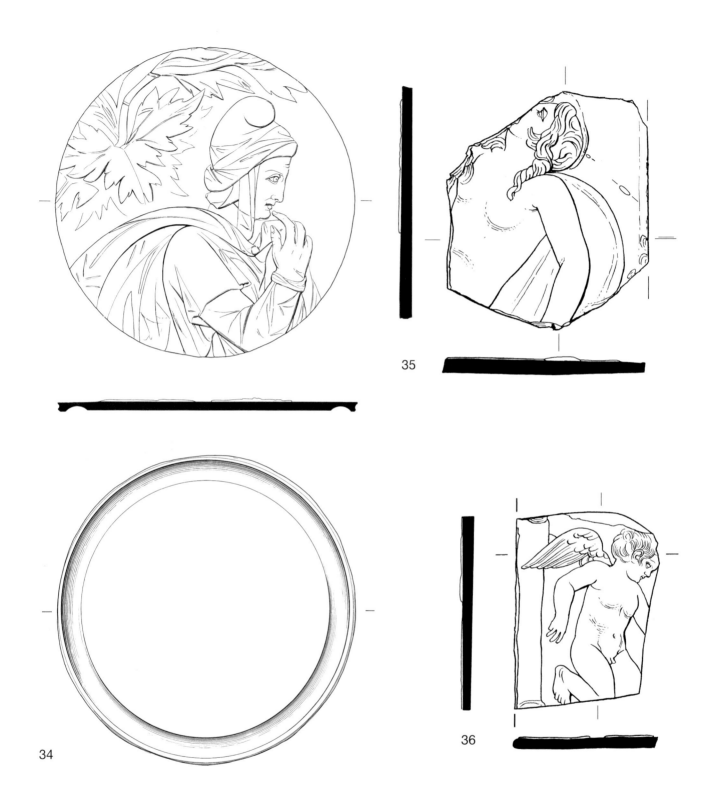

34

35

36

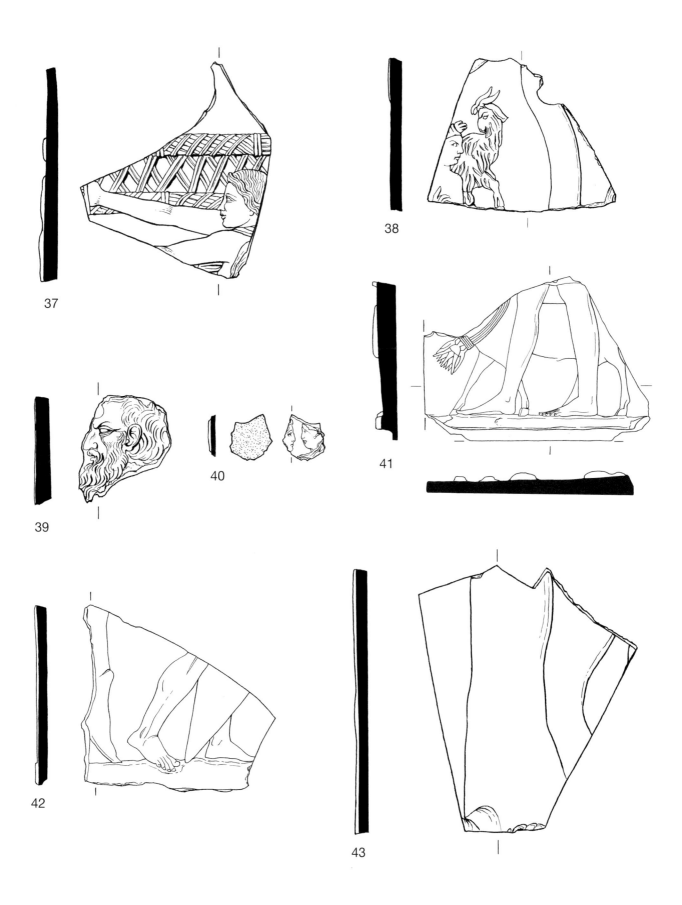

37

38

39

40

41

42

43

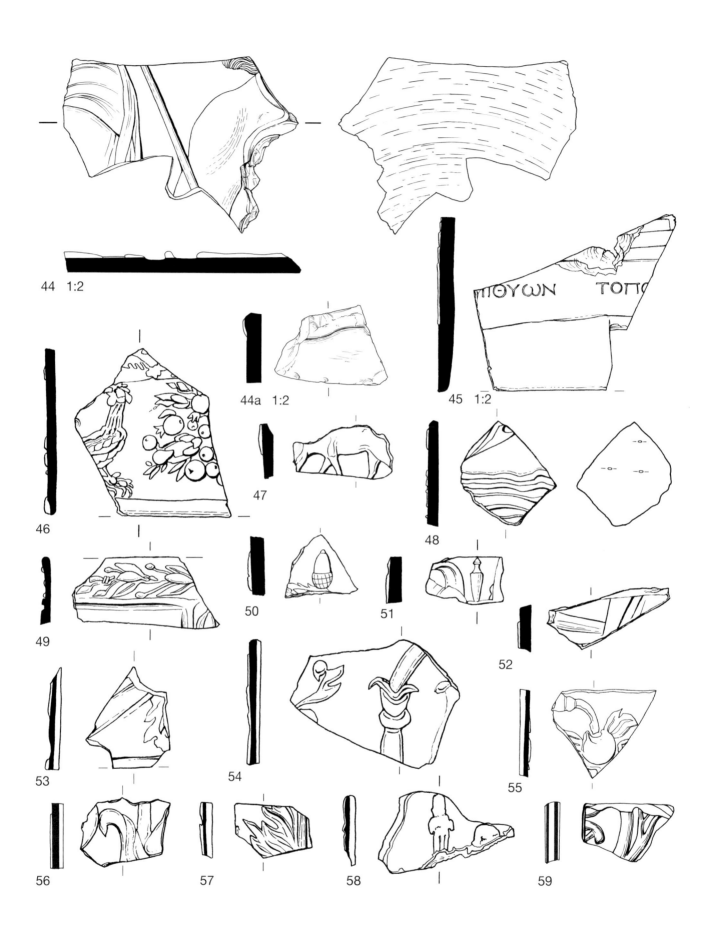

44 1:2

44a 1:2

45 1:2

46

47

48

49

50

51

52

53

54

55

56

57

58

59

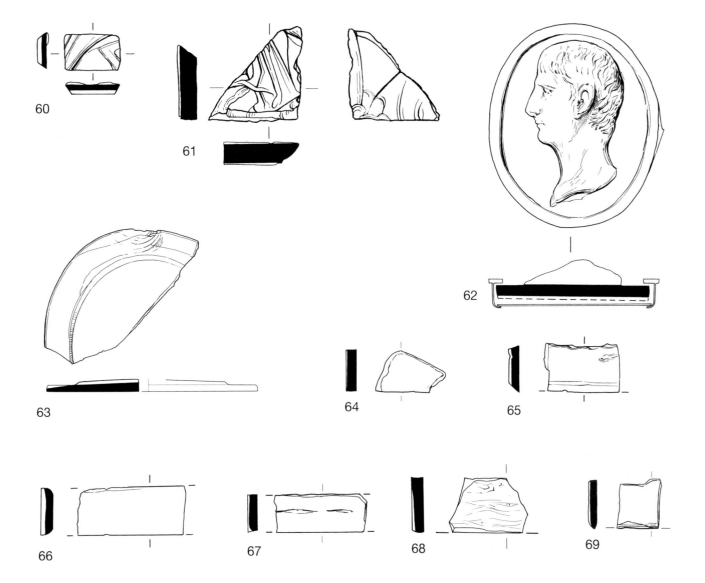

60

61

62

63

64

65

66

67

68

69

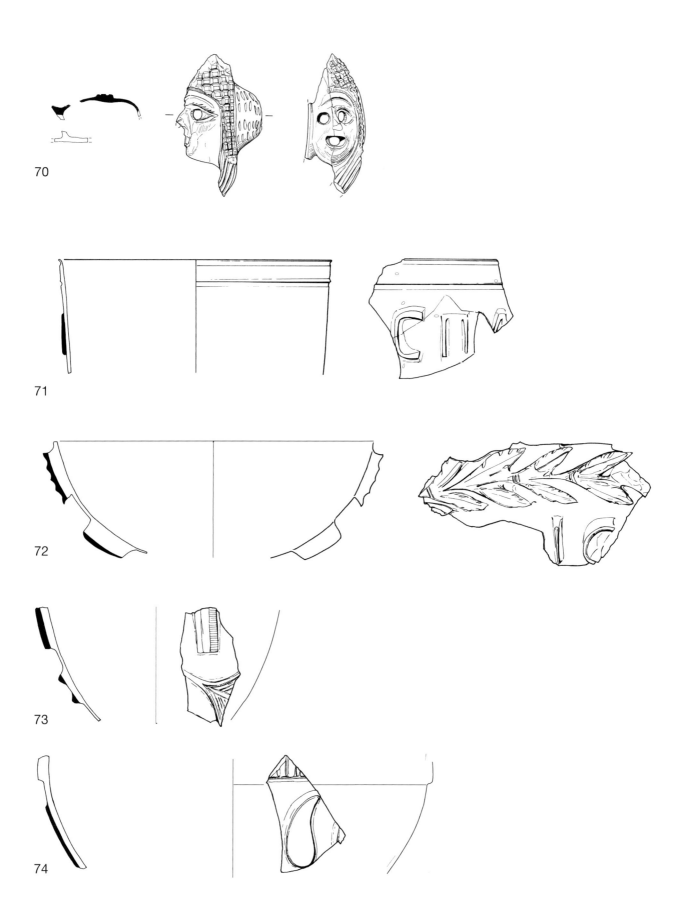

70

71

72

73

74

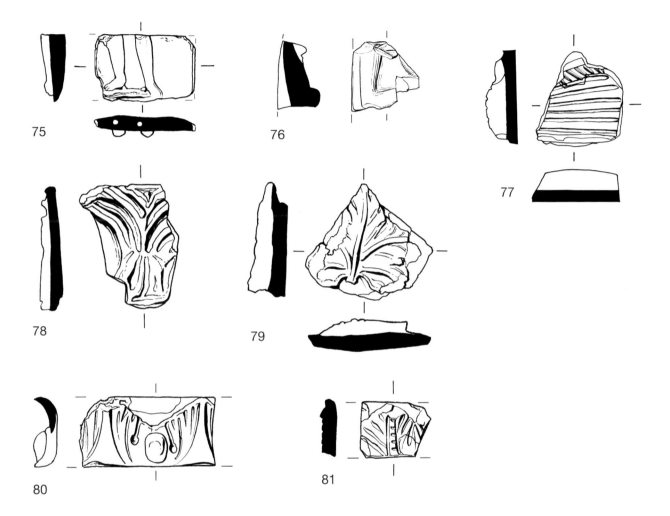

75

76

77

78

79

80

81

Appendix I

Laboratory Studies of Roman Cameo Glass

William Gudenrath

Detailed scientific analysis was carried out during the twentieth century on the Portland Vase, the Auldjo Jug and many of the fragments published in this catalogue as well as objects and fragments from other collections. As this investigation is ongoing, it will, no doubt, continue to yield interesting and useful information about this small but important group of ancient glass objects. Articles by H.P. Rooksby and W.E.S. Turner, working in the middle of the century, and later those of Mavis Bimson and Ian Freestone, both formerly of the British Museum Research Laboratory, form the basis for this brief overview of the subject (Rooksby 1959; Turner 1959; Bimson and Freestone 1983; Freestone 1990). These studies generally focus first on describing the exact chemical make-up of a glass, then often go on to hypothesize as to how and why the glassmakers made the glass as they did. Sometimes experiments have been employed and reported on.

The chemical compositions of the glasses were analysed by one or more of the following three methods: electron microprobe, x-ray fluorescence and x-ray diffraction. The scanning electron microscope was used to detect and observe inclusions in the glasses, such as bubbles of air (and other gases) and undissolved particles of silica. Also, most importantly, this instrument was employed to look at the microstructure, distribution and patterns of the opacifying agent in opaque white glasses. Later instrumentation and techniques have the distinct advantage over earlier technology of being non-destructive or requiring extremely small samples for the analysis.

The blue glasses of the Portland Vase (**1**), its accompanying base disc (**34**), the Auldjo Jug (**2**), the Egyptianizing fragment (**23**) and the plaque fragment (**42**) are typical Roman-period glasses of the soda-lime-silica type: 65–70% silicon dioxide (SiO_2), 8% calcium oxide (CaO) and 15–17% sodium oxide (NaO). Potash (K_2O) and magnesia (MgO) are 1% or less of the composition. The blue colour was achieved primarily by the addition of cobalt (Co) in concentrations so low as to be difficult to detect by some methods, about 0.1%. Experiments by Turner indicated that, in order to reproduce the spectrum of the vase closely, the addition of about 2% iron oxide (Fe_2O_3) and 1.5% manganese oxide (MN_2O_3) was also required. These levels are similar to the oxide concentrations revealed in his chemical analysis of the vase.

The ground colour of the Portland Vase appears almost black in reflected light. It is possible that the glassmaker's objective was to reproduce the effect created by carving natural onyx. Certainly, this effect is heightened by the sharp contrast of the blue glass with intensely opaque white glass overlay.

The exact nature of the opaque white glasses in ancient cameo work has received considerably greater attention than the blue glasses, mainly because of the widely varying levels of lead (PbO) present: the Portland Vase overlay contains about 12% lead, while its base disc is essentially lead-free. The Auldjo Jug (**2**) overlay has a remarkably high lead content of about 23%.

This is comparable with the concentrations found in some modern 'full lead-crystal' glasses.

In an extensive survey of cameo glass fragments in the British Museum directed primarily toward determining lead contents, it was observed that the majority of the lead-bearing overlays are from vessel fragments, whereas non-lead (or low-lead) overlays are associated with plaque fragments (Bimstone and Freestone 1983, 61, tables 4a, 4b). There are two hypotheses that attempt to explain the purpose of the addition of lead: it helped manipulate the glass's coefficient of expansion in order to resolve compatibility issues and/or it produced a softer glass that could be more easily cold-worked. Compatibility is by far the more critical concern: two dissimilar glasses, after being joined by fusing, must on cooling lose volume at about the same rate and to about the same degree in order to avoid ultimately cracking apart. The first explanation seems particularly open to question: the fact that hundreds of artefacts of both leaded and unleaded glasses have survived some two thousand years with their overlays still perfectly fused to the background glass belies this; the glassmakers were clearly capable of producing highly compatible lead-free glasses. Concerning the second theory, it is true that the addition of lead results in a softer glass, and it should be noted that arguably the finest and most subtly sculpted example of ancient cameo cutting occurs on a plaque fragment (**39**) that has a high lead content and shows the head of a bearded man, perhaps Silenus. That said, excellent carving was carried out on lead-free glass, the Portland Vase base disc being a fine example.

Thus, the reason (or reasons) for the wide variance in lead levels in opaque white overlay glass remains to be fully explained. Perhaps we are simply seeing different workshop practices reflecting different locations and/or times. More tantalizingly, though, might these varying lead levels be interpreted as a chronological progression of technical developments? Assuming a close working relationship between the glassworkers and the lapidary workers who carved the decoration, these variations might be revealing a logical and highly practical movement from the use of an exceedingly hard material, natural hardstone, to a significantly softer material, man-made soda-lime glass, and finally to a much softer material still, high lead-bearing glass. Perhaps the greater the lead content, the later the date – though this may oversimplify complex developments.

The opacifying agents and the mechanism by which opacity occurs in the white glasses have also been closely investigated. In the Portland Vase the opacifier is calcium antimonite ($Ca_2Sb_2O_7$). It would appear that the particles that cause the opacity, by their small size and uniform dispersion, crystallized in the molten glass, the oxides having been dissolved during the melting process. Interestingly, the association of sulphur with the antimony suggests the mineral stibnite (Sb_2S_3) as the likely form of the additive to the glass mixture for producing opacity.

One further fascinating aspect of the ancient glassmaker's art has been revealed by Freestone's laboratory investigation (Freestone 1990, 105):

> If the concentrations of antimony and lead oxides in the white glasses are subtracted from their bulk compositions and the residual soda-lime-silica composition is summed to 100%, they appear to be very similar to the levels in their associated blue glasses. Thus, it appears that the white and blue glasses of the Portland Vase were produced from the same or closely related batches of colorless soda-lime-silica glass that were either colored by adding blue pigment or opacified by adding antimony oxide with or without lead oxide. The same is true of the two glasses in the disk.

Finally, in at least one area of debate concerning the origin of the Portland Vase, scientific analysis has provided an unequivocal resolution. It has, at times, been argued that the vase was either the product of a Renaissance workshop or that it was significantly altered during that period (see pp. 37–42). The alumina (Al_2O_3) level, 2–3%, is typical of Roman period glass.

Glasses of other periods – early Near Eastern, Islamic and Venetian – often have alumina contents below 2%, as well as having several percentage points each of potash and magnesia. Here, science speaks with exceptional clarity: the Portland Vase is a Roman-period object.

The work referred to above undoubtedly forms a foundation on which future research will be based as more artefacts come to light and more objects are made available for study. As Ian Freestone (1990, 107) puts it:

> Future work is likely to concentrate on the relationship of the vase to other Roman cameo glasses. The small group of cameos already examined suggests a range of cobalt pigments and marked variations in the lead contents of the overlay glasses. Detailed trace element and isotopic studies, utilizing the proton and ion microprobes, may release from our minute samples evidence that limits the number and organization of workshops producing these high-quality glasses. Such an investigation is possible with current technology, but it will depend on the collection of analytical data for large numbers of objects. Thus, we can expect the Portland Vase to yield more of its secrets in the future.

Appendix II
Forms, Themes and Colour of Roman Cameo Glass

Paul Roberts

In the course of researching this catalogue, the authors have examined most of the known pieces of Roman cameo glass. As a result it has been possible to create a tentative profile of various characteristics of the glass. The six pie charts below attempt to display visually the findings of aspects of this research. For the British Museum (the seventy pieces from the classic early period, 1– 69) and then for the world assemblage (which also incorporates the British Museum data), three pairs of charts quantify the known pieces of cameo glass according to three main criteria: category (plaque, open vessel or closed vessel), decorative theme and colour.

Such a discussion can of course only give a broad overview. Details of the British Museum pieces can be found in the relevant areas of the catalogue, while pieces in the world assemblage appear mainly as comparanda, though it is hoped to present a collation of the world assemblage at some point in the future.

Forms

Charts 1 and 2 show cameo glass from the British Museum (1) and world collections (2) divided according to the broadest object categories. For the purposes of this study the following divisions have been used: plaques, open vessels (cups, bowls, dishes, etc.) and closed forms (amphorae, jugs, bottles, etc.).

The separation of sherds of plaques from those of vessels was relatively simple, given the flat form and the generally poorly finished back surface of the plaque fragments. But in the case of vessel fragments, the distinguishing of sherds of closed vessels from those of open vessels was often less straightforward. In order to try to allot the fragments to particular vessel forms, the authors used their knowledge of the fifteen or so complete or near complete cameo glass vessels, together with comparanda from other elements of Roman tableware in glass, Arretine pottery and silverware. Quantification for all categories could be affected by the possibility that some pieces belong to the same vessel, but given the relative scarcity of links between known pieces it seems that most can be taken to belong to individual items. More uncertainty arises in the (infrequent) cases where identification was made on the basis of photographs alone – particularly where these were sometimes of varying quality. The lack of any three-dimensionality or a side or profile view, combined with descriptions that are sometimes less than illuminating, renders identification necessarily very tentative, and in some cases impossible.

In terms of broad categories, vessels were the most common overall group in the British Museum (47%, including 34% open vessels and almost 13% closed) and in world collections as a whole (64%, including almost 45% open vessels and 19% closed). The British Museum's collections, however, possess a high proportion of fragments of plaques (40%) compared with the world figure of 26%.

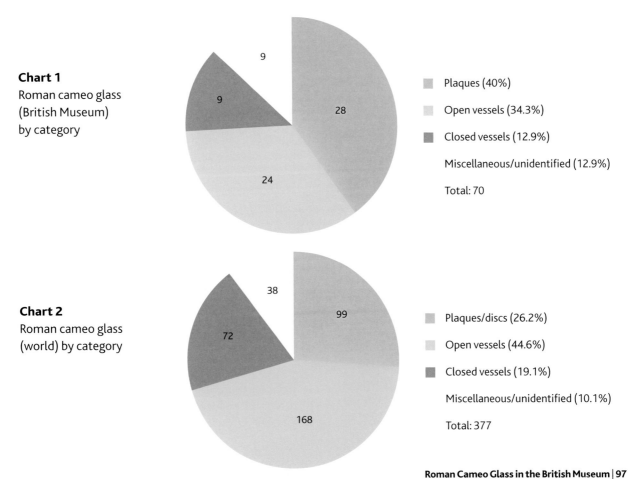

Chart 1
Roman cameo glass
(British Museum)
by category

9
9
28
24

Plaques (40%)
Open vessels (34.3%)
Closed vessels (12.9%)
Miscellaneous/unidentified (12.9%)
Total: 70

Chart 2
Roman cameo glass
(world) by category

38
99
72
168

Plaques/discs (26.2%)
Open vessels (44.6%)
Closed vessels (19.1%)
Miscellaneous/unidentified (10.1%)
Total: 377

Decorative themes

Caution is of course necessary when attempting any form of iconographic analysis, in particular of the necessarily incomplete picture presented by fragments. As with questions of form, the identification was made more difficult where the fragment was small, or in those cases where only images could be examined.

Even when a figure and (in the case of whole or nearly whole pieces) its context are complete, and its iconography can be fairly securely identified, there is still the thorny issue of determining what (if any) significance the iconography was intended to have. A clear example of this is the controversy surrounding the iconography of the Portland Vase, which rages to this day in spite of the complete preservation of all the figures. Sometimes, indeed, a degree of ambiguity may have been the deliberate intention of the artist. Nevertheless, it is, we believe, useful to attempt a basic division (however imperfect) by decorative themes as a starting point for future research.

Charts 3 and 4 show proportions of decorative themes on glass (both plaques and vessels) from the British Museum (3) and world collections (4), and there are marked similarities. In both cases the most popular theme is vegetal decoration (around 35%). Next are Bacchic subjects (see below), with 17% at the British Museum and 22% in the world. One very distinctive theme, with elements that cannot be confused with other themes, is Egyptian decoration: approximately 8% of British Museum pieces and 6% of the world assemblage carry decorative motifs that are unmistakably Egyptian in inspiration. Again, there is a range of subjects, from deities or their worshippers to sacrifices and Nilotic scenes, but all are indisputably Egyptian. Another theme is that of cupids/erotes, seemingly in isolation, appearing on some 5% of British Museum pieces and 3% of the world assemblage.

Bacchic imagery is one of the most important themes, but it is likely that it would be even more so if the all the fragments that have Bacchic imagery could be identified with certainty. As it is, a semi-naked human figure on a fragment could be just that – after all, several of the figures on the Portland Vase are half-naked or fully naked, and a Bacchic interpretation of the imagery is by no means the most likely hypothesis – but if more of the figure remained, it might be possible to identify a Bacchic figure, for example a tail or a pointed ear signifying a satyr, or a tambourine or *liknon* (basket) hinting at a maenad.

With regard to vegetal (and faunal) motifs, it is clear from more complete examples that some cameo pieces were wholly or substantially decorated with vegetal and animal elements. In the British Museum we need only look at the Auldjo Jug (2) or the plaque(s) with vegetal decoration. These may have carried Bacchic symbolism (for example, the use of vine or ivy motifs), but their decoration is not overtly Bacchic. Yet it should be remembered that flora and fauna also feature on most, if not all, of the plaques and vessels with definitely recognizable Bacchic themes. An isolated piece of vegetal or animal decoration could therefore come from a piece that originally carried a Bacchic message. This is perhaps even more likely in the case of plaques, where Bacchic imagery is particularly common. Similarly, cupids/erotes can of course feature in their own right, as suggested for the British Museum piece 15, but cupids/erotes also appear in scenes of a clearly Bacchic nature such as the Pompeii plaques MANN 153651–2 (Painter and Whitehouse 1990d, 154–6).

The term 'Bacchic' as used here is, of necessity, a cover-all. It includes all aspects of Bacchic figures and rites connected with the life and worship of the god Bacchus/Dionysus, ranging from the preparation for the *thyasos* (Bacchic procession) and for the *thyasos* itself, through the performance of sacred rites involving the *liknon* and other ritual objects, to more restful scenes featuring Bacchus and his consort Ariadne. All are here grouped under the heading of 'Bacchic'.

Given that some of the other decorative elements could be linked to Bacchic themes, it is possible to envisage that well over 50% of British Museum and world assemblage had a Bacchic association. This predominance of explicit or implicit Bacchic imagery is very appropriate, given that the main use of cameo glass was as tableware for the storage and consumption of liquid, and wine in particular.

Colour

Charts 5 and 6 are divided according to the background colour of the glass. Blue glass was overwhelmingly predominant as a background, both in the British Museum (57%) and in the world assemblage (69%). Purple was the second most popular colour in the British Museum (21%) and in the world (13%). There were a number of pieces in turquoise green (just under 3% in both assemblages). Other colours such as brown or green were rare, with only two or three examples in the world assemblage, while the example in the British Museum of a plaque with a clear glass background (43) is unique.

Multi-layered glass is found in both vessels and plaques. Proportionately, the British Museum has a higher percentage (14%) than the world average (5%) owing to the presence of seven plaque fragments of three-layered glass (53– 8, 60). The use of such multi-layered decoration poses some interesting problems. It can be understood on vessels, because the quality and beauty of a scene can be enhanced by carving or incising to reveal the different layers of colour (as in the case of the three incuse pieces known to have existed – see 22). It is more difficult to understand the rationale behind the use of such layers on plaques, whether three-layered or even, in one example at the British Museum, five-layered (59). Given that light could not penetrate beyond the first sandwiched layer of white, it is difficult to see the purpose of one or more layers beyond this, unless some part of the plaque bore incuse decoration. To date no such incuse decoration on a plaque has been identified.

In a related way, the popularity of purple glass is understandable in the context of vessels, particularly those where the various shades of light purple would be shown to good effect through transmitted light. But in darker, thicker pieces such as the British Museum acanthus jug fragment (5), light would less easily have passed through. This raises the question of whether colour was consciously chosen for particular vessels/plaques. Among the vessels, there does not seem to be any correlation in known pieces between particular forms and glass colour. Perhaps the choice was dependent simply on the batch of glass available. With regard to the plaques, however, we have argued (above, p. 33) that there is certainly a correlation between the choice of purple glass and the larger, more monumental plaques, vessels and other forms in the British Museum and elsewhere. This would seem to be the result of a conscious decision.

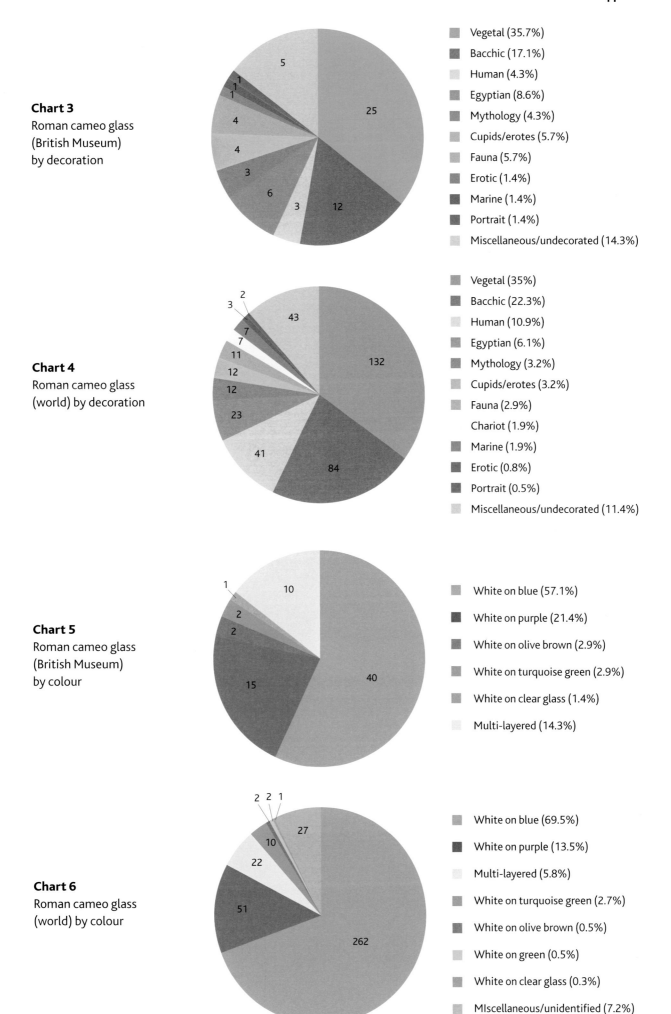

Chart 3
Roman cameo glass
(British Museum)
by decoration

Vegetal (35.7%)
Bacchic (17.1%)
Human (4.3%)
Egyptian (8.6%)
Mythology (4.3%)
Cupids/erotes (5.7%)
Fauna (5.7%)
Erotic (1.4%)
Marine (1.4%)
Portrait (1.4%)
Miscellaneous/undecorated (14.3%)

Chart 4
Roman cameo glass
(world) by decoration

Vegetal (35%)
Bacchic (22.3%)
Human (10.9%)
Egyptian (6.1%)
Mythology (3.2%)
Cupids/erotes (3.2%)
Fauna (2.9%)
Chariot (1.9%)
Marine (1.9%)
Erotic (0.8%)
Portrait (0.5%)
Miscellaneous/undecorated (11.4%)

Chart 5
Roman cameo glass
(British Museum)
by colour

White on blue (57.1%)
White on purple (21.4%)
White on olive brown (2.9%)
White on turquoise green (2.9%)
White on clear glass (1.4%)
Multi-layered (14.3%)

Chart 6
Roman cameo glass
(world) by colour

White on blue (69.5%)
White on purple (13.5%)
Multi-layered (5.8%)
White on turquoise green (2.7%)
White on olive brown (0.5%)
White on green (0.5%)
White on clear glass (0.3%)
MIscellaneous/unidentified (7.2%)

Glossary

William Gudenrath and David Whitehouse

This is a selective list of terms in the text that are not in daily use. Words that appear in **bold face** in the definitions have their own entries elsewhere in the glossary. Many of the definitions are based on entries in Whitehouse 2006.

Amphora: A jar with two handles and a body that often tapers to a pointed base. The form can be used both for tableware in glass and other media and for transport vessels.

Appliqué: In glassworking, a bit of hot glass, usually small and flat, fused to the surface of an object. Appliqués can be decorated by pressing them in a mould before they are attached, or stamped after they are attached, or decorated by cold working.

Arretine ware: Fine red-slip pottery with a glossy, sometimes glaze-like surface made in very large quantities between about 30 BC and AD 100 at Arezzo (ancient Arretium) in central Italy. Arretine ware, which may be plain or have moulded decoration, was exported throughout the Roman world and even beyond.

Blank: In glassworking, any cooled object that requires further forming or decoration to be finished.

Blown glass: Glassware formed by inflating a mass of molten glass at the end of a blowpipe. The glassblower produces the desired form by swinging the molten glass, rolling it on a smooth surface, manipulating it with tools, or shaping (and sometimes decorating) it in a mould.

Cage cup: A vessel decorated by undercutting, so that the decorative surface stands free of the body of the vessel, to which it is attached by struts.

Calathus: A drinking vessel with a tall, flaring body, wide mouth and single handle.

Cameo: An object, generally small, carved in relief from stone or some other material with layers of contrasting colours, so that different parts of the decorated surface create an image or scene.

Cameo glass: Glass of one colour covered with one or more layer(s) of contrasting colour(s). The outer layers are carved, cut, engraved or (in modern times) acid-etched to produce a design that stands out from the background. Roman cameo glass **blanks** were either **cast** or blown using the **dip-overlay** technique.

Cantharus: A drinking vessel with a bell-shaped body, two high-looped handles and a foot.

Cast glass: A glass object that has been given its initial form and sometimes decoration by pouring or dripping molten glass onto a heat-resistant surface or into a mould. Often the glass has to be forced downwards with a tool to fill the mould completely.

Dip-overlay method: The technique used in antiquity to produce **blanks** for most **cameo glass** vessels. After an initial gather of (typically) dark blue glass has been inflated to form a tube, on hardening it is lowered part-way into a crucible of molten (typically) opaque white glass. The two glasses are inflated together and given their final shape (see p. 26 for a photographic sequence of this process).

Egyptianizing: Formed or decorated in a style that resembles Egyptian art or design.

Enamelled decoration: Decoration made by painting a glass **blank** at room temperature with finely ground, coloured-glass particles in a liquid medium. After drying, the object is fired to a sufficiently high temperature to fuse the particles to each other and to the surface of the object.

Grozing: The act of trimming and neatening a ragged glass edge by nipping it repeatedly with metal snips or pliers.

Hydrofluoric acid: A highly corrosive acid that attacks glass and other silicates. Pure hydrofluoric acid dissolves glass, leaving an etched or acid-polished surface.

Internal grinding marks: Fine, more or less concentric grooves, which cover the interior of many vessels and fragments of cameo glass. These grooves are the result of a cold-working process, used to detect potentially perilous bubbles in the blue base glass of cameo vessels.

Krater: A mixing bowl, the original purpose of which was to mix wine and water.

Lathe-turned: An object is said to be lathe-turned when it shows indications of having been mounted in a machine, such as a potter's wheel, and rotated while a tool was pressed against it to remove material from the surface or to polish it.

Marvering: Rolling or pressing glass onto a hard smooth surface during manufacture in order to shape it.

Modiolus: A drinking vessel with a broad, cylindrical body and a single handle.

Mould-blown glass: A glass object formed by molten glass being blown, with the aid of a blowing tube, into a mould of two or more parts, usually made of earthenware or metal.

Obsidian: A volcanic mineral, usually black, that was the first form of natural glass used by humans to make tools and weapons. The Romans used obsidian to make tableware vessels, architectural decoration, mirrors, jewellery and statuary.

Opaque: Impervious to the rays of visible light. See also **translucent** and **transparent**.

Oscillum: A small, disc-shaped object decorated on both surfaces, which was intended to be suspended out of doors, where it moved in the breeze.

Patera: A dish or bowl with a straight handle resembling a frying pan, frequently used for pouring libations.

Poinçon: A punch or stamp, used to decorate the interior of the moulds that produced red-slip wares.

Pontil: A solid metal rod. When tipped with a small quantity of hot glass, the pontil is attached to the base of a partly formed vessel, which is then detached from the blowpipe in order to finish the mouth.

Provenance: In this catalogue, the recorded place of an artefact's discovery, acquisition or first mention.

Pyxis: A small covered box, often cylindrical, used to contain cosmetics, medicines and jewellery.

Red-slip ware: Pottery coated with an iron-rich slip, which turns reddish orange in an oxygen-rich kiln. The slip can vary in appearance from shiny to matt. **Arretine ware** is a type of red-slip ware.

Sigillata: See **red-slip ware**.

Silica: Silicon dioxide (SiO_2), one of the main ingredients of glass. Sand is often the source of the silica used in glassmaking.

Skyphos: A cup with two opposed handles, often ring-shaped, with thumb rests and a stemmed foot.

Tazza: In descriptions of glass, a shallow cup or bowl with a stem and a foot. The Tazza Farnese (see p. 25), however, is a dish with neither a stem nor a foot.

Terminus ante quem: The date or event marking the beginning of a given period. In archaeological terms, a date before which something must have been created or deposited.

Terminus post quem: The date or event marking the end of a given period. In archaeological terms, a date after which something must have been created or deposited.

Translucent: An adjective describing a substance that transmits light. Although translucent and **transparent** are sometimes used as synonyms, they have different meanings. See also **opaque**.

Transparent: An adjective describing a substance through which objects can see seen. See also **opaque** and **translucent**.

Weathering: Changes on the surface caused by chemical reaction with the environment. Weathering usually involves the leaching of alkali from the glass by water, leaving thin siliceous films that may produce an iridescent effect.

Concordance

Registration no.	Catalogue no.	Registration no.	Catalogue no.	Registration no.	Catalogue no.	Registration no.	Catalogue no.
1859,0216.1	2	1868,0501.8	21	1886,1117.46	81	1976,1003.23	48
1859,0216.1a	8	1868,0501.926	62	1923,0401.1203	36	1976,1003.3	40
1859,0216.1b	7	1869,0306.32	65	1923,0401.1204	42	1976,1003.4	3
1860,0928.13	25	1870,0606.11	72	1945,0927.1	1	1976,1003.5	16
1865,1214.104	75	1879,0522.46	33	1945,0927.2	34	1976,1003.6	31
1865,1214.105	6	1886,1117.28	63	1953,1022.3	70	1976,1003.7	17
1865,1214.84a	19	1886,1117.29	61	1953,1022.4	71	1976,1003.8	11
1865,1214.84b	13	1886,1117.30	52	1956,0305.1	10	1976,1003.9	27
1867,0507.728	15	1886,1117.31	55	1976,1003.1	30	1982,0404.1	20
1868,0501.107c	59	1886,1117.32	57	1976,1003.10	9	1999,0803.1	22
1868,0501.133	46	1886,1117.33	18	1976,1003.11	80	1999,0927.1	24
1868,0501.134	29	1886,1117.34	32	1976,1003.12	78	2005,0803.1	68
1868,0501.135	50	1886,1117.35	12	1976,1003.13	44	2005,0803.2	66
1868,0501.136	4	1886,1117.36	5	1976,1003.14	35	2005,0803.3	67
1868,0501.137	26	1886,1117.38	54	1976,1003.15	39	2005,0803.4	69
1868,0501.138	28	1886,1117.39	56	1976,1003.16	43	2005,0803.5	64
1868,0501.140	51	1886,1117.40	59	1976,1003.18	37	2005,0803.6	44a
1868,0501.141	74	1886,1117.41	49	1976,1003.19	38	EA 16600	23
1868,0501.142	73	1886,1117.43	53	1976,1003.2	14	EA 16630	41
1868,0501.143	45	1886,1117.44	79	1976,1003.20	47		
1868,0501.7	76	1886,1117.45	77	1976,1003.22	58		

Bibliography

Anderson, W.E.K. 1998, *The Journal of Sir Walter Scott*. Edingburgh, Canongate.

Asskemp, R., Brouwer, M., Christiansen, J., Kenzler, H., and Wamser, L. 2007, *Luxus und Dekadenz*. Mainz, von Zabern.

Bailey, D.M. 2007, 'A Collar for a God: an Egyptianising Scene on a Fragment of Roman Cameo Glass' in Gilmour, L. (ed.) *Pagans and Christians – from Antiquity to the Middle Ages*. BAR International Series 1610, pp. 131–6. Oxford, Tempus.

Baratte, F. 1986, *Le Trésor d'orfèverie romaine de Boscoreale*. Paris, Musée du Louvre.

Bartoli, D. 1984, *Marcus Perennius Bargathes Tradizione e innovazione nella ceramica aretina. Catalogo della mostra, Arezzo, Museo Caio Clinio Mecenate, 1984*. Rome, Viella – Vision.

Bartoli, P.S. 1697, *Gli antichi sepolchri, ovvero Mausolei Romani, ed Etruschi Trovati in Roma, ed in altri luoghi celebri … Raccolti, disegnati, ed intagliati da Pietro Santi Bartoli*. Roma, Licenza de Superiori.

Béraud, I. and Gébara, C. 1990, 'La Datation du verre des necropolis gallo-romaines de Fréjus', *Annales du 11ᵉ Congrès de l'Association Internationale pour l'Histoire du Verre, Bâle, 29 août–3 septembre 1988*, pp. 153–65.

Biaggio Simona, S. 1991, *I vetri romani provenienti dalle terre dell'attuale Cantone Ticino*. Locarno, Armando Dadò.

Bierbrier, M.L. (ed.) 1995, *Who Was Who in Egyptology* (3rd rev. edn). London, Egypt Exploration Society.

Bimson, M. and Freestone, I. 1983, 'An Analytical Study of the Relationship Between the Portland Vase and Other Roman Cameo Glasses', *Journal of Glass Studies*, vol. 25, pp. 55–64.

Biroli Stefanelli, L.P. 1991, *L'Argento dei Romani*. Rome, 'L'Erma' di Bretschneider.

Biroli Stefanelli, L.P. 2006, 'Le Argenterie nel Mondo Romano', in Guzzo (ed.) 2006, pp. 19–29.

Boetzkes, M., Stein, H. and Weisker, C. 1997, *Der Hildesheimer Silberfund*. Hildesheim, Gerstenberg.

Bonhams 2004, 'Highly important antiquities, 14th July', Sale Catalogue. London, Bonhams.

Bragantini, I. 2006, 'Il Culto di Iside e l'Egittomania antica in Campania', in De Caro 2006, pp. 158–67.

Brooks, R. 2004, *The Portland Vase*. New York, Harper Collins.

Brown, A.C. 1968, *Catalogue of Italian Terra Sigillata in the Ashmolean Museum Oxford*. Oxford, Clarendon Press.

Burlington Fine Arts Club 1895, *The Art of Ancient Egypt*. London, privately printed.

Carandini, A., Ricci, A. and de Vos, M. 1982, *Filosofiana, the Villa of Piazza Armerina*. Palermo, Flaccovio.

Casini, S. 1992, 'Unguentario di vetro cammeo' in G. Pucci (ed.) *La Fornace di Umbricio Cordo*, p. 81, tavv. LV–LVI. Florence, All'Insegna del Giglio.

Chase, G.H., Comstock, M.B. and Vermeule, C. 1916, *Catalogue of Arretine Pottery in the Museum of Fine Arts, Boston*. Cambridge (MA), Riverside Press.

Christie's 1999, 'Ancient glass formerly in the G. Sangiorgi Collection', Sale Catalogue. New York, Christie's.

Clarke, J.R. 1998, *Looking at Lovemaking: Constructions of Sexuality in Roman Art 100 B.C.–A.D.250*. Berkeley, University of California Press.

Clayton, M. 1985, *The Christie's Pictorial History of English and American Silver*. Oxford, Phaidon.

Cool, H.E.M. and Price, J. 1994, *Colchester Archaeological Report 8: Roman Vessel Glass from Excavations at Colchester, 1971–85*. Colchester, Colchester Archaeological Trust.

Cooney, J.D. 1976, *Catalogue of Egyptian Antiquities in British Museum IV: Glass*. London, British Museum.

A.T. Croom 2000, *Roman Clothing and Fashion*. Tempus, Stroud.

Czurda-Ruth, B. 1979, *Die römischen Gläser vom Magdalensberg*, Kärnter Museumschriften 65. Klagenfurt, Verlag des Landesmuseums für Kärnten.

Dalton, O.M. 1915, *Catalogue of the Engraved Gems of the Post-Classical Periods in the Departments of British and Medieval Antiquities and Ethnography in the British Museum*. London, British Museum.

Daumas, M. 1998, *Cabiriaca: recherches sur l'iconogaphie du culte des Cabires*. Paris, de Boccard.

Dawson, A. 1995, *Masterpieces of Wedgwood in the British Museum*. London, British Museum Press, rev. edn.

De Caro, S. 2006, *Egittomania: Iside e il Mistero*. Milan, Electa.

De Montfaucon, B. 1719, *L'Antiquité expliquée*. Paris, 5 vols.

De Montfaucon, B. 1724, *Supplément au livre de l'antiquité expliquée*. Paris, 5 vols.

De Tommaso G. 1990, 'Un vetro cammeo dal territorio di Populonia (Livorno)', *Rassegna di Archeologia*, 9 (1990), pp. 419–22.

Doppelfeld, O. 1966, *Römisches und fränkisches Glas in Köln*. Köln, Greven.

Dunbabin, K.M.D. 1999, *Mosaics of the Greek and Roman World*. Cambridge, Cambridge University Press.

Dusenbery, E.B. 1964, 'Two fragments of a Roman glass cup', *Journal of Glass Studies*, vol. 6, pp. 31–3.

Eisenberg, J.M. 2003, 'The Portland Vase: A glass masterwork of the Late Renaissance', *Minerva*, vol. 14, no. 5, pp. 37–41.

Eisenberg, J.M. 2004, 'The Portland Vase: Further observations', *Minerva*, vol. 15, no. 1, p. 18.

Ettlinger, E. 1990, *Conspectus Formarum Terrae Sigillatae Italico Modo Confectae*. Bonn, Habelt.

Freestone, I. 1990, 'Laboratory studies of the Portland Vase', *Journal of Glass Studies*, vol. 32, pp. 103–7.

Froehner, W. 1903, *Collection Julien Gréau Verrerie Antique, Émaillerie et Poterie Appartenant à M. John Pierpont Morgan*. Paris, privately printed.

Gaimster, D. 2000, 'Sex and Sensibility at the British Museum', *History Today*, September 2000, pp. 11–15.

Gell, Sir William 1957, *Reminiscences of Sir Walter Scott's Residence in Italy, 1832*. London, Thomas Nelson.

Giove, T. 2006, 'Casa dell'Argenteria (VI, 7, 20–22)' in Guzzo (ed.) 2006, pp. 114–22.

Goldman, N. 1994, 'Reconstructing Roman costume', in Sebesta and Bonfante (eds) 1994, pp. 213–37.

Goldstein, S.M. 1979, *Pre-Roman and Early Roman Glass in The Corning Museum of Glass*. Corning (NY), Corning Museum of Glass.

Goldstein, S.M., Rakow, L.S. and Rakow, J.K. 1982, *Cameo Glass: Masterpieces from 2,000 Years of Glassmaking*. Corning (NY), Corning Museum of Glass.

Grose, D.F. 1977, 'Early Blown Glass: The Western Evidence', *Journal of Glass Studies*, v. 19, pp. 9–29.

Grose, D. 1983, 'The Formation of the Roman Glass Industry', *Archaeology*, vol. 36, no. 4, pp. 38–45.

Grose, D.F. 1989, *Toledo Museum of Art: Early Ancient Glass*. New York, Hudson Hills Press/Toledo Museum of Art.

Gudenrath, W., 2006, 'Enameled Glass Vessels 1425 BCE–1800: The Decorating Process', *Journal of Glass Studies*, vol. 48, pp. 23–70.

Gudenrath, W., Painter, K. and Whitehouse, D. 1990a, 'The Portland Vase', *Journal of Glass Studies*, vol. 32, pp. 14–23.

Gudenrath, W. and Whitehouse, D. 1990b, 'The Manufacture of the Vase and its Ancient Repair', *Journal of Glass Studies*, vol. 32, pp. 108–21.

Guidobaldi, M.P. and Esposito, D. 2009, 'Le nuove ricerche archeologiche nella Villa dei Papiri di Ercolano', *Cronache Ercolanesi* 39 (2009), 331–70.

Guyan, W.U. 1975, 'Die Jagdschale', *Helvetia Archeologica*, vol. 22, no. 3, pp. 44–77.

Guzzo, P.G. (ed.) 2006, *Argenti a Pompeii*. Milan, Electa.

Guzzo, P.G. 2006, 'Ministerium' in Guzzo (ed.) 2006, pp. 78–96.

Gwinnett, J. and Gorelick, L. 1983, 'An Innovative Method to Investigate the Technique of Finishing an Ancient Glass Artifact', *Journal of Glass Studies*, vol. 25, pp. 249–56.

Hansard 1845, vol. 78, c. 783, House of Commons Debate, 13 March 1845.

Bibliography

Hansen, I.L. 2009, *Hellenistic and Roman Butrint*. London, Butrint Foundation.

Harden, D.B. 1983, 'New light on the history and and technique of the Portland and Auldjo cameo vessels', *Journal of Glass Studies*, vol. 25, pp. 45–54.

Harden, D.B. and Toynbee, J.M.C. 1959, 'The Rothschild Lycurgus Cup', *Archaeologia*, vol. 97, pp. 179–212.

Harden, D.B., Hellenkemper, H., Painter, K. and Whitehouse, D. 1987, *Glass of the Caesars*. Milan, Olivetti.

Harrison, J.E. 1903, *Prolegomena to the Study of Greek Religion*. Cambridge, Cambridge University Press.

Haynes, D.E.L. 1968, 'The Portland vase again', *Journal of Hellenic Studies*, vol. 88, pp. 58–72.

Haynes, D.E.L. 1975, *The Portland Vase*. London, Trustees of the British Museum, 2nd revised edn.

Haynes, D.E.L. 1995, 'The Portland vase – a reply', *Journal of Hellenic Studies*, vol. 115, pp. 146–52.

Henig, M. 1990, *The Content Family Collection of Ancient Cameos*. Oxford and Houlton, Ashmolean Museum.

Hind, J. 1995, 'Achilles and Helen on White Island', *Journal of Hellenic Studies*, vol. 115, pp. 59–62.

Hochuli-Gysel, A. 1977, *Kleinasiatische Glasierte Reliefkeramik*. Bern, Stämpfli.

Hogg, E. 1835, *Visit to Alexandria, Damascus and Jerusalem*. London, Saunders and Otley.

Isings, C. 1957, *Roman Glass from Dated Finds: Archaeologica Traiectina II*. Groningen and Djakarta, Wolters.

Israeli, J. and Katsnelson, N. 2006, 'Refuse of the Glass Workshop of the Second Temple Period from Area J' in H. Geva (ed.), *Jewish Quarter Excavations in the Old City of Jerusalem Conducted by Nahman Avigad, 1969–1982, Volume III: Area E and Other Studies,* pp. 411–60. Jerusalem, Israel Exploration Society and Institute of Archaeology, Hebrew University of Jerusalem.

Jaffé, D. 1989, 'Peiresc, Rubens, dal Pozzo and the "Portland Vase"', *Burlington Magazine* v.31, no. 1037, pp. 554–9.

Jamieson, P. 2009, *Auldjo: A Life of John Auldjo 1805–1896*. Norwich, Michael Russell (publishing) Ltd.

Jenkins, I. 1994, *The Parthenon Frieze*. London, British Museum Press.

Jenkins, I. and Sloan, K. 1996, *Vases and Volcanoes: Sir William Hamilton and his Collection*. London, British Museum Press.

Kenrick, P. 2000, *Corpus Vasorum Arretinorum*. Bonn, Habelt (2nd rev. edn of original by A. Oxe and H. Comfort).

Koltes, J. 1982, *Catalogue des collections archéologiques de Besançon. 7, La verrerie gallo-romaine*. Paris, Belles Lettres.

Kuttner, A.L. 1995, *Dynasty and Empire in the Age of Augustus*. Berkeley (CA), University of California Press.

Lanna, Freiherr Adalbert M.Fr. von 1909, *Sammlung des Freiherrn von Lanna, Prag*. Berlin, Rudolph Lepke's Kunst-Auctions-Haus.

La Rocca, E. 1984, *L'Età d'Oro di Cleopatra. Indagine sulla Tazza Farnese*. Rome, 'L'Erma' di Bretschneider.

Lepri, B. 2007, 'Complesso archeologico di Veio-Campetti: il materiale vitreo nelle stratificazioni di età romana (I–III secolo d.C.) e tardo antica (IV–VII secolo d.C.)'. www.fastionline.org/docs/FOLDER-it-2007-81.pdf

Lierke, R. (ed.) 1999, *Antike Glastöpferie (ein vergessenes Kapitel der Glasgeschichte)*. Mainz, von Zabern.

Lightfoot, C. 1988, 'Report: no. 83', in P. Hinton (ed.), *Excavations in Southwark 1973–1976, Lambeth 1973–1979*. London and Middlesex Archaeological Society Surrey. Joint Publication no. 3, 374–8, no. 83 and fig. 167.

LIMC: *Lexicon Iconographicum Mythologiae Classicae* (1981–97). Zurich-Munich, Artemis, 8 vols.

Ling, R. 1991, *Roman Painting*. Cambridge, Cambridge University Press.

Lista, M. 2006, 'Casa di Inaco e Io (VI, 7, 19)', in Guzzo (ed.) 2006, pp. 168–79.

Mandruzzato, L. and Marcante, A. 2005, *Vetri Antichi del Museo Archeologico Nazionale di Aquileia: il vasellame da mensa*. Venezia, Comitato Nazionale Italiano dell'Association Internationale pour l'Histoire du Verre.

Marabini Moevs, M.T. 2006, *Cosa: The Italian Sigillata*. Ann Arbor, University of Michigan Press.

Mastroroberto, M. 2006a, 'Il Tesoro di Moregine', in Guzzo (ed.) 2006, pp. 224–37.

Mastroroberto, M. 2006b, 'Il Tesoro di Moregine e le "coppe della riconciliazione"', in Guzzo (ed.) 2006, pp. 30–43.

Matheson, S.B. 1980, *Ancient Glass in The Yale University Art Gallery*. Yale (CT), Yale University Art Gallery.

Mattusch, C. 2008, *Pompeii and the Roman Villa*. London, Thames and Hudson.

Meconcelli Notarianni, G. 1979, *Vetri antichi nelle collezioni del Museo civico archeologico di Bologna*. Bologna, Museo civico archeologico di Bologna.

Menu von Minutoli, J.H.C. 1836, *Über die Antfertigung und die Nutzandwendung der farbingen Gläser*. Berlin.

Möbius, H. 1964, 'Alexandria und Rom', *Bayerische Akademie der Wissenschaften. Philosophisch-Historische Klasse, Abhandlungen, Neue Folge*, vol. 59, pp. 8–45.

Mutz, A. 1972, *Die Kunst des Mettaldrehens bei den Römern*. Basel and Stuttgart, Birkhäuser.

Naumann-Steckner, F. 1989, 'Vidi tunc adnumerari unius scyphi fracta membra: Kameoglas-fragmente im Römisch-Germanischen Museum Köln'. *Kölner Jahrbuch* 22 (1989), pp. 73–86.

Newby, M. and Painter, K. (eds) 1991, *Roman Glass: Two Centuries of Art and Invention*. Occasional Papers XIII, London, Society of Antiquaries.

Nuber, H.E. 1973, 'Kanne und Giffschale. Ihr Gebrauch im täglichen Leben und die Beigabe in grabern der römischer Kaiserzeit', in *Bericht der Römisch-Germanischen Kommission*, 53 (1972), pp. 1–232.

Ogden, J. 2004, Letter in 'Portland Vase Letters', *Minerva*, vol. 15, no. 1, pp. 20–21.

PAH: Pompeianarum Antiquitatum Historia, ed. G. Fiorelli, 1861–4. Naples, 4 vols.

Painter, K. and Whitehouse, D. 1990a, 'The history of the Portland Vase', *Journal of Glass Studies*, vol. 32, pp. 24–84.

Painter, K. and Whitehouse, D. 1990b, 'Earlier Interpretations of the Scenes', *Journal of Glass Studies*, vol. 32, pp. 172–6.

Painter, K. and Whitehouse, D. 1990c, 'The Interpretation of the Scenes', *Journal of Glass Studies*, vol. 32, pp. 130–36.

Painter, K. and Whitehouse, D. 1990d, 'Early Roman cameo glasses', *Journal of Glass Studies*, vol. 32, pp. 138–65.

Painter, K. and Whitehouse, D. 1990e, 'The History of the Vase', *Journal of Glass Studies*, vol. 32, pp. 85–102.

Painter, K. and Whitehouse, D. 1990f, 'Style, Date and Place of Manufacture', *Journal of Glass Studies*, vol. 32, pp. 122–5.

Painter, K. and Whitehouse, D. 1991, 'The Portland Vase', in Newby and Painter (eds) 1991, pp. 33–45.

Paturzo, F. 1996, *Arretina Vasa. La ceramica aretina da mensa in età romana, Arte. Storia e tecnologia*. Cortona, Calosci.

Pellatt, A. 1849, *Curiosities of Glass Making*. London, David Bogue.

Perry, C.W. 2000, *The Cameo Glass of Thomas and George Woodall*. Shepton Beauchamp, Richard Dennis.

Platz-Horster, G. 1979, 'Zu Erfindung und Verbreitung der Glasmachpfeife', *Journal of Glass Studies*, vol. 21, pp. 27–31.

Platz-Horster, G. 1992, *Nil und Euthenia*. Berlin, de Gruyter.

Pollini, J. 1993, 'The Tazza Farnese: Augusto Imperatore "Redeunt Saturnia Regna"', *American Journal of Archeology*, vol. 96, pp. 249–53, 283–300.

Price, J. 1991, 'Decorated mould-blown glass tablewares in the first century AD', in Newby and Painter (eds) 1991, pp. 56–85.

Ritterling, E. 1913, 'Das frührömische Lager bei Hofheim i.T.', *Annalen des Vereins für nassauische Altertumskunde* 40, pp. 1–416.

Roberts, P.C. 1997, 'Mass-Production of Early Roman Finewares', in I. Freestone and D. Gaimster (eds) *Pottery in the Making*, pp. 188–93. London, British Museum Press.

Roberts, P.C. 2005, '"Singing all summer and dancing all winter": a group of lead-glazed ware vessels in the British Museum' in N. Crummy (ed.) *Image, Craft and the Classical World. Essays in Honour of Donald Bailey and Catherine Johns*, pp. 23–38. Montagnac, Monographies Instrumentum 29.

Robinson, J.C. 1860, *Catalogue of the Works of Art Forming the Collection of Matthew Uzielli of Hanover Lodge, Regent's Park*. London, privately published.

Rooksby, H.P. 1959, 'An Investigation of Ancient Opal Glasses with Spectral Reference to the Portland Vase', *Journal of the Society of Glass Technology* 43, pp. 285T–288T

Rooses, M. and Ruelens, C. 1909, *Correspondence de Rubens*. Anvers, Buschmann.

Rütti, B. 1981, 'Römische Glas', in *3000 Jahre Glaskunst*, pp. 59–118. Lucerne, Kunstmuseum Luzern.

Rütti, B. 1991, 'Early Enamelled Glass', in Newby and Painter (eds) 1991, pp. 122–36.

Saguì, L., Bacchelli, B., Barbera, M. and Pasqualucci, R. 1995, 'Nuove scoperte sulla provenienza dei pannelli in opus sectile vitreo della

collezione Gorga', in *Atti del II Colloquio dell'Associazione Italiana per lo Studio e la Conservazione del Mosaico (Roma 1994)*, ed. I. Bragantini and F. Guidobaldi, pp. 447–66. Bordighera, Istituto internazionale di studi liguri.

Saldern von, A. 1991, 'Roman Glass with Decoration Cut in High-Relief', in Newby and Painter (eds) 1991, pp. 111–21.

Sangiorgi, G. 1914, *Collezione di vetri antichi dalle origini al V Sec. D.C.*. Milan, Casa editrice d'arte Bestetti e Tumminelli.

Scatozza Höricht, L.A. 1986, *I vetri romani di Ercolano*. Rome, 'L'Erma' di Bretschneider.

Sebesta, J.L. and Bonfante, L. 1994, *The World of Roman Costume*. Madison (WI), University of Wisconsin Press.

Simon, E. 1957, *Der Portlandvase*. Mainz am Rhein, Römisch-Germanisches Zentralmuseum zu Mainz.

Simon, E. 1964, 'Drei antike Gefässe in Corning, Florence and Besançon', *Journal of Glass Studies*, vol. 6, pp. 13–30.

Simon, E. 1986, *Augustus, Kunst und Leben in Rom und die Zeitwende*. Munich, Hirmer.

Simon, E. 1999, 'Die Portland Vase und die Ikonographie des Kameoglases' in R. Lierke (ed.) *Antike Glastöpferie (ein vergessenes Kapitel der Glasgeschichte)*, pp. 89–96. Mainz, von Zabern.

Slade, F. 1871, *Catalogue of the Collection of Glass Formed by Felix Slade*. London, Wertheimer, Lea & Co.

Sotheby's 1987, 'Ancient glass, 20 November', Sale Catalogue. London, Sotheby's.

Stefani, G. 2006a, 'Casa del Menandro (I, 10)', in Guzzo (ed.) 2006, pp. 191–223.

Stefani, G. 2006b, 'La villa di tesoro di argenterie di Boscoreale', in Guzzo (ed.) 2006, pp. 180–90.

Stern, E.M. 1995, *The Toledo Museum of Art: Roman Mold-Blown Glass, the First through Sixth Centuries*. Rome, 'L'Erma' di Bretschneider in association with the Toledo Museum of Art.

Stevenson, J.H. 1999, 'Alexander Nesbitt, a Sussex antiquary, and the Oldlands estate', *Sussex Archaeological Collections* 137 (1999), pp. 161–73.

Tait, H. (ed.) 1991, *Five Thousand Years of Glass*. London, British Museum Press.

Tassinari, S. 1993, *Il vasellame bronzeo di Pompei*. Rome, 'L'Erma' di Bretscheider, 2 vols.

Tatton-Brown, V. 1991, 'The Roman Empire' in Tait (ed.) 1991, pp. 62–97.

Toynbee, J.M.C. 1934, *The Hadrianic School*. Cambridge, Cambridge University Press.

Turner, W.E.S. 1959, 'Studies in Ancient Glasses and Glassmaking Processes. Part VI: The Composition of the Portland Vase', *Journal of the Society of Glass Technology* 43, pp. 262T–284T.

Vannini, A. 1988, *Museo Nazionale Romano. Le ceramiche. V, 2. Matrici di ceramica aretina decorata*. Rome, de Luca.

Vollenweider, M.-L. 1995 *Camées et Intailles, Tome 1, Les portraits grecs du Cabinet des Médailles*. Paris, Bibliothèque Nationale, 2 vols.

Walker, S.E.C. 1991, *Roman Art*. London, British Museum Press.

Walker, S.E.C. 2004, *The Portland Vase*. London, British Museum Press.

Walters, H.B. 1899, *Catalogue of the Bronzes, Greek, Etruscan and Roman in the Department of Greek and Roman Antiquities*. London, British Museum.

Walters, H.B. 1908, *Catalogue of the Roman Pottery in the Departments of Antiquities, British Museum*. London, British Museum.

Walters, H.B. 1926, *Catalogue of the Engraved Gems and Cameos, Greek, Etruscan and Roman in the British Museum*. London, British Museum.

Weinberg, G.D. 1992, *Glass Vessels in Ancient Greece: Their History Illustrated from the Collection of the National Archaeological Museum, Athens*, p. 105, no. 62. Athens, Archaeological Receipts Fund.

Weinberg, G.D., and Stern, E.M. 2009, *The Athenian Agora: Results of Excavations Conducted by the American School of Classical Studies at Athens. Vol. 34: Vessel Glass*. Princeton, N.J., American School of Classical Studies at Athens.

Weiss, C. and Schüssler, U. 2001, *Kameoglasfragmente im Marten von Wagner Museum der Universität Würzburg und im Allard Pierson Museum Amsterdam*, pp. 199–251. Jahrbuch des Deutschen Archäologischen Instituts 115 (2000).

Whitehouse, D. 1989, 'The Seasons Vase', *Journal of Glass Studies*, vol. 31, pp. 16–24.

Whitehouse, D. 1990, 'Late Roman Cameo Glass', *Annales du 11e Congrès de l'Association Internationale pour l'Histoire du Verre, Bâle, 29 août–3 septembre 1988* (1990), pp. 193–8.

Whitehouse, D. 1991, 'Cameo glass', in Newby and Painter (eds) 1991, pp. 19–32.

Whitehouse, D. 1994, *English Cameo Glass*. Corning, Corning Museum of Glass.

Whitehouse, D. 1997, *Roman Glass in the Corning Museum of Glass, Volume 1*. Corning, Corning Museum of Glass.

Whitehouse, D. 1999, 'Glass Lagynoi Again', in A. Cadei (ed.) *Arte d'Occidente: Termi e metodi. Studi in Onore di Angiola Maria Romanini*. Rome, Sintesi informazione.

Whitehouse, D. 2004, 'The art of crafting the Portland vase', *Minerva*, vol. 15, no. 1, pp. 19–20.

Whitehouse, D. 2006, *Glass: A Pocket Dictionary of Terms Used to Describe Glass and Glassmaking*. Corning, Corning Museum of Glass, rev. edn.

Whitehouse, D. 2007, *Reflecting Antiquity*. Corning, Corning Museum of Glass.

Wight, K. 2003, 'The Iconography of the Getty Skyphos' in *Annales du 15e Congrès de l'Association Internationale pour l'Histoire du Verre, New York-Corning, 2001*, pp. 36–490. Nottingham, Association Internationale pour l'Histoire du Verre.

Williams, D.J.R. 2004, 'Crystalline Matter', *British Museum Magazine* 48 (Spring 2004), p. 47.

Williams, D.J.R. 2006, *The Warren Cup*. London, British Museum Press.

Williams, N. 1989, *The Breaking and Remaking of the Portland Vase*. London, British Museum Press.

Willis, N.P. 1835, *Pencillings by the Way*. London, Macrone.

Wilson, D.M. 2002, *The British Museum – A History*. London, British Museum Press.

Zahn, R. 1929 *Sammlung Baurat Schiller*. Berlin, Rudolph Lepke's Kunst-Auctions-Haus.

General Index

References to the catalogue entries – apart from those for the Portland Vase and the Auldjo Jug (**1** and **2**), which are very long – are given in **bold type** and refer to the catalogue number. All other references are to page numbers: these include references to the catalogue introduction on pp. 32–3, the Portland Vase and Auldjo Jug catalogue entries on pp. 34–47 and the catalogue section introductions on pp. 74, 75 and 77.

Index of Donors, Vendors and Previous Owners of Cameo Glass in the British Museum

Index of Findspots

All references are to catalogue entries.

Capri **33**
Cumae **62**

Pompeii **2**, **7**, **8**

Rome **1**, **5**, **10**, **12**, **18**, **22**, **24**, **32**, **34**, **49**, **52**, **53**, **54**, **55**, **56**, **57**, **59**, **61**, **63**, **77**, **79**, **81**
Rome (almost certainly) **4**, **6**, **13**, **19**, **20**, **21**, **26**, **28**, **29**, **45**, **46**, **50**, **51**, **60**, **65**, **72**, **73**, **74**, **75**, **76**

Uncertain/unknown **3**, **9**, **11**, **14**, **15**, **16**, **17**, **23**, **25**, **27**, **30**, **31**, **35**, **36**, **37**, **38**, **39**, **40**, **41**, **42**, **43**, **44**, **44a**, **47**, **48**, **58**, **64**, **66**, **67**, **68**, **69**, **70**, **71**, **78**, **80**